Brandstand

STRATEGIES FOR RETAIL BRAND BUILDING

Brandstand

STRATEGIES FOR RETAIL BRAND BUILDING

Arthur A. Winters, Peggy Fincher Winters, Carole Paul
and the editors of *Retail Ad World*

Published by Visual Reference Publications, Inc., New York, NY

The cases in Brandstand were developed by the editors of
Retail Ad World. For more information on RAW and subscribing
to this monthly publication, contact:
Visual Reference Publications,
302 Fifth Ave., New York, NY 10001.
Phone: 212-279-7000 or 800-251-4545, Fax: 212-279-7014
URL: www.visualreference.com
E-Mail: visualreference@visualreference.com

Visual Reference Publications, Inc.
302 Fifth Avenue
New York, NY 10001

Distributors to the trade in the United States and Canada
Watson-Guptill
770 Broadway
New York, NY 10003

Distributors outside the United States and Canada
HarperCollins International
10 East 53rd Street
New York, NY 10022-5299

Library of Congress Cataloging in Publication Data:
Brandstand, Strategies for Retail Brand Building

Printed in China
ISBN 1-58471-070-5

ABOUT THE AUTHORS

Arthur A. Winters
Peggy Fincher Winters
Carole Paul
And the Editors of Retail Ad World

Dr. Arthur Allen Winters and **Prof. Peggy Fincher Winters** are contributors to technical assistance research and development for global fashion companies. They conduct international seminars and consultations in strategic planning for integrated marketing and communications. Dr. and Prof. Winters are partners in Telefashion Geomarketing, Inc., a consulting firm specializing in strategic planning and brand concept management. They have served as judges for many advertising awards, such as The EFFIES.

Dr. Winters is Professor Emeritus and founder of the Advertising and Marketing Communications Department, The Fashion Institute of Technology/State University of New York. He has over 40 years experience as an advertising agency and marketing professional, as well as an educator and an author, with a specialty in marketing and communications strategic planning. Dr. Winters holds graduate and doctoral degrees in economics, PR, and marketing from Williams College, and Pace and Temple Universities. He has been quoted in numerous professional and trade publications, and has authored and co-authored books, articles and interactive multimedia instructional programs.

Prof. Peggy Fincher Winters has been a professional and an educator in fashion marketing, advertising and marketing communications for over 25 years. Founder of the FIT/SUNY Internship Program, she has developed curriculum and provided internship/career counseling. She is a strategic planner and creative producer of advertising and public relations campaigns. She has been a TV spokesperson, written articles, books and videos, and has been quoted on fashion, marketing, advertising, experiential education and career development issues. Prof. Winters holds degrees in merchandising, marketing and education from Ellsworth College and The University of Memphis.

Carole Paul is Editor-in-Chief of *Retail Ad World,* a monthly advertising and marketing publication, published by Visual Reference Publications, Inc. Ms. Paul has been on both sides of the desk (agency/retail) for over 30 years. She has worked at advertising agencies such as Deutsch as a copywriter on Glamour magazine and Crouch & Fitzgerald. Additionally, Ms. Paul has worked for Lord & Taylor, in the advertising/sales promotion department, where she wrote ad copy, window signage and more. She has judged numerous advertising competitions and is experienced in all media. She has written major TV campaigns, print and direct mail, and has worked on a vast number of major retail and fashion accounts. Ms. Paul was honored by The Andy Award of Excellence, Direct Mail Campaign for *Glamour* magazine and the CEBA award for Revlon.

The authors travel worldwide in order to keep their fingers on the pulse of the international retail and marketing landscape.

BRANDSTAND

Strategies for Retail Brand Building

The *brand* is the mind of marketing. *Brand concept management* is the mission of the marketer. The brand is an asset that stands for a company's character, its people, and the consumer's confidence in its products or services. Building the brand takes much more than creating **brand awareness** of a product. It must also widen and deepen **the customer's concept of the brand**. It must **position or reposition brand image**, differentiate product/service performance, enhance customer experience and develop long-term customer relationships.

Brandstand focuses on ten brand strategies that widen the brand:

- **Brand Awareness**
- **Brand Image Positioning**
- **Attributes Branding**
- **Benefits Branding**
- **Commitment Branding**
- **Destination Branding**
- **Experiential Branding**
- **Brand Associations**
- **Spiral Branding**
- **Viral Branding**

A brand can be: *a store destination* (Target), *a store brand* (I.N.C., Federated Department Stores), *a designer* (Donna Karan), *a collection* (Ethan Allen), *a manufacturer* (Hart Schaffner & Marx), *a service* (Red Envelope), *an experiential connection* (Lands' End "Shop with a Friend™"), *an event* (Macy's Thanksgiving Day Parade), or even *a country of origin* (Made in Italy).

Building **brandwidth** has become a *multichannel operation* and a *multimedia process* of **integrated marketing communications**. It uses advertising and promotion in **spiral branding** that surrounds the consumer. It persuades the consumer with functional **attributes** that satisfy needs and complement lifestyle and lifestage. **Brand associations** could also stand for those emotional **benefits** that relate to the consumer's needs for

SPECIALTY STORES— APPAREL

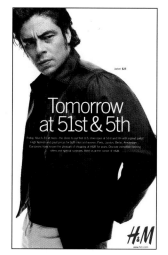

DESIGNERS

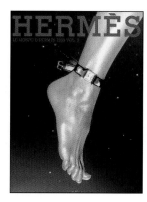

MANUFACTURERS

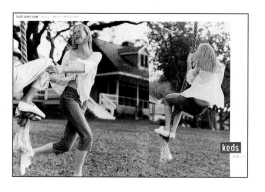

CONTENTS

GENERAL MERCHANDISERS

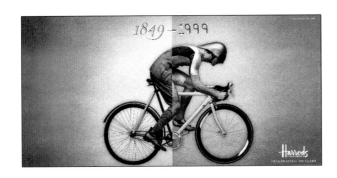

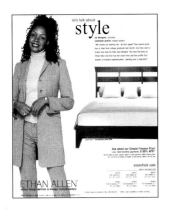

HOME FURNISHINGS

MISCELLANEOUS

SHOPPING CENTERS

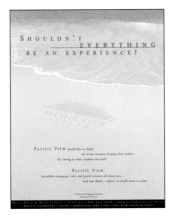

self-esteem, self-actualization, economic aspirations, and societal positioning.

A brand needs to make a **commitment** to values that are relevant to the consumer. There are also brand commitments to personal service and a post-purchase satisfaction that are concerned with the customer's joy of owning, wearing, using, displaying, and love of buying. It may utilize **viral branding** to spread the message by word-of-mouth from one customer to another.

In this era of **brand concept management**, the producer and retailer must reinvent and innovate brand strategies or close shop. They need to be constantly alert to know what their competition is doing and where the consumer is *going* rather than *where she's been.* The history of marketing is full of descriptions of legendary leaders who had an intuition for "in" trends and hot items. They are also known for their talent in building brandwidth.

The cases selected for **Brandstand** reflect the changing world of **brand concept management**. Illustrations of what online, offline and direct marketers and merchandisers are communicating are organized in separate sections:

- **Specialty Stores—Apparel**
- **Designers**
- **Manufacturers**
- **General Merchandisers**
- **Home Furnishings**
- **Miscellaneous**
- **Shopping Centers**

We encourage you to use **Brandstand** to identify, interpret, analyze, and evaluate the branding and creative strategies in each case. Our **Brandstand Checklist** and a **Brandwidth Model** follow. We will indicate in the following cases how the advertising and promotional messages reveal their marketing objectives and brand building strategies. We hope that **Brandstand** will stimulate your thinking for *how to use advertising and marketing communications to build brandwidth.*

Arthur A. Winters
Peggy Fincher Winters
Carole Paul

HOW TO USE BRANDSTAND

The *Brandstand Checklist* and the *Brandwidth Model* are designed to stimulate your analysis of each case. Examine how the creative strategies are executed to attain the desired results as indicated in the branding objectives.

The Brandstand Checklist:

MARKETING SITUATION:
- Has the company clearly described the marketplace and identified the markets in which they are competing? Is there target audience feedback regarding the brand's *awareness level; competitive positioning; purchasing patterns; usage history ...?*
- Where is the company in *multichannel marketing* (in-store, catalog, web)? Is there an *integration of marketing communications* and *media planning?*

BRAND OBJECTIVES:
- Are the marketing communications based upon the *objectives of building brandwidth?* Objectives should clearly indicate what results are expected from: **brand awareness, brand image positioning or repositioning; brand meaning enhancement;** brand association generation; brand product positioning or repositioning; brand attribute appeals; brand benefit appeals; brand experience appeals; brand commitment for customer relations; a **brand media mix** that recognizes the customer's media habits.
- Is there a *brandstand* strategy for: the shopping experience, category dominance, destination preference, merchandise assortment, product differentiation, value-pricing, customized services ...?

CREATIVE STRATEGY:
- How does the strategy *brandstand the consumer experience?* Does it create an environment in which *atmospherics* and *visual merchandising* inform and entertain?
- Does the creative strategy identify *product attributes* or *consumer benefits* or *both?*
- Does the message reflect the *personal positioning* of the consumer, as well as the *image positioning* or *repositioning* of the brand, store or mall?
- Does the message surround the target audience with *spiral branding?*
- Has the media plan considered *viral branding* to program and encourage "word-of-mouth" advertising?

TARGET AUDIENCE:
- What evidence is there that the primary and secondary target audiences have been profiled for their awareness, trial, acceptance and continued use of the brand?
- In addition to demographics (age, gender, income, education, location...), consumers should be described in psychographics relevant to their: values; attitudes; lifestyles/lifestages; shopping behaviors; purchasing patterns; special offer preferences; quality/price/value demands; product usage; customized service requests

BRAND BUILDING RESULTS:
- Is there evidence that a brand concept manager has monitored the program and evaluated the results as stated in the branding objectives? Are there specific outcomes? Has the advertising and promotion contributed to the effectiveness of the marketing effort to *build brandwidth?*

The Brandwidth Model

Brand Image Positioning

Attributes
Benefits
Commitments

Brand Personality
Experiential Connections
Destinations

Brand Awareness

BRANDWIDTH

Brand Meaning

Spiral Branding
Viral Branding
Events Branding

Brand Associations
Values & Attitudes
Customer Bonding

Brand Media Mix

What makes a BRAND STAND?

Making a brand *stand* in today's mega markets takes much more than **brand awareness**.

"Brandstanding" requires more than **differentiating brand positioning** for awareness and acceptance. Brand Positioning is one thing. **Customer Relationship Management (CRM)** is another. Using CRM to build the brand is an example of what we call *Brandwidth.* It is a process of managing business-to-customer relationships to create content for interactive communications that is wider and deeper. It is designed to produce mutual benefits and create loyalties that stand up over a period of time.

A brandstand can be a **"lifestyle branding strategy"**—personalized positioning for the **customer-as-brand**. Talbots' campaign (page 11) is an example of a *brandstand* that positions the brand as well as the customer who wants to "*stand out not stick out.*"

Brandwidth describes the brand-building process and the various strategies designed to add **equity** to the brand.

The *Brandwidth Model* shows the interaction between branding strategies, brand appeals, and media integration that are fundamental to the brand plan, its goals and its marketing objectives.

Each of the cases selected for **BRANDSTAND** are examples of what works to build *Brandwidth.*

Specialty Stores —Apparel

A Classic Revival

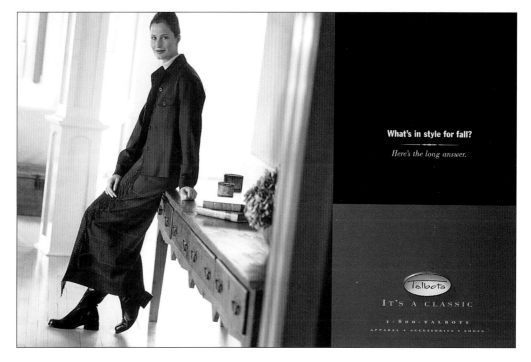

STRATEGY IS A BIG BUZZ word in business these days. But what happens when a retailer implements a strategy too quickly?

Back in 1997, Talbots veered onto a course that turned what just happened to be its 50th anniversary year into a year of living dangerously. What prompted the long-successful retailer of women's classic apparel to abruptly change direction was an overreaction to a general trend toward more casual careerwear combined with a desire to attract a younger customer.

When the new shorter skirts and jazzed-up styling arrived in Talbots' 600+ stores, the result was startling. What was in theory an incremental shift turned into a major departure from the classic clothing, shoes and accessories its core customers—affluent women 35 and older—had always counted on. The new look didn't appeal to younger women either, a situation that was reflected in profits.

Talbot's **BRAND EQUITY** was in danger and a full-scale effort was made to **"reposition" their** **brand image.** Talbots used advertising to persuade their customers that they were bringing back the "classic" **ATTRIBUTES** that would satisfy their wardrobe needs and complement their lifestyle and lifestage.

To win back its customers, Talbots decided to return to its roots—the classic styling it had

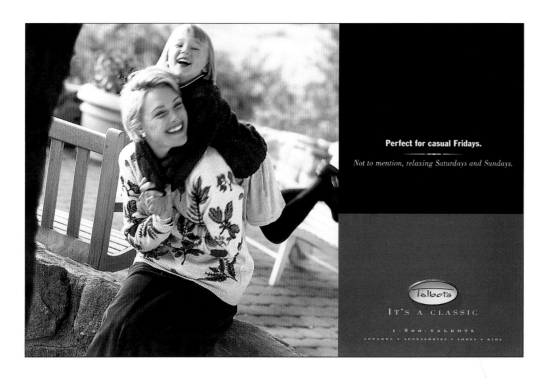

- Brand Image Positioning
- Attributes Branding
- Benefits Branding

BRANDSTANDS

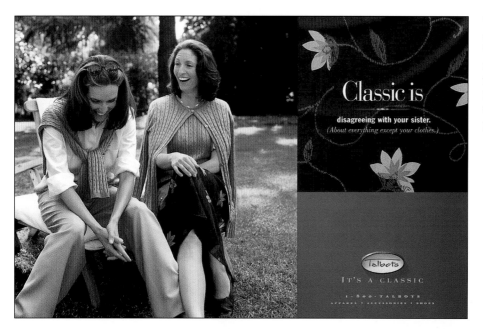

The BRANDSTAND PARADIGM clearly applies in this case. Talbots had to reintroduce and redefine the brand meaning to their existing customers. This new campaign also served to create brand awareness with potential customers.

Talbots had created a campaign that speaks visually and verbally to the target customer's self image, her lifestyle and lifestage. She's "a classic"—stylish, looks good anywhere, she's smart, affluent, contemporary, and is busy at work and at play.

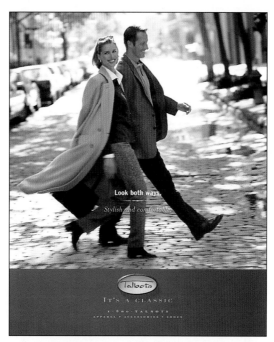

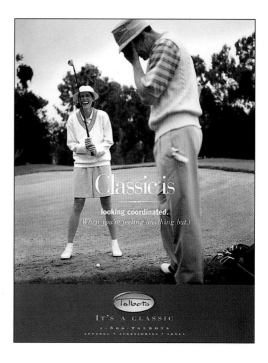

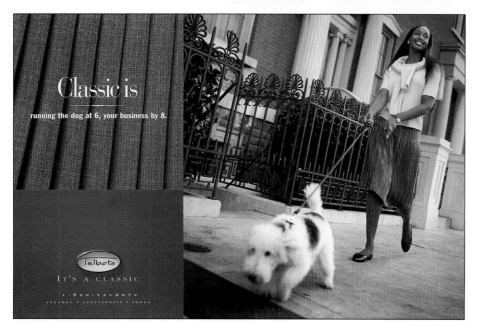

always done well. The first order of business would be to lengthen the hemline and change the merchandise mix. The merchandising team was overhauled and controls were put in place to prevent a similar situation from happening again.

In addition to bringing customers back, there were new objectives. One was to influence the women who were already Talbot customers to increase what they bought. Another objective was to build its customer base by introducing the Talbots brand to a broader audience, attracting middle-aged women who weren't Talbots customers.

Then Talbots was ready to show its stuff. "We intensified our program from an advertising and marketing standpoint, adding TV for the first time," says Mary Pasciucco, senior vice president, catalog development and advertising. "We tested it in a couple of markets in fall of 1998,

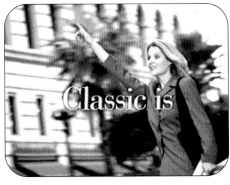

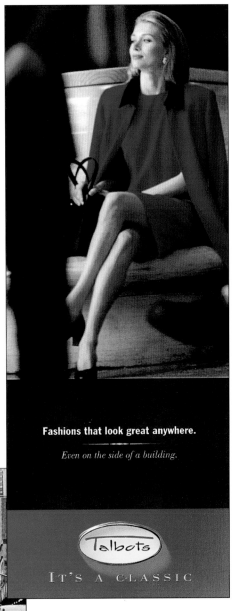

The TV commercials tell the classics story musically using "I'm always true to you, darling, in my fashion ..." Talbots was extending its TV advertising program to numerous top-rated network shows in major markets, as well as on several cable networks nationwide.

This BENEFIT BRANDING strategy identifies the brand and reflects the personal positioning of their target audience.

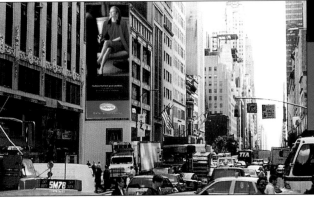

Talbots was moving up in the world. This ad appeared as a wall scape, a new form of advertising for the retailer.

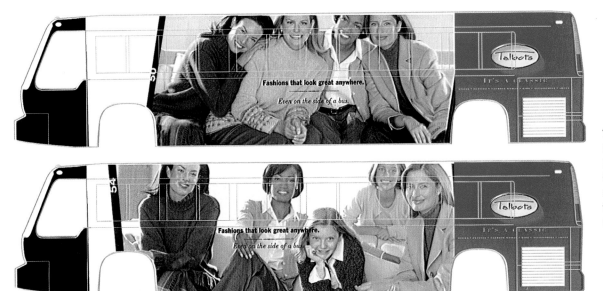

The media blitz was centered in major markets—Boston, New York, San Francisco and Chicago. King-sized bus sides and wraps, and cable car and trolley advertising vary from market to market.

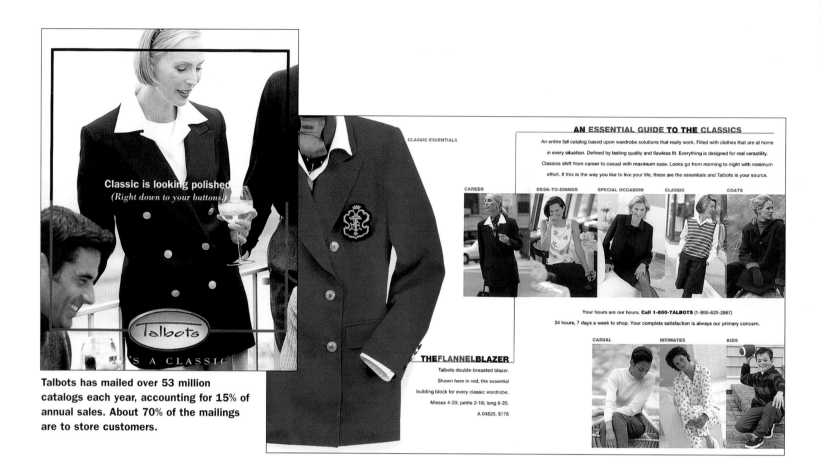

Talbots has mailed over 53 million catalogs each year, accounting for 15% of annual sales. About 70% of the mailings are to store customers.

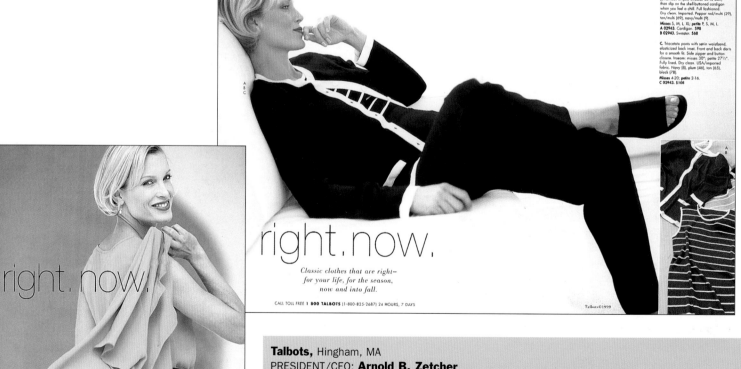

right.now.

Classic clothes that are right—
for your life, for the season,
now and into fall.

Talbots, Hingham, MA
PRESIDENT/CEO: **Arnold B. Zetcher**
SENIOR VICE PRESIDENT, CATALOG DEVELOPMENT AND ADVERTISING: **Mary Pasciucco**
AGENCY: **In-house** (catalogs)
ADVERTISING AGENCY: **Arnold Communications,** Boston
CREATIVE DIRECTOR: **Kathy Kiely** (spring campaign), **Jay Williams** (fall campaign)
ASSOCIATE CREATIVE DIRECTOR: **Rod Smith** (spring campaign), **Susan Titcomb** (fall campaign)
ASSOCIATE CREATIVE DIRECTOR/COPYWRITER: **Mary Webb** (spring and fall Campaigns)
WEBSITE: **www.talbots.com**

Spring Preview 1999

which had a significant impact both in terms of sales and customer perception. We're reinforcing our classic positioning by putting a modern spin on it to reflect the woman who is our customer." "Classics are even more relevant today than they've ever been," she added. "They really suit a contemporary lifestyle."

As a result of the overall increase in business in each of the markets where the TV ad campaign was tested, Talbots was expanding its TV campaign. Pasciucco explained: "We came back in November for additional markets for four-week flights, then in March and again in May."

The media plan also included additional placements in national magazines read by Talbots' core customers, as well as those read by the most likely potential customers. Ads have run in *Martha Stewart Living, Gourmet, House Beautiful, Redbook, Southern Living, Vanity Fair, Vogue, Travel & Leisure, In Style*, and the *New York Times Magazine*. The media mix included a series of color newspaper ads, along with bus wraps and other outdoor ads, as well as TV spots for a media blitz in several markets. "We're trying to tie all our sub-brands together to better define Talbots," said Pasciucco.

In addition, the company introduced a line of larger-sized clothing, and with it, an ad campaign to promote the image of a woman who wants to be well dressed, but is too savvy to succumb to Paris fashion trends.

Talbots has also expanded its Kids line to include babies. "It's a logical extension," said Pasciucco. "The earlier you can get children to be customers the longer you have them, and attracting new mothers is a good way to introduce younger customers to the brand." And, she added, "The launching of their e-commerce has brought Talbots' brand to life on the web."

At this rate, cyberclassics can't be far behind.

Talbots Woman and Talbots Kids had been launched to broaden the traditional customer base.

Brand awareness—Brand loyalty and longevity.

Live a Little

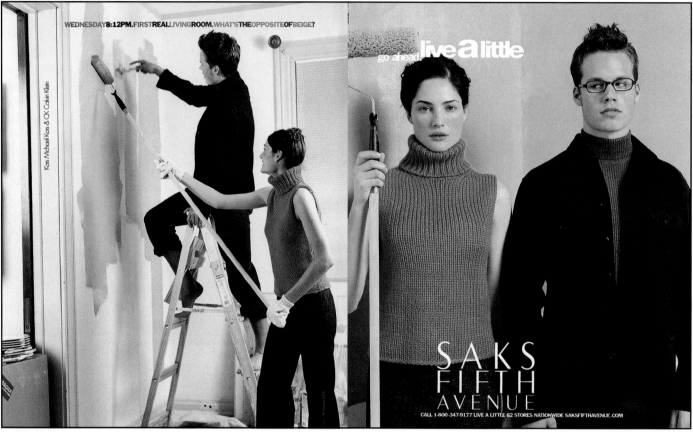

Magazine ad.

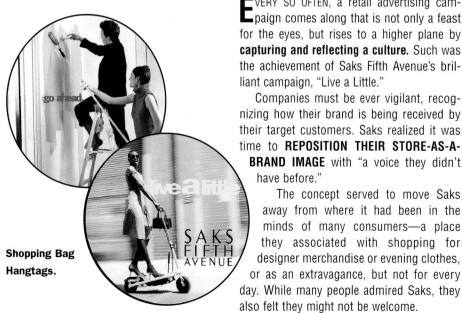

Shopping Bag Hangtags.

EVERY SO OFTEN, a retail advertising campaign comes along that is not only a feast for the eyes, but rises to a higher plane by **capturing and reflecting a culture.** Such was the achievement of Saks Fifth Avenue's brilliant campaign, "Live a Little."

Companies must be ever vigilant, recognizing how their brand is being received by their target customers. Saks realized it was time to **REPOSITION THEIR STORE-AS-A-BRAND IMAGE** with "a voice they didn't have before."

The concept served to move Saks away from where it had been in the minds of many consumers—a place they associated with shopping for designer merchandise or evening clothes, or as an extravagance, but not for every day. While many people admired Saks, they also felt they might not be welcome. **Clearly that perception needed to be**

changed, according to Russ Hardin, creative director. The marketing department had made up their mind. "Betty Chabot, senior vice president of marketing, was instrumental in acting on the need to adjust our course," said Hardin. "Marketing was already looking at where the customer base was currently and a new marketing strategy was in the works when I joined the company."

The groundwork had been done. Focus groups had revealed that people were stepping back from where they were five years with all the technology that tends to reduce personal contact—cell phones, PDAs, the Internet, and sitting in front of computers all day (and night).

When Hardin looked at what other retailers and designers were doing in their ads, he saw people dour and unhappy, staring off into space, many with their backs to each other, alone together. Instead of being bombarded

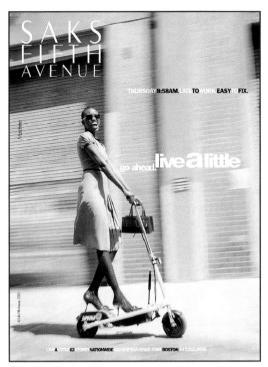

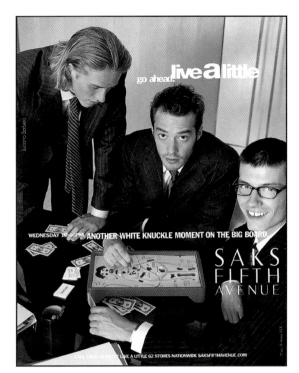

Magazine ads ran as single pages and spreads.

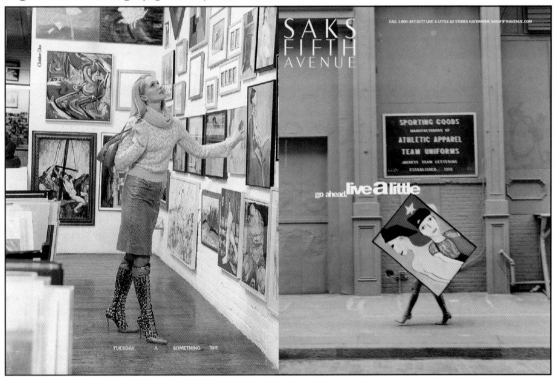

by the spectre of technology, **he wanted people to feel connected to each other and to Saks.** Saks' campaign was designed to develop a long-term relationship with existing and new, potential customers. Note the connection being made for **DESTINATION BRANDING.** "The campaign is to find those little things in life that give pleasure—finding the little moments when you can feel human again."

Since the research had shown that consumers perceived Saks as largely about designer clothes and spe-

- Destination Branding
- Brand Image Repositioning

BRANDSTANDS

cial occasion clothing, **the strategy was to emphasize it as an all-occasion store for all times of life and all times of day.** This breadth provided an opportunity to address what Hardin referred to as the "whole diversity of the population, the full and beautiful range of age, race, and economic levels of people."

"The campaign embraces this new sense of individuality, and diversity," said Hardin. "Merchandise plays a secondary role." To keep the merchandise from overpowering the spirit of the campaign, the

Paint your living room lime green. Eat a little (or a lot of) ice cream. Walk five miles, or run just one. Dare to dye your hair red. Don't dye your hair ever again. Dye <u>his</u> hair red (or try to). Laugh out loud at the movies. Try to get through the day without your cell phone, your e-mail, your palm pilot, your voice mail, ...cially your TV ...before). ...a new friend. ...od friend. ...owling. ...riday night. ...new one. ...tomorrow ...know... ...happy. ...ch day. ...the world.

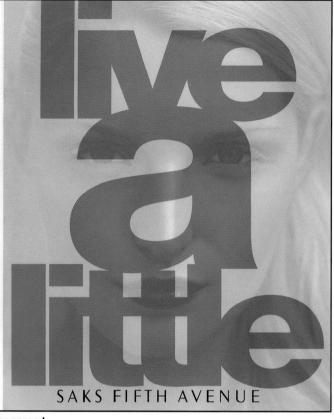

live a little

SAKS FIFTH AVENUE

Inside front cover spread.

go ahead.

August catalog front cover.

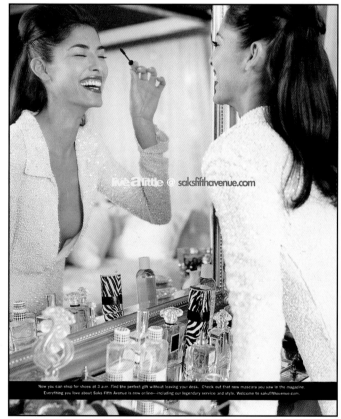

live a little @ saksfifthavenue.com

Now you can shop for shoes at 3 a.m. Find the perfect gift without leaving your desk. Check out that new mascara you saw in the magazine. Everything you love about Saks Fifth Avenue is now online—including our legendary service and style. Welcome to saksfifthavenue.com.

Back cover.

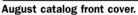

tell us in 50 words or less what the phrase "live a little" means to you and have the chance to win a fabulous prize

Hawaii escape featuring 5-night accommodations at W Honolulu-Diamond Head (roundtrip airfare provided by Travel & Leisure magazine) • Vanity Fair magazine Hollywood Getaway at the Peninsula Hotel • Bisang cashgora cape with fox trim • SFA cashmere robes for him and her • Cartier watch • Baume & Mercier watch • David Yurman necklace and bracelet • "Life's Little Pleasures" basket from In Style magazine • The ultimate cosmetic and fragrance gift basket • Designer shoe wardrobe for her (six pairs) • Five designer suits for him (from Cornelian, Hugo Boss, Hickey-Freeman, Joseph Abboud and Polo Ralph Lauren) plus a Burberry raincoat.

How to enter:

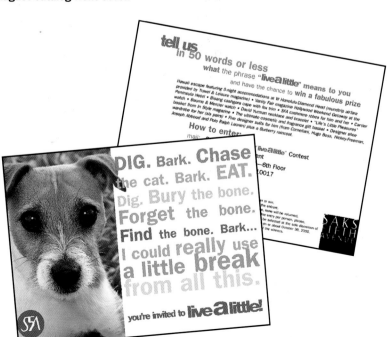

DIG. Bark. Chase the cat. Bark. EAT. Dig. Bury the bone. Forget the bone. Find the bone. Bark... I could really use a little break from all this.

you're invited to live a little!

Postcard detailing contest
inserted in catalog.

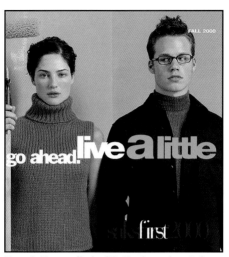

Newsletter mailed with the launch catalog.

manufacturer's names were run subtly up the side of the ad like a copyright or photographer's credit line.

According to Hardin, the concepts "just happened." Thinking about what "living a little" looks like is an additive process of adding an element to an idea such as "Wednesday 8:12 pm. First real living room. What's the opposite of beige?" came from picturing a young couple who, on the spur of the moment when coming home from work, decide to paint their living room lime green. They're so fired up they don't change their clothes—and asking himself what would they be wearing led to having them in Calvin Klein and Michael Kors. It looks as though we've interrupted their playful painting moment and, asking for a snapshot, they strike an "American Gothic" pose (Did you catch the paint on his nose?).

Hardin enjoyed being able to work with a brand as wonderful as Saks and to be able to "tamper" with it. "I don't take it lightly," he said. "We're giving Saks a 'voice' it didn't have before. We had to take a big ol' step, not half one." He saw the challenge as "keeping the bar high as more concepts and situations were called for so they remain charming and amusing—always up and with an edge—and not be too 'Hallmark.' We don't want it to cross the line of 'oh, that's so cute.' We want to maintain a level of sophistication with a certain whimsy."

Hardin credited photographer Grace Huong with the campaign's fun and freshness. "She's wonderful at creating wonderful moments, she can twist these little moments into little slices of life." So he gave her the situations, the cast, the scenes and turned her loose, and continued to do so since they turned out so well.

The type treatment "lives a little," too.

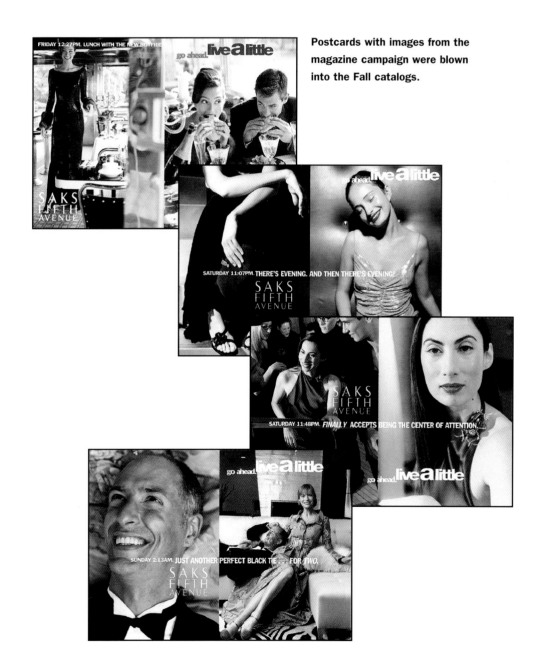

Postcards with images from the magazine campaign were blown into the Fall catalogs.

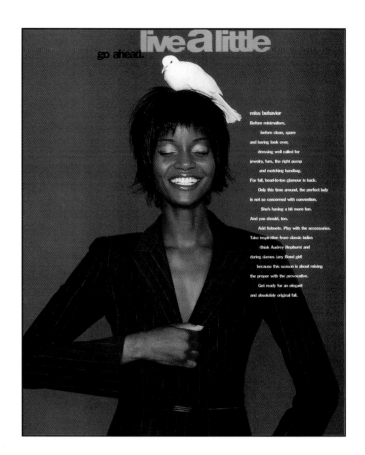

The September catalog carried out
"Live a Little" a lot.

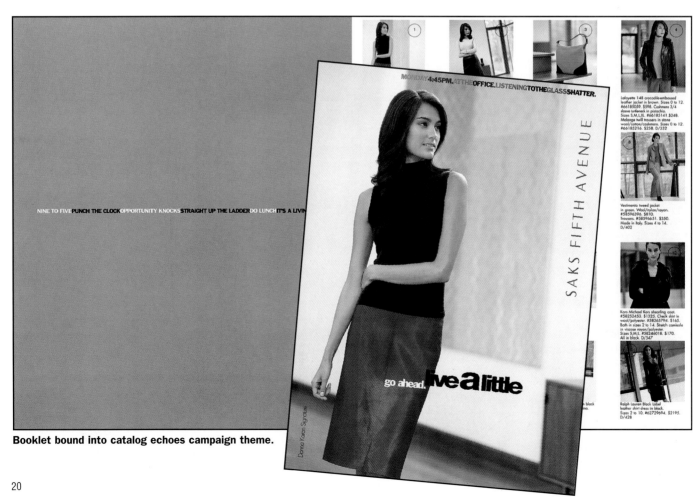

Booklet bound into catalog echoes campaign theme.

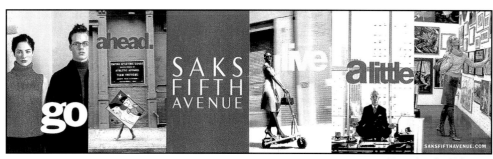

Bus sign in Chicago.

It's bouncy and fun and lively and reinforces the wit and energy of the ads. "When initially developing the 'chunk' of type, 'live a little' tested best with focus groups and customers," Hardin explained. "As I tested layouts with it and saw the first images I shot, I started thinking it needed a little more of a push, an imperative. 'You know you want to,' a whisper: 'go ahead.' That's why it's smaller [and set off a little below the baseline]—'go ahead. live a little'"—it eggs the reader on.

Saks' integrated marketing communications plan also included:

"Live a Little" was launched at a party August 13, 2000, with 600 vendors and the press in attendance. The concept was then spelled out in a 186-page catalog mailed to 450,000 Saks customers. The newsletter (a booklet of events) was polybagged with it. To further add to the upbeat, offbeat spirit of "Live a Little," postcards with images from the ads were blown into the catalog. The postcards were also in the stores for "clienteling."

Another fanciful touch was circular tags, with images from the ad campaign, that were provided to all stores during launch week. Clipped onto shopping bags, these colorful "swingers" served as mobile billboards.

"Live a little" ran a lot as magazine ads—most frequently as spreads throughout the fashion and other magazines—and as magazine inserts. In addition, outdoor advertising was done in Chicago, New York, Las Vegas, Los Angeles, Atlanta and Dallas. Formats included bus signs, phone kiosks, billboards and the elevated train platform in Chicago.

The visual/verbal messages in this campaign ENHANCED THE CUSTOMER EXPERIENCE. They maintain Saks' sophisticated images while adding a new charm and whimsy, recognizing that their best customers have a new ATTITUDE.

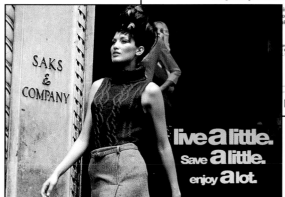

You're invited to shop on any one day between Wednesday, October 18 and Wednesday, October 25 and receive 15% off* all your purchases on that day.

Direct mail for select customers.

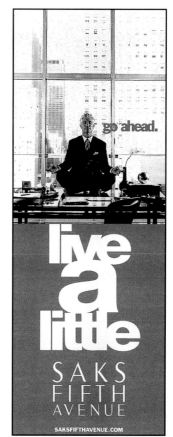

Phone Kiosk.

Join Saks Fifth Avenue to celebrate the launch of

live a little

Wednesday, July 19

6 to 9

Boathouse Pavilion

Central Park

Kindly RSVP to 212.940.4249 by July 14.

Please come to the 72nd Street and Park Drive North entrance.

Launch Invitation.

Paint your living room lime green. Eat a little (or a lot of) ice cream. Walk five miles, or run just one. Dare to dye your hair red. Don't dye your hair ever again. Dye his hair red (or try to). Laugh out loud at the movies. Try to get through the day without phone, your e-mail, pilot, your voice mail, ur laptop, your TV - especially your TV we all managed before). sit someone. Make a new friend. friend. Be a good friend. y-dipping. Go bowling. e on Tuesday, not Friday night. habit. Make joy a new one. fe like there is no tomorrow as far as we know... 't. Dare to be happy. a little more each day. have fun...change the world.

Saks Fifth Avenue, New York
SENIOR VICE PRESIDENT OF MARKETING: Betty Chabot
AGENCY: **In-house**
CREATIVE DIRECTOR: **Russ Hardin**
PHOTOGRAPHER: **Grace Huong,** New York
ILLUSTRATOR; **David Croland,** New York

A Certain Cachet

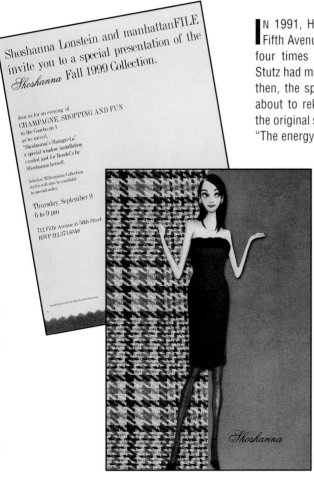

Shoshanna Lonstein and manhattanFILE invite you to a special presentation of the Shoshanna Fall 1999 Collection.

Join us for an evening of
CHAMPAGNE, SHOPPING AND FUN
in the Gazebo on 1
as we unveil
"Shoshanna's Shangri-La",
a special window installation
created just for Bendel's by
Shoshanna herself.

Selected Millennium Collection
styles will also be available
to special order.

Thursday, September 9
6 to 9 pm

712 Fifth Avenue at 56th Street
RSVP 212.373.6348

I N 1991, HENRI BENDEL moved its store to Fifth Avenue, in New York City, to a location four times larger than the store Geraldine Stutz had made famous on 57th Street. Since then, the specialty retailer has been casting about to rekindle the cachet that had made the original store a unique fashion institution. "The energy is back," said Teril Turner, director of marketing. "We've even changed the music! We've been listening to customers tell us they want to find new, exciting, cutting-edge companies, brands and colors. There's a lot new going on in store, lots of excitement. We're interested in reintroducing the store to bring new customers in."

Indeed there was lots to attract them as part of the strategy was a new emphasis on events. Notes Turner, "We said to ourselves, 'we're not in the mail-order business, what can we do to reach a broader audience?'" Special events have become so important, they occur virtually one after another, frequently weekly. For the retailer who wants to enhance the shopping experience, special events are **STORE-AS-A-BRAND ATTRIBUTES.**

One happening was a glamorous reception for Shoshana Lonstein to honor her new collection and to unveil "Shoshana's Shangri-La," a special window installation created just for Bendel's by Shoshana herself. Other events included a special presentation of the Yeohlee Fall collection and a cocktail reception with the designer, with 10% of the proceeds from purchases during the event going

GIRLS' NITES AT BENDEL'S

a series of seminars and book signings featuring the hottest topics in fashion and beauty. Meet, mingle and dish with the experts, and enjoy cocktails, hors d'oeuvres and a special deluxe goody bag.

Thursday Nights at 6 pm

FILE
and
HENRI BENDEL
present

Girls' Nites
at Bendel's

RSVP
To reserve your place at the Girls' Nites of your choice,
call 212.373.6348. Space is limited.

712 Fifth Avenue at 56th Street, New York

HENRI BENDEL
NEW YORK

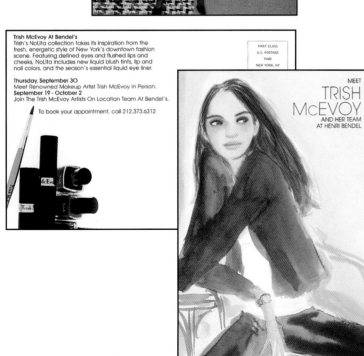

Trish McEvoy At Bendel's
Trish's NoLIta collection takes its inspiration from the fresh, energetic style of New York's downtown fashion scene. Featuring defined eyes and flushed lips and cheeks, NoLIta includes new liquid blush tints, lip and nail colors, and the season's essential liquid eye liner.

Thursday, September 30
Meet Renowned Makeup Artist Trish McEvoy In Person.
September 19 - October 2
Join The Trish McEvoy Artists On Location Team At Bendel's.

To book your appointment, call 212.373.6312

FIRST CLASS
U.S POSTAGE
PAID
NEW YORK, NY

MEET
TRISH
McEVOY
AND HER TEAM
AT HENRI BENDEL

- Brand Image Positioning
- Destination Branding
- Commitment Branding
- Attributes Branding

BRANDSTANDS

to the Museum of the City of New York's costume collection. Supporting the customer's causes is a **brand's commitment** to being part of their lives. An event with *InStyle* magazine celebrated the October issue's "Beauty Bonanza" with complimentary makeovers and product samples, drawings for special prizes, and cocktails and hors d'ouerves. A portion of the evening's sales throughout the store were donated to the charity *Dress for Success*.

The store initiated the first in a series of "Girls' Nites at Bendel's," to which according to Turner there has been an "overwhelming response." In fact, these hands-on workshops had proven so popular they became a weekly beauty event. Girls' Nites featured the hottest topics in fashion and beauty in a setting where customers could "meet, mingle and dish with the experts." Cocktails, hors d'oeuvres and a special gift were part of the equation. But they're not all about girls just wanting to have fun. There can be substance as well as style. (The subject of one event was "Make Over Your Financial Future.")

The 6" x 6" square mailer with the signature Miss Bendel and her dogs on the cover is printed on a beautiful silky smooth stock. The compact size makes it an easy take-along.

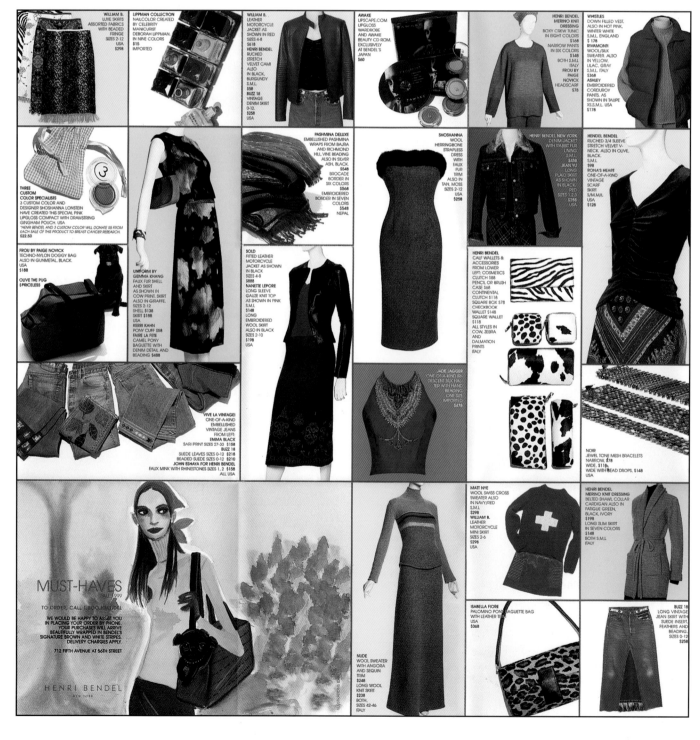

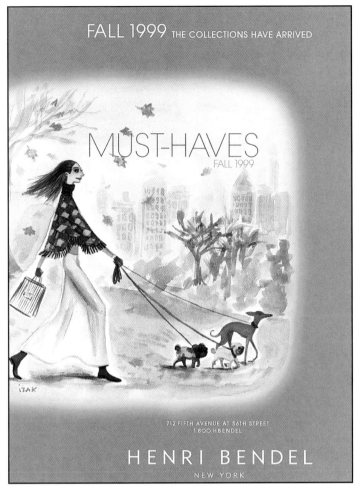

In addition to being direct mailed, "Must-Haves" was also mounted on an anchor page in *New York* magazine for subscribers in selected zip codes. Other issues of the magazine carried the ad only.

With beauty proving to be such a powerful attraction, Bendel's was doing it up in a big way, literally, with an oversized mailer. "It's the first of this scale devoted only to beauty," said Turner. Indeed it is big, $10^{3/4}"$ x $14^{1/4}"$. It's also beautiful.

The mega-mailer was the latest addition to Bendel's stepped-up advertising and direct mail program to reach a broader audience. They also introduced a new direct mail concept, "Must-Haves."

"It's an item-driven campaign based on a change in merchandising strategy," Turner explained. "By emphasizing the item and the color, Must-Haves embodies the shopping experience we want our customers to have. Our customer responds to color. We're not the destination for the minimalist!"

Bendel's, like so many specialty stores, has had to compete with the Bergdorf Goodman level of **DESTINATION BRANDING**. Adding to a destination-minded customer base requires a separate strategy for each consumer segment that is being targeted.

Part of Bendel's style was its distinctive illustrations that included a fanciful depiction of the Bendel's shopper, who typically is walking at least one dog. The drawings were the work of Izak, a French illustrator living in New York. "Bendel's has a history of working with illustrators," Turner said. "We brought it back, now it's new again." Said Turner of the woman striding across the front of the Fall mailer, "We call her Miss Bendel."

Must-Haves was mailed to a list of 40,000 from Bendel's extensive database. In addition, in September the Fall version was affixed to an anchor page in *New York* magazine. "This is new for us," said Turner. "We're testing it. Little by little we're building our advertising."

There's a new focus on call to action. Turner pointed out that besides *The New York Times*, much of the advertising was in *New York* magazine, *Manhattan File*, and *Time Out* because they had the immediacy of a weekly format for the call-to-action beauty-type ads.

Bendel's was also venturing into media that was new for them, such as a regional issue of *InStyle*. And there were new forms of promotion. Goodie bags were distributed for five weeks on the Hampton Jitney, the bus from Manhattan to the Hamptons. The tiny goodie bags, in the form of Bendel's signature shopping bag, contained a small sample of a beauty product with a card inviting the recipient to an event. When customers brought the card to the event they were given another free sample.

**FALL BEAUTY
AT BENDEL'S...**

AWAKE
BENEFIT
BLOOM
BOBBI BROWN
LAURA MERCIER
LORAC
M·A·C
MAKE UP FOR EVER
MARIO BADESCU
NATUROPATHICA
SMACK
SMASHBOX
THERAPY SYSTEMS
THREE CUSTOM COLOR
T. L'CLERC
TRISH MCEVOY
VISEART

September 1-30
Present this ad with
a beauty or skincare
consultation at
Henri Bendel and
receive a special gift.

HENRI BENDEL
NEW YORK

1.800.H.BENDEL
712 FIFTH AVENUE at 56TH STREET

LOOKING FLAWLESS HAS
NEVER BEEN SO SIMPLE
LAURA MERCIER
AT HENRI BENDEL

Meet The Laura Mercier Beauty Team
Learn to create your perfect fall face
with the simple four-step beauty routine
that has made Laura Mercier the makeup
artist of choice among celebrities and
fashion insiders. To book your consultation
call 212.373.6379.

Especially For InStyle Readers:
Present this ad at your consultation and enjoy
a $25 savings on any Laura Mercier purchase
of $50 or more Aug. 15 through Sept. 12, 1999.

712 Fifth Avenue at 56th Street

HENRI BENDEL
NEW YORK

**Bendel's BRAND IMAGE
is being positioned as
one that offers the
experience and
entertainment of the
SPECIAL EVENT.**

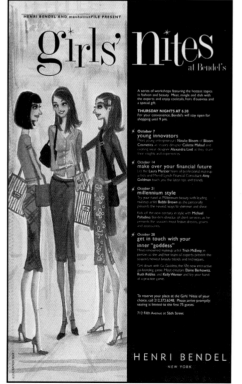

HENRI BENDEL AND manhattanFILE PRESENT

girls' Nites
at Bendel's

A series of workshops featuring the hottest topics
in fashion and beauty. Meet, mingle and dish with
the experts and enjoy cocktails, hors d'ouevres and
a special gift.

THURSDAY NIGHTS AT 6:30
For your convenience, Bendel's will stay open for
shopping until 9 pm.

**October 7
young innovators**
Meet young entrepreneurs Natalie Bloom of Bloom
Cosmetics, interiors director Colette Malouf and
evening wear designer Alexandra Lind as they share
their insights and experiences.

**October 14
make over your financial future**
Let the Laura Mercier team of professional makeup
artists and Merrill Lynch Financial Consultant Amy
Goldman teach you the latest tips and trends.

**October 21
millennium style**
Try your hand at Millennium beauty with leading
makeup artist Bobbi Brown as she personally
presents the newest ways to shimmer and shine.

Kick off the new century in style with Michael
Palladino, Bendel's director of client services, as he
presents the season's must have dresses, gowns
and accessories.

**October 28
get in touch with your
inner "goddess"**
Meet renowned makeup artist Trish McEvoy in
person as she and her team of experts present the
season's newest beauty trends and techniques.

Get down with Go Goddess, the life new interactive
girl-bonding game. Meet creators Elaine Berkowitz,
Ruth Robles and Kelly Werner and try your hand
at a practice game.

To reserve your place at the Girls' Nites of your
choice, call 212.373.6348. Please arrive promptly,
seating is limited to the first 75 guests.

712 Fifth Avenue at 56th Street

HENRI BENDEL
NEW YORK

Introducing
The NoLIta Collection,
New For Fall 1999 From
TRISH McEVOY

Trish's NoLIta collection takes its inspiration
from the fresh, energetic style of New York's
downtown fashion scene. Featuring defined
eyes and flushed lips and cheeks, NoLIta
includes new liquid blush tints, lip and nail
colors, and the season's essential liquid
eye liner.

Thursday, September 30
Meet Renowned Makeup Artist
Trish McEvoy In Person.
September 19 - October 2
Join the Trish McEvoy Artists On Location
team at Bendel's.

To book your appointment, call 212.373.6312.

Especially for InStyle Readers:
Present this ad at your consultation
September 19 - October 2, 1999 and receive
a purse size atomizer of one of Trish's new
fragrances. This special preview is available
only at Bendel's, while supplies last.

712 Fifth Avenue at 56th Street

HENRI BENDEL
NEW YORK

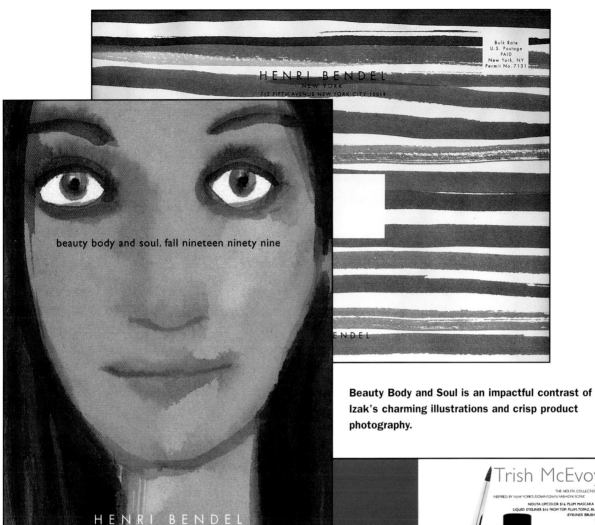

beauty body and soul. fall nineteen ninety nine

HENRI BENDEL
NEW YORK

Beauty Body and Soul is an impactful contrast of Izak's charming illustrations and crisp product photography.

beauty

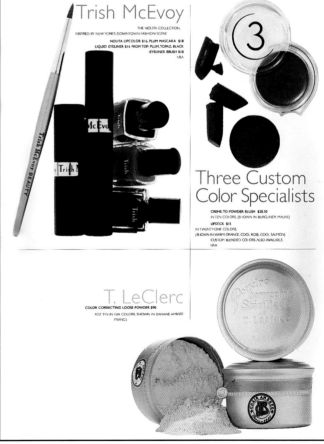

Bendel's balance of art and photography uses graphic esthetics to develop the brand's personality. It adds meaning to the customer's perceptions of the brand that complement her own.

Henri Bendel, New York
AGENCY: **In-house**
CREATIVE DIRECTOR/DIRECTOR OF MARKETING: **Teril Turner**
ILLUSTRATOR: **Izak,** New York

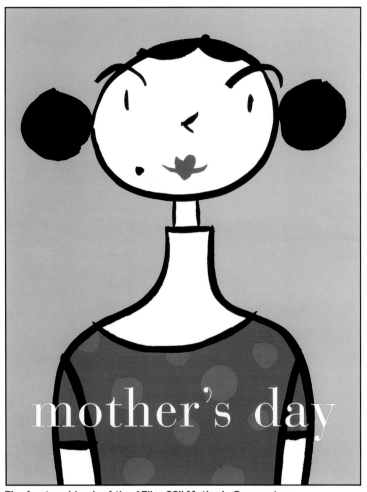

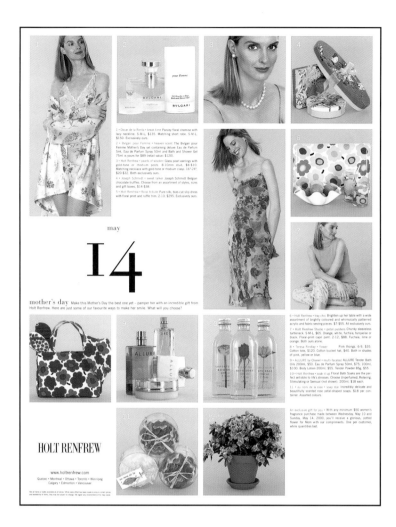

The front and back of the 17" x 22" Mother's Day poster.

A Special Experience

- Experiential Branding
- Spiral Branding

FOUNDED AS A HAT SHOP in 1837, Holt Renfrew long ago branched into all manner of other finery. Many people consider it Canada's leading national fashion specialty store for men and women.

A legacy of this order underscores the fact that over the years Holt Renfrew has done a lot of things right. What's notable is that it's also doing a lot of *new* things right.

In 1999 a new president, Andrew Jennings, took over the reins. His view appeared to resonate throughout everything Holt Renfrew is doing these days, "There has never been a better time for our business in this marketplace."

Certainly, it can be said that there was never a better time for Holt Renfrew's customers. Its vision to use **EXPERIENTIAL BRANDING: always make the customer's experience special and innovative** spilled over into new ventures in store and in direct mail.

"We've issued more direct-mail pieces this year than we ever have before, because we want to **speak to our customer more often one-on-one,"** said Sally Scott, director of promotions and marketing. To that end, every month Holt Renfrew's card customers received what she referred to as a "newsletter" with their monthly statement. The four-color piece was filled with fashion news, information about upcoming events and other timely items of interest. But that's only the beginning. In addition to the newsletter, nearly every month, there was a different direct-mail piece going out. *Very* different. In fact, rarely were two design formats alike. One month it could take the form of a conventional catalog, the next a poster.

The idea behind doing these different for-

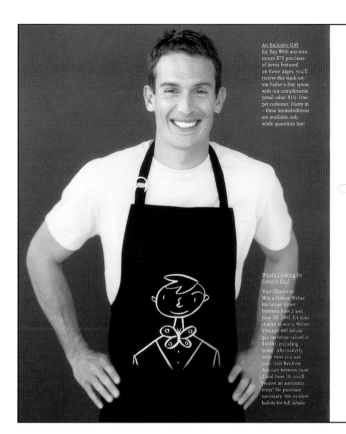

An Exclusive Gift for You With any minimum $75 purchase of items featured on these pages, you'll receive this black cotton Father's Day apron with our compliments (retail value: $15). One per customer. Hurry in – these limited-editions are available only while quantities last!

June 2000

On behalf of Holt Renfrew, I am proud to present our first ever Father's Day gift guide, a celebration of fathers across Canada. The special gifts selected for this guide represent the diverse interests and desires of the men who bring so much joy to their families. We are sure you will find that special something that will make this Father's Day a memorable occasion.

From all of us at Holt Renfrew, here's to Dad on his special day.

Kind regards,

Andrew R. Jennings, PRESIDENT

What's Cooking for Father's Day? Your Chance to Win a Deluxe Weber Barbecue! Enter between June 2 and June 18, 2000, for your chance to win a Weber Summit 450 deluxe gas barbecue valued at $4,000 (including taxes). Alternatively, every time you use your Holt Renfrew Account between June 2 and June 18, you'll receive an automatic entry! No purchase necessary. See in-store ballots for full details.

The 24-page, 8" x 10" booklet for Father's Day. The celebration included a drawing for a $4,000 Weber Grill and a specially designed GWP—a cook-out apron with the purchase of any item from the Father's Day booklet priced at $75 or more.

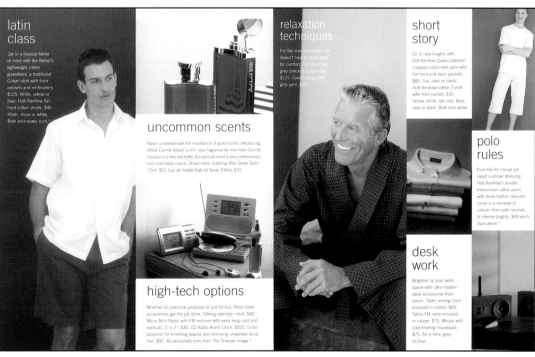

The front and inside of the Father's Day newsletter (statement stuffer).

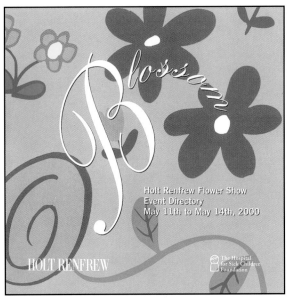

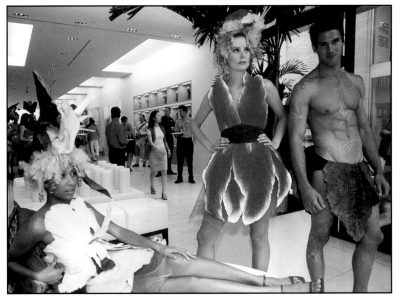

Blossom, Holt Renfrew's first annual flower show, celebrated Mother's Day with three floors of fragrance gardens inspired by top perfumes. The event was free, but donations were accepted for The Hospital for Sick Children's Motherisk Program. The 6" x 6" in-store booklet, shown above, detailed related events and precise locations of the various exhibits.

Flower girl and boy at pre-parade reception.

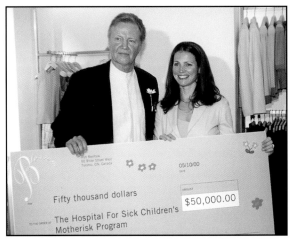

Celebrities joined in the celebration. Jon Voight and Julia Ormand present check on behalf of Holt Renfrew.

The newsletter (statement stuffer) for May.

The mailers cover a wide range of formats. This colorful 16-page, 6" x 6" booklet predicts the 12 items that will be future fashion necessities.

Beauty is big business. And very "event-ful"—this 28-page, 8" x 10" catalog begins by listing in-store beauty happenings.

mats each month, Scott explained, was to speak to customers often in "new and exciting ways." As part of this constant freshness, this marked the first time the retailer had done direct-mail for Mother's Day and Father's Day. True to its **SPIRAL BRANDING** strategy, each mailer had its own distinct format—one was a poster, the other a booklet. Both were designed to tie into the newsletter with color a common thread between the two.

Every direct-mail vehicle is designed to **spiral** into the store, creating a special experience for the customer. "We know our customers are busy and **when they want to go shopping we want it to be a great experience**," Scott explained. "It's not just about sending out a booklet, it's about reinforcing that booklet—integrating it in-store. That's when it becomes key. If a loyal customer receives a Mother's Day poster, then when she comes in, she should have that experience in the store." So in the case of the poster, it was not only hang-

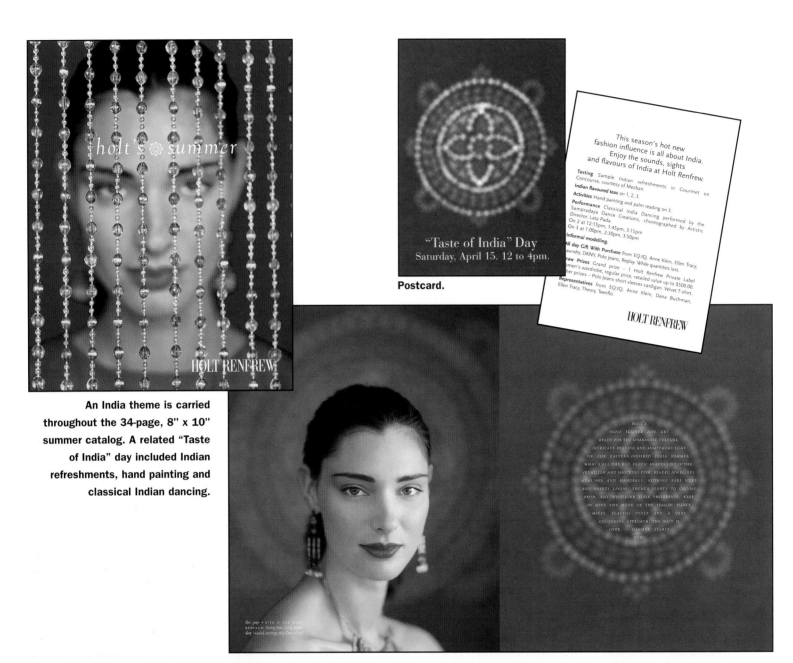

holt's ✳ summer

HOLT RENFREW

"Taste of India" Day
Saturday, April 15. 12 to 4pm.

Postcard.

This season's hot new
fashion influence is all about India.
Enjoy the sounds, sights
and flavours of India at Holt Renfrew.

Tasting Sample Indian refreshments in Gourmet on Concourse, courtesy of Mezban.
Indian flavoured teas on 1, 2, 3.
Activities Hand painting and palm reading on 3.
Performance Classical India Dancing performed by the Sampradaya Dance Creations, choreographed by Artistic Director, Lata Pada.
On 2 at 12:15pm, 1:45pm, 3:15pm
On 3 at 1:00pm, 2:30pm, 3:50pm
Informal modelling.
All day Gift With Purchase from EQ:IQ, Anne Klein, Ellen Tracy, Laundry, DKNY, Polo Jeans, Replay. While quantities last.
Draw Prizes Grand prize – 1 Holt Renfrew Private Label women's wardrobe, regular price, retailed value up to $500.00. Other prizes – Polo Jeans short sleeves cardigan, Velvet T-shirt.
Representatives from EQ:IQ, Anne Klein, Dana Buchman, Ellen Tracy, Theory, Teenflo.

HOLT RENFREW

An India theme is carried
throughout the 34-page, 8" x 10"
summer catalog. A related "Taste
of India" day included Indian
refreshments, hand painting and
classical Indian dancing.

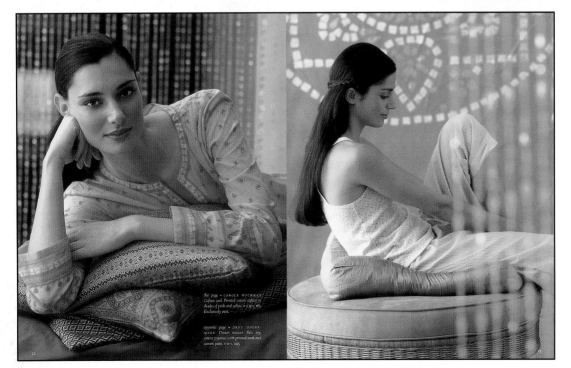

as seen in
holt's

Matching hang tag.

Holt's, Spring 2000. This 88-page, 8" x 10" catalog featured whimsical illustrations (far right) on the inside front and inside back covers.

ing in the store, its charming image was repeated on special little shopping bags.

Another interesting **SPIRAL BRANDING** device that marries the direct-mail and in-store experience is what Scott called "swing tags." This is a special hang tag designed for garments featured in direct mail. "When cus-tomers walk into the store and see these icons in the store, it reinforces what we're doing and makes it more relevant," she said. It also makes it easier to locate the item.

Holts wanted the store experience to be fun too. Customers might come upon an ice cream trolley dispensing free ice cream, a live music performance, or a special event. **Experiential** events included a large-scale fragrance and flower gala which included special atmospheric flower and fragrance gardens throughout the store.

Holt Renfrew, Toronto
PRESIDENT AND MANAGING DIRECTOR: **Andrew Jennings**
DIRECTOR OF PROMOTIONS AND MARKETING: **Sally Scott**
CATALOG AGENCY: **Concrete Design Communications,** Toronto
ADVERTISING AGENCY: **Roche, Macaulay & Partners,** Toronto
WEBSITE: **www.holtrenfrew.com**

Enter Marketing!

LAURA CANADA was on a roll. For more than 40 years the women's specialty retailer operated as a single boutique in Montréal. But that's all history. Starting in 1973, the company began expanding. Laura Canada numbers more than 120 stores in five provinces. And more stores are on the way.

As the company grew, new concepts were developed to meet the various fashion needs of Canadian women. They established four divisions: The Laura division, with an emphasis on fashion forward clothing for the career woman; Laura Petites and Laura II, for petites and plus size customers; and the newest division, Melanie Lyne, is higher end,

her mandates was to create a customer loyalty program. "As a company we wanted a way to thank our customers for selecting us as their **shopping destination**," she said. "But we wanted to put a different angle on it and really focus on our customer."

Questionnaires went out to customers asking what they would want in a loyalty program. The response was clear: they wanted a discount. Customer relations are enhanced when there is belief in the brand. It happens when the **brand makes a commitment** to a program that is based on what the customer has asked for.

So the retailer introduced The Laura

$2 from every card purchased will be donated to the Canadian Cancer Society to fund breast cancer research and support programs.

Special subscription offer for Chatelaine magazine.

$100* Travel Gift Coupon.

$10* Town Shoes or The Shoe Company Gift Certificate.

featuring designer brands and fashion forward clothing. Each division has a distinct image and customer base.

The growing number of stores and divisions isn't the only thing about Laura Canada that was expanding. For the first time since the privately owned company was founded in 1930, a marketing director was brought on board to implement the "m" word.

"Marketing for Laura Canada is very new," said marketing director, Sandra Bracken. "The company had been a family-run type retail organization, but it understands that in today's market you need to change. You need to put marketing in place to be a world-class retailer."

When Bracken joined the company, one of

Privilege Program for Laura, Laura Petites and Laura II. The program was designed to reward members on every purchase with a 10% discount on all clothing, promotionally priced merchandise as well as regular price.

"We wanted to differentiate ourselves from the other programs," said Bracken. "We're asking the customer to pay for the Privilege Card ($35), so we wanted to give her more. We came up with the idea to partner with other Canadian retailers who have desirable products for Laura Canada's target customer. One thing we learned from the questionnaire, for example, was our customers' number one magazine was *Chatelaine*, so there's a special exclusive offer to get a subscription."

The membership package actually

- Brand Awareness
- Commitment Branding
- Spiral Branding
- Destination Branding

BRANDSTANDS

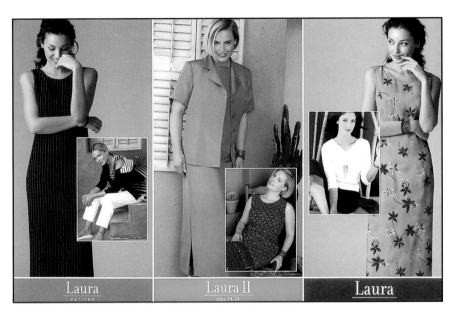

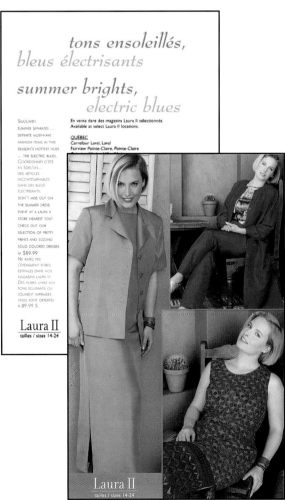

Making a commitment to communicate is an essential of integrated marketing planning. These jumbo postcards were mailed each month to customers in the Laura Privilege Program. They were also used at times for the purpose of attracting their *infrequent* shoppers.

The catalog featuring three Laura divisions has two "front covers." The center spread, below, serves as a convenient "separation for the third division.

includes ongoing annual discount savings coupons valued at up to $150 to be used at other retailers or services. Other perks are eligibility for monthly drawings for holiday getaways and other prizes, as well as a charity donation to the Canadian Cancer Society for breast cancer research and support programs. Two dollars from every card purchased is donated. "This is a huge selling point with our customers," said Bracken. "We've raised $132,000 for cancer research!" That's 66,000 members in the program—certainly an impressive figure.

So impressive in fact that we were curious to know if there had been any resistance to paying $35 for a program that most retailers offer free. "Initially there was a little bit of resistance, but once the customers were hearing more about it, and understanding the special benefits, that changed. They realized that if someone is buying a coat, she's already paid for her card with one purchase!" (At Laura's price points, $350 for a coat is fairly typical.)

The program was promoted with a two and a half week "Privilege Card Push" the beginning of September. All walk-in customers were told that if they purchased the card, they would get $20 off a purchase of $150. The instant $20 savings combined with the regular Privilege Card 10% discount in effect made the purchase of the $35 card free. "This virtually doubled our weekly sales," Bracken reported. The push was supported with POP and window banners.

Laura Canada had instituted other marketing initiatives. **It had made a strong commitment to direct mail, because as Bracken noted, "We all know as marketers that it costs more to get new customers than to**

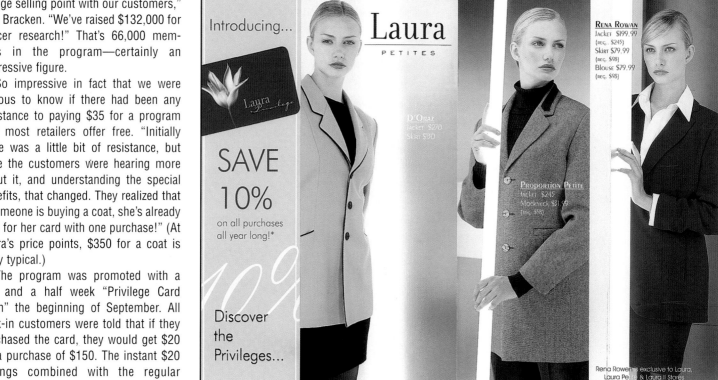

keep the ones you have. We have a large mailing list, so it's one of the areas we need to keep exploring. As successful as the program has been, we really feel that we've just begun and that by using direct mail, we can easily double those numbers."

Mailings, in the form of jumbo postcards, were done monthly. They were sent first to

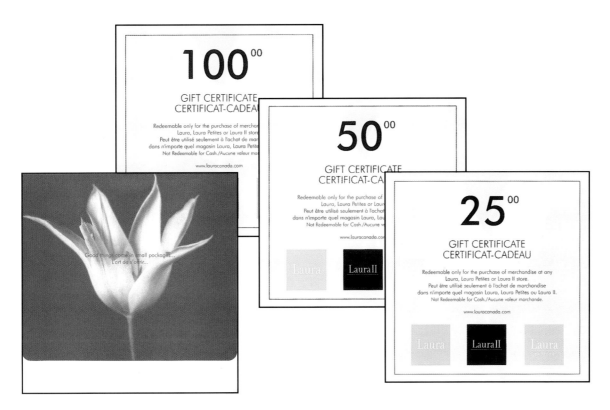

COMMITMENT BRANDING often involves a commitment that a business makes to the community and to society. Customers have become increasingly loyal to a Laura Canada that will support good causes as well as supply good clothing.

Laura Privilege Card members, then a decision was made whether to mail it to others. For example, a mailing that included $25 savings went only to Laura Privilege Card holders as a special benefit available just for them.

While the monthly mailings shared a consistent format, they were extremely versatile in terms of the type of message or promotion they highlighted. For example, mailings were used to introduce new collections, a contest and special savings. The postcards could also be used to promote several divisions or an individual one. In addition, they created two catalogs a year. The Fall 1999 catalog was inserted into 400,000 issues of *Chatelaine* magazine.

Laura Canada was getting its act together in other ways too. There were beautiful new gift certificates. The Laura Gift Certificate was launched in November, Melanie Lyne's in December. What was thought to have been a six-month supply was snapped up so fast, it had to be reordered in December.

The company was branding the different divisions with new wrap and pack, including redoing shopping bags, garment bags, and boxes. A special box with a handle was created for coats. "It's a great walking billboard that people will use and re-use," said Bracken. The Laura Canada customer was getting their message from a surround set of media. This **BRAND SPIRAL** informed and inspired the customer with special offers that are designed to differentiate the brand.

In addition, Laura Canada ventured into radio to promote the three different "Laura" divisions.

There were also plans underway to market the newest division Melanie Lyne. One of the goals was to target younger customers by focusing on branding and direct mail. A loyalty program was being developed for fall, and a radio campaign was ready to air.

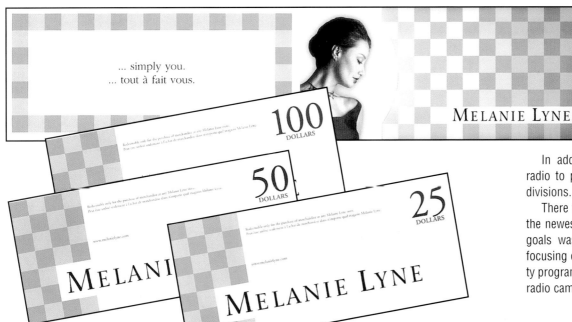

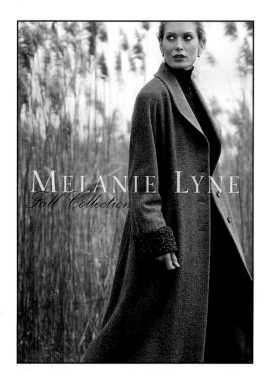

Melanie Lyne catalogs.

Laura Canada, Montréal
MARKETING DIRECTOR: **Sandra Bracken**
AGENCY: **In-house**

($25 Coupon Direct-mail piece - Melanie Lyne Brochure - Direct Mail)
CREATIVE DIRECTOR: **Maria Madonis**
ART DIRECTOR: **Terri Sundholm**
PHOTOGRAPHER: **Max Abadian**

(Direct-mail pieces/magazine inserts)
CREATIVE DIRECTOR: **Maria Madonis**
ART DIRECTOR: **Anna Abramowicz**
PHOTOGRAPHER: **Max Abadian**

(Melanie Lyne & Laura Gift Certificates)
CREATIVE DIRECTOR: **Maria Madonis**
ART DIRECTOR: **Terri Sundhollm**

(Privilege Card)
MARKETING AGENCY: (Privilege Card) **The Zap Group**, Montréal
AGENCY: (Privilege Card) **Bazooka Design**, Montreal
CREATIVE DIRECTOR: (Privilege Card) **Brenda Lavoie**
PHOTOGRAPHER: (Privilege Card) **Pierre Lafreniere**

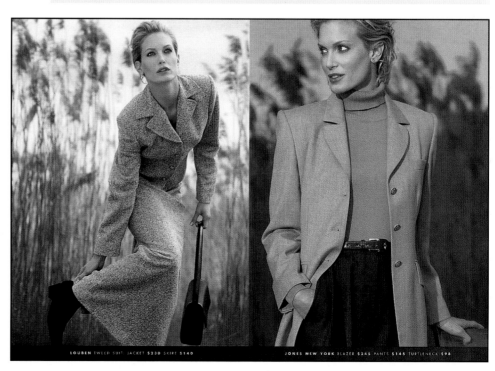

The In-House Challenge

WITH MORE THAN 500 stores covering 37 states and Puerto Rico, Marshalls is one of the nation's largest off-price family apparel and home fashions retailers.

The company's brand image is positioned in it's slogan— "Brand names for less. Every day." Their **BRAND AWARENESS** is well established. Marshalls is able to offer consumers savings on brand names because it's able to get "a buy" on goods itself. This is their theme and the basis for their **ATTRIBUTES BRANDING.** The retailer's business model is based on being opportunistic, moving quickly to take advantage of an opportunity to get the best price.

This unpredictable (albeit enormously successful) way of operating has myriad implications for how Marshalls handles its advertising, making time to get the advertising done a critical factor.

While Hill Holiday still handled its broadcast and national advertising, Marshalls had gradually been shifting more of its advertising in-house. "We're on such tight deadlines," said Lisa Trager, creative services manager. "Being in-house lets us do things quicker."

Marshalls had been placing more emphasis on marketing the **attributes** of their most competitive and best-priced merchandise to target audiences in specific markets. Because of the short timeline, the in-house agency was trying to be more full service. "It's more efficient," Trager said, "because we're closer to the merchandise."

The advertising department already had done a lot of signage and direct mail, including monthly bill enclosures. Marshalls decided to do ROP newspaper ads on a limited basis in house as well. The ads were created in clusters to support events in certain markets because Trager explained "there are some very good events that are only in certain stores instead of nationally. Sometimes they're softer markets that need a

- Attributes Branding
- Commitment Branding

BRANDSTANDS

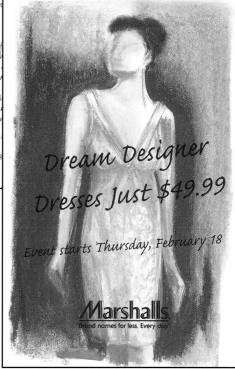

No merchandise to shoot? An illustration simulating a designer's sketch circumvents the problem.

Oversized postcard, (11" x 6").

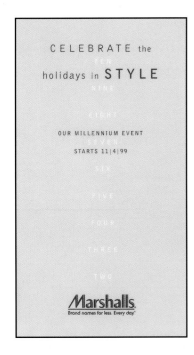

CELEBRATE the
TEN
holidays in **STYLE**
NINE

EIGHT

OUR MILLENNIUM EVENT
SEVEN
STARTS 11|4|99

SIX

FIVE

FOUR

THREE

TWO

Marshalls.
Brand names for less. Every day.

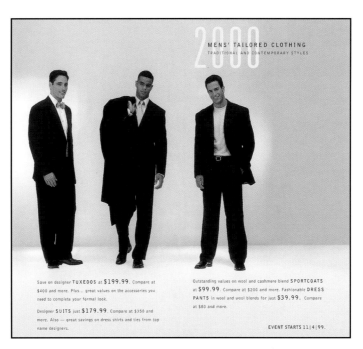

2000 MENS' TAILORED CLOTHING
TRADITIONAL AND CONTEMPORARY STYLES

Save on designer TUXEDOS at $199.99. Compare at $400 and more. Plus... great values on the accessories you need to complete your formal look.

Designer SUITS just $179.99. Compare at $350 and more. Also — great savings on dress shirts and ties from top name designers.

Outstanding values on wool and cashmere blend SPORTCOATS at $99.99. Compare at $200 and more. Fashionable DRESS PANTS in wool and wool blends for just $39.99. Compare at $80 and more.

EVENT STARTS 11|4|99.

Can this be Marshalls? You bet! While the price points and luxury of these items aren't the stores' typical fare, Marshalls' strategy of marketing specific merchandise to target audiences and giving them a sense of the merchandise is. For the millennium, Marshalls had tuxedos, crystal, ball gowns —and clearly wanted people to know about it!

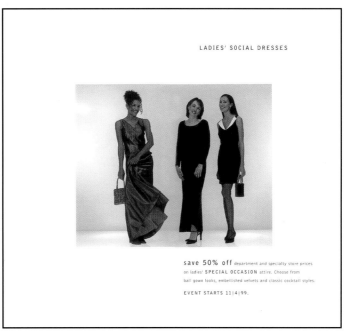

LADIES' SOCIAL DRESSES

save 50% off department and specialty store prices on ladies' SPECIAL OCCASION attire. Choose from ball gown looks, embellished velvets and classic cocktail styles.

EVENT STARTS 11|4|99.

MEN'S
fall
DESIGNER
EVENT

STARTS
**THURSDAY
SEPTEMBER 9**

Marshalls.
Brand names for less. Every day.

New arrivals from today's top designers at Marshalls' everyday low prices!

Designed for you at 40% and more off department and specialty stores. The look is slimmer, softer. Choose from wool suits for every style. Luxury fiber sportcoats, including suede-looks and cashmere blends. Microfiber and classic wool dress pants, too. This season, the smart money's at Marshalls!

STARTS THURSDAY, SEPTEMBER 9

Men's tailored clothing not available in all Marshalls' locations. Merchandise will vary by store. © 1999 Marshalls

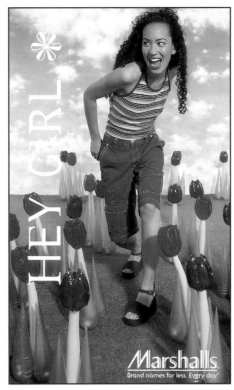

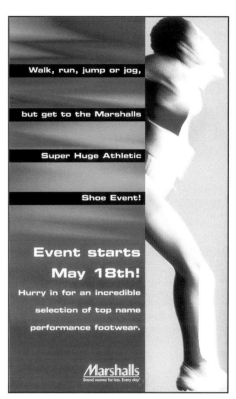

Jumbo postcards.

push. One thing that is a constant is the necessity to get the ads for them out fast."

The department has had plenty of practice in turning on a dime. Theirs is an unusual procedure for creating advertising, be it newspaper or direct mail. Rather than coming up with a concept, along with layout and copy in the usual order, Marshalls has its own M.O. Trager described a typical situation. "The buyers let someone in advertising know that they have 'a buy,' something exciting like a great children's buy, that's going to be in a lot of stores. At some point we get a sketchy idea of what the type of merchandise is that helps us create a kind of generic shell. The text could be anywhere. It's an evolving process. We're often designing without copy and shooting without copy.

There's a lot of pressure to get it done fast all the way up to the photo shoot, if there is one included. We're firming up information such as the actual prices pretty much to the last minutes—sometimes even what the merchandise is!"

In some instances, the department has to rely on stock photography because of time. "The time from when a direct mail job is officially opened with bare boned information until it's released to printer is only two weeks," said Trager. "I would love to have a month!"

That's just one type of challenge. When Marshalls got merchandise for a designer dress event sooner than expected, there wasn't time to shoot a mailer. In that case, the negative was turned into a positive. The mailer was done like a watercolor piece, so it

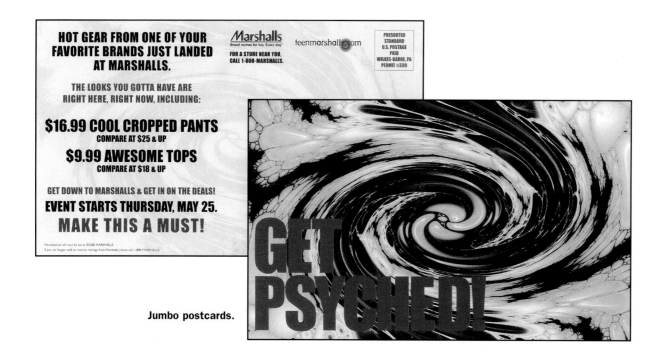

Jumbo postcards.

would look like it came off the designer's sketch pad.

Because Marshalls was already well known for women's apparel, two other merchandise groups, men's tailored clothing and juniors, have become initiatives.

For example, when Marshalls had some designer name merchandise for men, a mailer was done to brand the line. Designed as a full-color fold-out piece, it had a fresh and exciting look that's different from most of the mailers, which were frequently a jumbo postcard format.

In a similar vein, a mailer for the millennium was unusually elegant for Marshalls but in that case, the merchandise offering was also unusual. "We had crystal, tuxedos and ball gowns," said Trager. "That's not typical for us, so we wanted people to know about it and get the feeling of it. We're able to do this because we understand the **attributes** of the brand so well. The challenge is to

have other people understand it."

Juniors had a special look too. "We can get away with doing two-color pieces for teens if the colors and graphics are strong enough," said Trager. "'What are you waiting for?' had a great response." Like most of the mailers, it was done in large postcard format, which for cost reasons is usually 6" x 9."

Like with the men's designer names mailer and the millennium piece, if a piece calls for another size or format to better reflect the merchandise, Marshalls will go for it. A mailer for the home was printed on uncoated stock so it would have a warm comfortable feeling, and the nature of what was shown called for a larger oversized postcard (6" x 11" instead of the more frequently used cost-efficient 4" x 6" small format).

Trager summed up the work of the in-house agency this way: "You pick your battles to reflect the merchandise and fill the objectives. We try to push it a little bit."

Statement stuffers.

Marshalls actively supports the Juvenile Diabetes Foundation in a variety of ways. This card is put in store at registers. Customers can buy a picture of a sneaker for a dollar and have the sneaker with their name on it posted on a wall in the store.

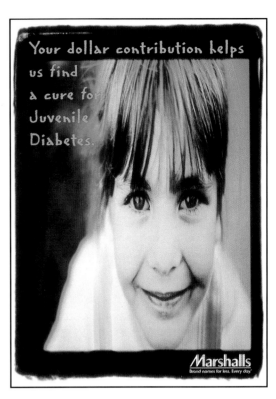

THE TOP NAMES AT ONE INCREDIBLE PRICE

BRAS
$4⁹⁹

COMPARE AT $12 - $14 & MORE

- A GREAT SELECTION OF BASIC & FASHION STYLES
- UNDERWIRE AND SOFT-CUP
- LACE, COTTON/LYCRA, MICROFIBER AND SATIN

HURRY IN FOR THE BEST SELECTION!
STARTS THURSDAY, JULY 6TH!

Marshalls
Brand names for less. Every day.®
Learn more about living the Marshalls life at
www.MarshallsOnline.com.

ROP ads are new—a way to support events in select markets.

It's Marshalls Super Huge Athletic Shoe Event!

Hurry in for an incredible selection of
THE TOP NAMES IN PERFORMANCE FOOTWEAR
all for 50% - 60% less than athletic specialty store prices.

kids' $14.99
compare at $30 & more

ladies' $19.99
compare at $40 & more

men's $24.99
compare at $50 & more

Don't miss this special event! Starts Thursday, May 18th!

Marshalls
Brand names for less. Every day.®

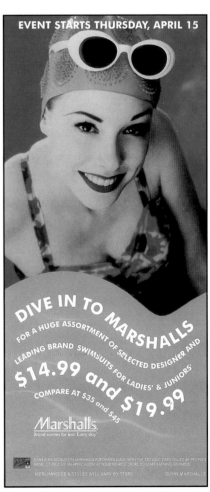

Bag stuffer used to re-drive traffic.

Marshalls, Inc., Framingham, MA
SR. VP CORPORATE MARKETING **George Sokolowski**
VP MARKETING: **Kerry Hamilton**
AGENCY: **In-house**
CREATIVE SERVICES MANAGER: **Lisa Trager**
GRAPHIC DESIGNERS: **Sarah Steinberg, Thom Wilk**
ADVERTISING AGENCY: **Hill Holiday,** Boston
WEBSITE: **www.marshallsonline.com www.teenmarshalls.com**

Getting to Know You

In the era of declining suit business, Men's Wearhouse kept growing and growing its market share, its sales and profits, its store count, its employee morale and its advertising. What set them apart from the rest of the pack was their ability to keep everything on a personal level even though they've been a public company since 1992.

The Men's Wearhouse was founded in 1973 in Houston, Texas, by George Zimmer. Back then, a bearded, long-haired Zimmer, who's been called an overgrown hippie, a brilliant businessman and an off-the-wall-visionary, traveled around in a Buick Electra.When he opened the first Men's Wearhouse (with a college roommate and a cousin) at 6100 Westheimer, the young company couldn't afford a cash register, so the money—first day sales reached $3,000—was kept in a cigar box. Two years later, with business picking up and three thriving stores in Houston, the first local TV commercial aired with Harold Gunn as the pitchman. Gunn was short, bald, loud and obnoxious. He appeared on the air for five years, first sporting a pink bunny suit and later showing up dressed as Charlie Chaplin.

- Commitment Branding
- Benefits Branding
- Destination Branding

BRANDSTANDS

COMMITMENT BRANDING was one of the first image building strategies adopted by George Zimmer. It was a natural outcome of his company motto. In 1986, Zimmer quietly took over the airwaves when he starred in his first Men's Wearhouse commercial. **The original "I Guarantee It" corporate motto,** he said, was partly inspired by Bill Murray's movie, "Stripes." "But, I mixed up 'I Guarantee It' with 'That's the Fact, Jack.'"

Zimmer—sans long hair but still bearded— remained the same low-key, cool kind of guy he always was. Except he became the company's official spokesman, Chairman and Chief Executive Officer. Some other things had changed along the way as well. The old Buick is a fleet of trucks, the cigar box a networked computer system, and The Men's Wearhouse had become one of America's most successful men's wear chains (650 stores across the U.S.; 110 stores across Canada) with total corporate sales of $1.333 billion in 2000, a $70+ million advertising budget embracing a hefty share of TV and radio campaigns, along with a small share of newspaper inserts, tailored for each division, and an enhanced website. An impressive $10 billion, 15-year-plan was expected to grow not only The Men's Wearhouse advertising budget, but all three of its divisions, as well as to purchase new companies and launch additional women's departments within The Company's (refers to the MW group of stores) group of K&G discount stores. And, if all that weren't enough, The Company had been cited for the second consecutive year by *Fortune* magazine as one of the 100 best companies to work for in America

Men's Wearhouse is based in Fremont, California, and operates a corporate office and two distribution centers in Houston totaling approximately 390,000 square feet. A third distribution facility with approximately 385,000 square feet was added in 2001. The MW group of brands has been one of North America's fastest-growing retailers adding approximately 360 stores in five years. The Company operates three brands: Men's Wearhouse and K&G Stores (U.S.) and Moores Clothing for Men in Canada. Three Men's Wearhouse stores in Manhattan have generated the highest nationwide volume.

According to Richard Goldman, Men's Wearhouse executive vice president, "K&G represents 65 big-box, no-frills, deep-discount men's stores—six of which include women's wear—that operate weekly from Friday to Sunday only and carry a mix of branded and label merchandise. The Company also operates the second-largest manufacturing facility of men's suits and sport coats in Canada with the majority of merchandise produced there used to supply the Moores stores."

BENEFITS BRANDING was chosen as a key strategy to help these customers feel comfortable. To successfully communicate the benefits men derived from shopping at the MW group of stores, the company had to know their target customers' needs and wants and how to deliver the right merchandise, service and atmosphere.

"The growth of The Men's Wearhouse

RENT? OWN?
THE BIG *Night*
DOESN'T HAVE TO PRESENT A BIG DILEMMA.

The 2000 Annual Report showcases a stylized mix of fashion from all three of its divisions in a glossy, editorial way.

Group of brands," explained Zimmer, "stems from one simple premise: Take what men consider a daunting and confusing task—shopping for clothing—and turn it into a comfortable, quick, easy and rewarding experience. The Company's goal," he added, "is to continue to reach more middle to upper income men, aged 25 to 54, with more choices by offering broad selections of quality merchandise to fit the needs of our customers' varied lifestyles." Thus, merchandise selection was broadened in terms of both tailored clothes as well as dress casual offerings with trousers, sport coats, knit and woven shirts, shoes, big and tall merchandise, outerwear and a tuxedo rental program in 120 stores. Square footage was increased at Men's Wearhouse stores by opening larger stores and expanding existing locations as their leases were renewed. Since 1992, the average square footage for Men's Wearhouse stores increased from around 4,100 square feet to 5,200 square feet.

"George and I realized early on that a sense of humanism in both the business and advertising environment is crucial," Goldman explained. "First, we created a sense of the family that we both wished we had across the board. We treat our employees like family, and

YOU'RE GOING TO LIKE THE WAY YOU LOOK.

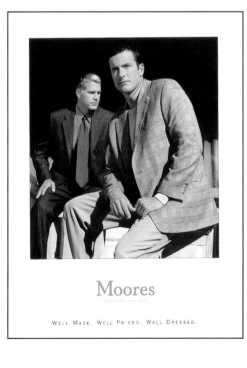

Moores

WELL MADE. WELL PRICED. WELL DRESSED.

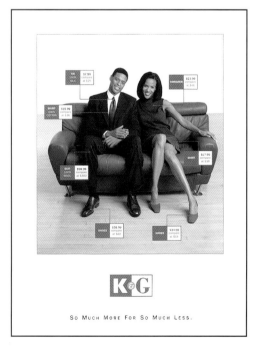

SO MUCH MORE FOR SO MUCH LESS.

INSIDE MEN'S WEARHOUSE

Mission Statement: "To maximize sales, provide value to our customers, and deliver top-quality customer service while still having fun and maintaining our values. These values include nurturing creativity, growing together, admitting to mistakes, promoting a happy and healthy lifestyle, enhancing a sense of community and striving toward becoming self-actualized people."
—George Zimmer, CEO, Chairman of the Board

- Based in Fremont, California, and Houston, Texas

- Founded in 1973 in Houston by George Zimmer

- Richard Goldman, Executive Vice-President, joined the company in 1973

- First TV commercial aired in 1975, running locally in Houston

- Advertising media breakdown: 40% TV, 40% print, 20% radio

- "I Guarantee It" original motto appeared in 1986

- "You're Gonna Like The Way You Look, I Guarantee It" add-on motto appeared in 1997

- All media buying done in-house

- Advertising budget: $70 million plus, with the lion's share of dollars allocated to the Men's Wearhouse division with 95% slated for broadcast

- IPO in April 1992 brings in $13 million, resulting in increased expansion and advertising

- Value-priced clothing division launched in 1996

- 2000 total corporate sales: $1.333 billion vs. $1.187 billion in 1999

- 2001 store count: Men's Wearhouse: 475 nationwide with 27 stores (three stores in Manhattan) in the New York Metro area

- K&G: 65 (six stores now carry women's wear)

- Moores Canada: 113

- Men's Wearhouse currently owns 13% of the U.S. clothing market and 18% in Canada

- Average store size: 5,000 square feet (moving to 6,000)

- Average transaction over $100: $390

- Average suit price: $300 plus

- Average sales per square foot: $400

- Average charge on credit card: $595

- Big and tall clothing share of market: 20% to 25%

- Direct sourcing: 35% to 40%

- 6,000 employees (10,000 employees in all three divisions) of which 25% are female

- Number of suits per door: 3,000 plus

- George Zimmer's 15-year plan: $10 billion net revenue

we approach our advertising in much the same way. Part of my role as in-house media buyer involves overseeing the ad budget, but I still work closely with our creative agency, Red Ball Tiger in San Francisco."

Strengthening their COMMITMENT BRANDING: "In 1997, we sat down with our agency because we knew it was time to tweak our image and expand on our original motto. We knew we were in an interesting position because in advertising, there's *the promise* and *the performance*. Most stores promise, but don't deliver. Up to that point, we were making a general statement, but we weren't backing it up or guaranteeing anything. We needed to put more meat on the bone. After the add-on, we were making the promise and we were also guaranteeing that we could deliver it. So, that's how the 'You're Gonna Like The Way You Look, I Guarantee It' add-on motto came about."

In 2001, The Men's Wearhouse segmented its advertising program into an 80% to 85% share for local TV. The :15 and :30 second spots, all featuring Zimmer and his recognizable motto, ran locally in 115 markets—mainly within news, sports and select prime time programming, to give The Company a better cpm in reaching the target audience of upwardly mobile males. Spots ran on a 30-week cycle, with a rotation change four to five times a year. Each spot highlighted a particular Men's Warehouse category, such as suits, dress casual, outerwear, or shoes. Service spots, which emphasized in-store perks like free pressing or 24-hour tailoring figured into the mix. Holiday sale spots ran four times a year. A "Click & Mortar" spot talked about The Company's website and e-commerce. "Our basic TV commercial is always evolving," Goldman said, and as such, a trio of brand new spots ran though summer and fall 2001. "Moving On," a :30-second casual suiting spot ran in all 115 markets, shows a guy who just isn't happy about the way casualwear is being worn in the workplace. He goes to Men's Wearhouse to be outfitted with his own kind of signature casual suit look. Another :30-second spot, called "Buddies," showed the breadth of Men's Wearhouse merchandise. Here, a group of thirty-something guys—all college buddies—are shown having dinner, sporting casual to dressy Men's Wearhouse clothes. This spot ran in approximately 50% of all markets. A :15-second spot, called "Double Duty," ran in all markets, and featured the new look of chic, unconstructed suits for comfort and fashion in the workplace. Radio advertising embraced a 15% to 20% share of dollars when it comes to :60-second customer call in testimonial spots. These ads had a 30-week cycle, embracing five to seven spots at a time in a linear rotation, hitting some 85% of the total reach

The "Buddies" TV spot emphasizes the breadth of Men's Wearhouse merchandise, showing a group of thirty-something guys dressed in casual and dressy clothes.

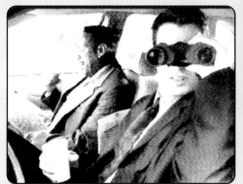 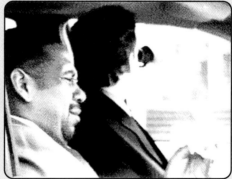

Slice-of-life TV advertising for the K&G stores shows detectives who live in a white collar world on a blue collar salary as spokespeople. The ten spot campaign is designed to run in sequence, so viewers can learn more about each character as the ads unfold.

market. At the end of each spot, Zimmer "speaks" to a "caller" who has previously left a voice message on The Men's Wearhouse 800 number. Black-and-white newspaper print ads, touting After-Christmas sales, run only on Christmas Day in all 115 markets, amounting to only 1% to 3% of the total advertising budget.

The Men's Wearhouse philosophy and mission is to share their attitudes and values with like-minded customers. They provide **the place** where the experience is not a hassle—**DESTINATION BRANDING.**

As for Zimmer's involvement in the ads, Goldman said that George appears to speak personally to each viewer. "There's no screaming and shouting; it's all done low-key with a very personal, one-to-one attitude. We know that men aren't great shoppers. We understand that many men actually hate to shop. So, we're trying to take a bad situation and make it bearable, and at the same time, we're showing these men that shopping with us is always going to be as enjoyable and easy as possible. It's never going to be like buying a used car."

In addition to TV, radio and print advertising, Men's Wearhouse got its message across via a hefty share of slick, full-color direct mail pieces and informational brochures, touting everything from corporate programs to tuxedo rentals for weddings and proms to year-end sales.

Television advertising for the K&G discount stores had run in 18 local markets with :15- to :30-second spots targeted to men, with a small share devoted to women (in markets where stores that carry women's wear are located). "In the ads, we chose detectives as our spokespeople, because they live in a white collar world on a blue collar salary. They need to look good, but they don't have a lot of money," said Red Ball Tiger's Bob Ravasio. "This is a 10-spot campaign, designed to run in sequence, so we learn a little more about each of the characters as the ads unfold," Ravasio added. "Another unique element is the use of :15s. Rather than just doing lifts, we chose to use outtakes from the :30s. It's humorous, and attention-getting in a very positive way." Radio ads were bought basically the same as TV. Black-and-white print

THE MEN'S WEARHOUSE

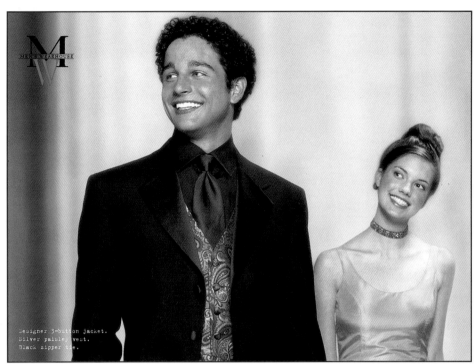

Promotions like The V.I.P. Corporate Program, Special Occasion Dressing and Once-A-Year Sales play an important role in capturing the attention of The Men's Warehouse male and female customers.

Special Perks

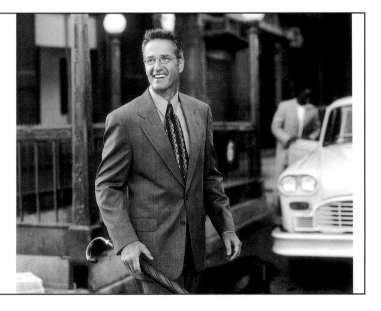

A 10% discount on regular-priced merchandise. V.I.P. members save an extra 10% on prices that are already 20%-30% less than department and specialty stores. For example, the same suit that sells for $400 at a department store and $250 at Men's Wearhouse is only $225 for V.I.P. members!

If you just can't make it to a Men's Wearhouse store, we'll provide free delivery to your office.

Often, your clothing simply needs pressing, so why go to the expense of having it dry cleaned? We offer free lifetime pressing at over 450 Men's Wearhouse locations nationwide.

Need an outfit for a last-minute business trip? 24-hour tailoring is available upon request. And we'll hem pants while you wait...so your meeting doesn't have to.

If you've gained or lost weight, we'll re-alter free of charge any seams we've previously altered.

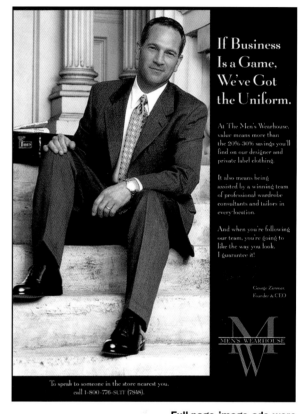

ads ran several times a year.

As for Moores, TV ads ran throughout Canada as :30-second spots, focusing on personalized vignettes of people making clothing in the Canadian factory. Originally initiated in Western Canada in 2000, the TV campaign had been effective in positioning this group of stores as a value-oriented, customer service retailer. Although Moores had not run any radio spots, two black-and-white print ads ran annually, announcing mid-year and year-end sales.

When asked about the importance of advertising in men's magazines, Goldman was quick to admit that he doesn't believe this type of print vehicle is right for The Men's Wearhouse. "We don't feel we can get our kind of selling experience message effectively across to our target audience in magazines. For us, our image is better served through the advertising we're doing now. The reach is broader, cleaner and much clearer with sight and sound." However, Goldman pointed out that full-page image ads were occasionally placed in publications that specifically target the male customer, such as The San Francisco Giants' 2000 Official Team Yearbook.

But The Men's Wearhouse did advertise and promote fashion—and lots of it—in its own way and under its control. In The Company's 2000 Annual Report a formalwear editorial, called "The Big Night," featured full-color bleed pages

of great-looking guys in tuxedos and a woman in eveningwear, along with stylized fashion copy. And, on its website, there's an abundance of fashion photos to go along with departments like "Guy'dLines," "Common Threads" and "Ask The Guru," along with an informational video, entitled "Casual Know-How," which shows and tells male consumers the right ways to dress down at work.

For its future, The Company was looking at ways to bring their message to the women's market, particularly within the K&G group of stores. As for George Zimmer, his wish campaign has been to show him shaving off his beard on national TV. "I'd be all dressed up in a tuxedo and telling the viewer, 'if you've never shopped at a Men's Wearhouse store, remember everything changes—I guarantee it'!"

Full-page image ads were occasionally placed in publications that specifically target the male customer, such as The San Francisco Giants' 2000 Official Team Yearbook.

The Men's Wearhouse,
Fremont, CA, Houston, TX
CEO, CHAIRMAN OF THE BOARD: **George Zimmer**
EXECUTIVE VICE-PRESIDENT: **Richard Goldman**
AGENCY: **Red Ball Tiger,** San Francisco, Ca.

Men's Wearhouse
WRITER/DIRECTOR: **Gregory Wilson**
ART DIRECTOR: **Paul Collis**
MANAGING DIRECTOR: **Bob Ravasio**
PRODUCER: **Lynn Cary**
ASSOCIATE PRODUCER: **Katherine Schwager**

Moores
WRITER/DIRECTOR: **Gregory Wilson**
ART DIRECTOR: **Paul Collis**
MANAGING DIRECTOR: **Bob Ravasio**
PRODUCER: **Lynn Cary**

K&G
WRITER/DIRECTOR: **Gregory Wilson**
ART DIRECTOR: **Paul Collis**
MANAGING DIRECTOR: **Bob Ravasio**
PRODUCER: **Lynn Cary**
ASSOCIATE PRODUCER: **Katherine Schwager**

The Fall-Winter 2000 Inspiring Individuals advertising campaign focuses on real people who are making a difference in the world. The ads are brief, not giving away the whole story, allowing the consumer to be intrigued and inspired by the story as it is.

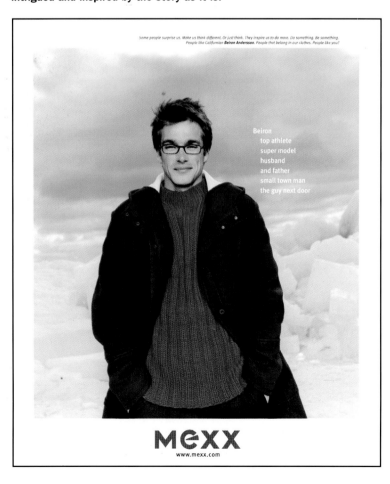

Global Branding

HIGHLY INNOVATIVE and individualistic, Mexx is a company that from the very beginning could never be called conventional.

What is now a 40-country enterprise, marketing a wide range of clothing and accessories for men, women and children, was originally two companies. Mexx dates from 1980, when it started designing and marketing cosmopolitan, affordable fashions for young women and men under the brand names of "Emanuelle" and "Moustache." The attitude was young, fun and contemporary. In 1986, **the two brands were combined to represent one global lifestyle** and sealed with XX representing two kisses... MEXX = M for Moustache + E for Emanuelle + XX for two kisses.

Mexx developed many product concepts. In addition to men's, women's and children's wear, they designed accessories, products for babies, lifestyle items and more. The products were merchandised for the Mexx retail stores, of which there were more than 600. In addition, Mexx installed shops in many department and chain stores. Its products were

- Brand Image Positioning
- Benefits Branding
- Brand Associations
- Viral Branding

BRANDSTANDS

sold in more than 6,000 stores around the world.

Mexx operates, first and foremost, **as a brand marketing company,** which **strives to build a unique and distinct brand equity on a global scale.** One of the key strategies driving this objective is ensuring **BRAND DIFFEREN-TIATION** via clear marketing communications concepts. All the creative concepts for its worldwide campaigns emanate from corporate headquarters in The Netherlands.

The **global brand positioning** is based on the company philosophy to be inspired by free-spirited, positive thinking individuals who reflect the key characteristics of the Mexx brand: optimistic, fun and nonconforming. True to the company's roots, its advertising is fresh, innovative and slightly off center.

During the late 1980s and early 1990s, when the MEXX name had become a single company (sealed with two kisses), the advertising campaigns featured two kissing couples urging the philosophy that "Everything should be XX." The brighter side of life!

In 1998, the company's XX philosophy continued to evolve with real people in mind. The ad campaign that year had fashion models replaced by "role models"—inspiring individuals who were setting positive examples in their chosen fields for others to follow. The campaign focused on a group of men and women with different backgrounds, cultures, ages, occupations and aspirations who were accomplishing things in their own unique way—an example to others as role models, rather than fashion models.

The focus on real people continued in the new campaigns in Spring/Summer and Fall/Winter 2000. Ambitious as well as evolutionary, the campaign featured Inspiring Individuals: People who: "Make us think different. Or just think. People who inspire us to do more. Do something. Be something. People that belong in our clothes."

"This has a much broader appeal for our diverse consumer base," confirmed Joan Drost, Mexx Marketing Communications Director, "because it is clearer to communicate to our target group. The creative platform is still based on the Mexx philosophy of real clothing for real people. Visually, it reflects the spontaneous, positive attitude that has long

When two companies merge into a new name, a strong marketing effort is required to establish a new **BRAND IMAGE POSITIONING** strategy.

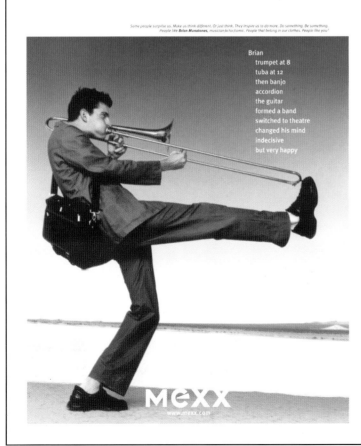
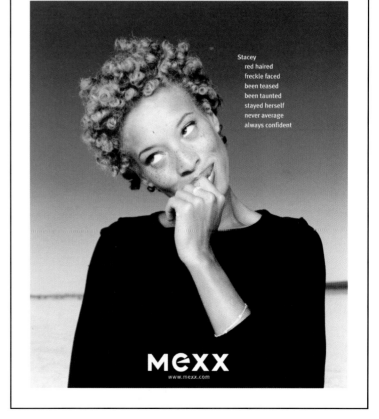

The Inspiring Individuals campaign was launched in Spring-Summer 2000.

#33:
Jesus Cisneros,
Parent/Theatre producer/
Performer

MEXX
www.mexx.com

Real people who are making a difference. Making their mark. Original individuals.
Role models '99.

Role Models campaign, 1999.

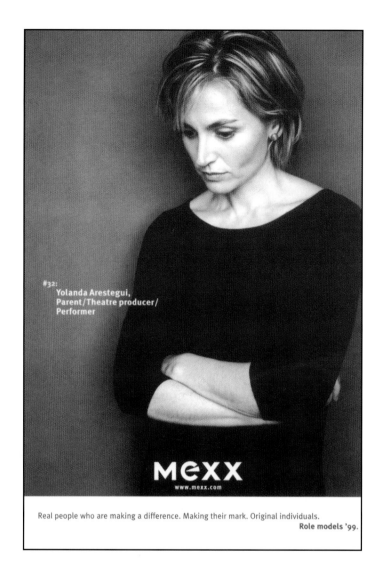

#32:
Yolanda Arestegui,
Parent/Theatre producer/
Performer

MEXX
www.mexx.com

Real people who are making a difference. Making their mark. Original individuals.
Role models '99.

The Mexx campaigns use **BRAND ASSOCIATIONS** that speak to their target consumers' emotional **BENEFITS** of self-actualization, self-esteem and positive societal positioning. Mexx makes the connection real by using real people who are inspiring and telling how they are inspired.

been associated with Mexx. About fun and feeling good. By making it less copy-intensive, this will assure optimal communication in all of the countries where Mexx products are sold."

Although the same campaigns were used internationally, the media plan varied from country to country. According to Julie Brisson, marketing manager for Mexx Canada, "The media used in North America is basically print. It includes fashion magazines such as *Flare, Elle Quebec, Les Ailes de la Mode,* and *Toronto Life Fashion.*"

Additionally, Mexx Canada did outdoor advertising in the country's major cities. There were wall murals in Toronto, and bus rears in Montreal and Vancouver. "We're more image than product," said Brisson. "Our customer is 22 to 35, so our advertising strategy is to cre-

Mexx International B.W., Voorschoten, The Netherlands
MARKETING COMMUNICATIONS MANAGER: **Joan Drost**
Mexx Canada, Montreal
PRESIDENT: **Joseph Nezri**
MARKETING MANAGER: **Julie Brisson**
MARKETING COORDINATOR: **Juliet Brisson**
WEBSITE: **www.mexx.com**

Being a global brand means being sensitive to each new market's values, attitudes and lifestyles. Word-of-mouth, or **VIRAL BRANDING** is helping to spread this lifestyle brand around the globe.

role model #24:
Frederik Fetterlein, Tennis player
I started playing tennis when I was ten years old, but didn't take it seriously until I was about fifteen. By the time I was 17, I was the number six junior player in the world. Playing tournaments takes discipline, commitment and focus. When you're younger, you're more concerned about the victory, but as you get older you realise that there are different things in life besides winning. Which is why working with Tereza and being involved in activities to help the abandoned children is very gratifying.

MEXX
www.mexx.com

Role Models campaign, 1998.

ate high impact. Magazines are not enough. Our customer likes to be surprised. We're a little bit quiet here (in Canada), but in general we try to be a little bit different."

The winter 2000 Inspiring Individuals campaign launched worldwide in August ran until January 2001 in print and outdoor. In summer 2001, Mexx turned the inspiring individual campaign around, by asking, "What inspires you?" Their Web pages helped them be interactive.

What will Mexx do next? Joseph Nezri, president, Mexx Canada, reported, "We are being approached aggressively to bring the concept to the states. We really want to look at it for Fall 2002. The big question is do we go with the complete concept (women's, kids, men's, babies, etc.)?"

The plan was make some tests in Canada to see if the complete concept would work in the U.S. "If we do it, we'll do it in one region," said Nezri. The East Coast of the U.S.—Boston most likely. We're doing market research and we'll see."

In May 2001, their entry in the U.S. was assured when they were acquired by Liz Claiborne.

role model #5 fall '98:
Viktoria Tolstoy, Singer My father Erik, a jazz pianist/vibraphonist, has been my biggest influence. I started listening to jazz when I was 15 and was really impressed by Miles Davis and Billie Holiday. I've just made my third CD. The next challenge is to go to America and play in the small jazz clubs. Tolstoy? I'm fourth generation on my mother's side, but I still haven't had time to read 'War and Peace'!

MEXX
www.mexx.com

Skål!

FASHION'S answer to Ikea, the Swedish-based retailer H&M had brought "fashion and value at the best price" to America's shores, splashing down on Fifth Avenue in New York followed by 34th Street and SoHo, then into the New York suburbs, north to Boston and south to Philadelphia.

H&M has a team of 70 designers who create

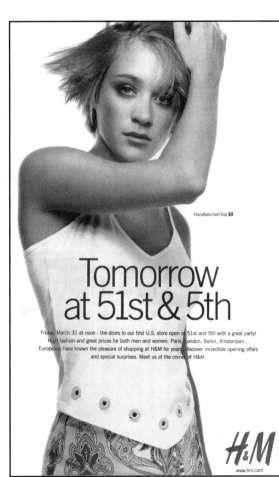

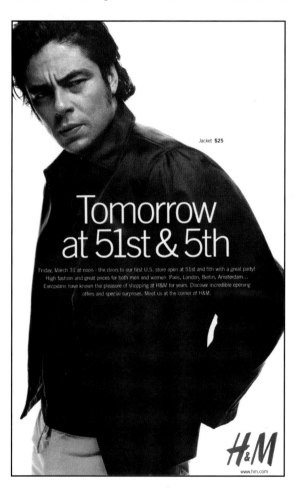

the U.S. by 2004. The choice of the high-profile Fifth Avenue location was part of the **marketing strategy to make H&M better known prior to future expansion. BRAND AWARENESS** is the first step in building brand equity, especially for an unknown company in a new market.

Christian Bagnoud, marketing advertising director, commented on how the prospect of opening a store in New York City compared with other openings. "In Paris and London they were really good. They had heard already about H&M. No one here knew us so it was a challenge."

Anyone in the vicinity of Rockefeller Center that first week knew the company had more than risen to the challenge. Lines stretched around the block, which was not so surprising—the city had been buzzing about the pending new arrival for months.

How did a relative unknown do it? Well, for one thing, from the moment construction began there was a giant vinyl billboard façade on the store front with a colorful fashion figure splashed across it. Secondly, H&M hired a public relations agency, PR Consulting, New York, to make sure the word got out. A press conference was held and soon everyone in the New York metropolitan area was reading about this soon-to-be Fifth Avenue retail happening.

all different lines of clothing for men and women as well as babies, children, teenagers, maternity and plus sizes, including accessories, lingerie, swimwear and cosmetics. The company sells its own designs exclusively in H&M stores. Lots of stores—over 600 in 14 countries.

H&M planned to have a total of 85 stores in

Public relations and publicity were used effectively to create the buzz about this new store-as-brand in New York City. H&M employed the **EXPERIENTIAL BRANDING** strategy to make this

Stretch jersey top **$9**

Opening offers

Women
Tank top **$3.50**
Gingham skirt **$5.50**
Cropped pants **$9**
Lace bra & brief **$3** each

Men
Short sleeve shirt **$6.50**
V-neck sweatshirt **$7.50**
Ribbed sweater **$9**

"Meet me at the corner of H&M"

Today at noon we're opening a new store at 51st and 5th.

Of course we celebrate this with a great party! You'll find the latest fashion—for men and women—at incredible low prices. Great opening offers and surprises as well! Paris, London, Berlin, Amsterdam… Europeans have known the pleasure of shopping at H&M for years. Now we are here and you're invited!

The first 500 customers will get a $30 gift certificate with first purchase good towards future purchases.

H&M

www.hm.com

an experience the target consumers could not miss.

One novel thing H&M did to **build awareness** took place months before the opening. When they advertised for future hires, instead of running the usual help wanted ad, week after week the company took a full color, half-page ad on the front page of the employment section in *The New York Times*. Clearly, this is a company that knows a thing or two about innovative marketing.

"We try to be different," said Bagnoud. "We are very well known in Europe for our advertising." The store did quite a job here. Full page 4C ads and some double-page spreads hit all the big newspapers in the area—*The New York Times, New York Post, New York Daily News, Village Voice,* as well as *Time Out* and local college papers. Radio spots were on multiple stations as well.

H&M's integrated effort lead to the excitement that was generated by this unknown Swedish retail-

H & M Hennes & Mauritz Inc., New York
ADVERTISING AGENCY: **Ronnberg McCann Corporate Advertising,** Stockholm
DIRECTOR OF ADVERTISING: **Sanna Linberg**
MARKETING ADVERTISING DIRECTOR: **Christian Bagnoud**
WEBSITE: **www.hm.com**

er's opening on Fifth Avenue. It spread through the fashion scene by word-of-mouth **VIRAL BRANDING** and set the stage for being welcomed into a new market.

Designers

BRANDS are the SOUL of FASHION

- Fashion is now more **marketing** (building a brand) than it is merchandising (building a collection)

- The major **APPEAL** of a brand is the **STORY** behind it

- Fashion Brand Strategy is **HOW** to THINK about the **CONSUMER's THINKING**

- Fashion brand building is **WHAT** to **COMMUNICATE** to the CONSUMER

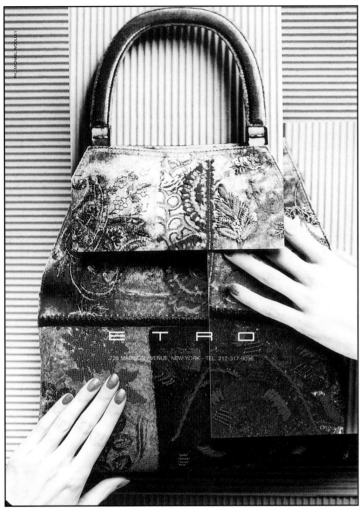

A flair for conceiving every detail as a piece
of art runs through all things Etro.

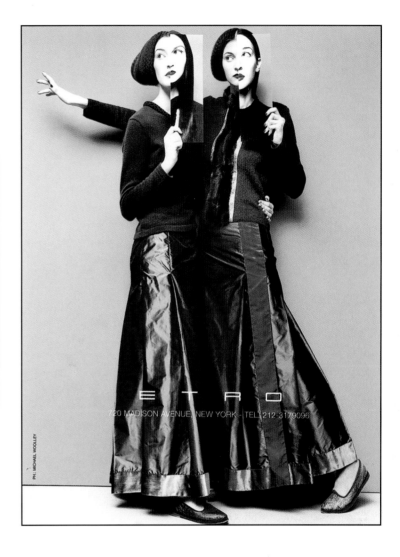

A Veritable Fashion Fantasia

ETRO CAN BE DIFFICULT TO DEFINE, but one thing is perfectly clear: Etro is a family—namely, Gimmo, the head of this Italian family, who created the paisley pattern that made the Etro trademark famous.

Its evolution from family only to company to brand was largely driven by Gimmo's four children and interpretations of the paisley pattern. Over the years Etro expanded into home accessories, then men's and women's accessories, leathergoods and travel accessories. Ready to wear, fragrance and toiletries followed, and in 1999, EtroVision, an eyewear collection was introduced.

Brand equity begins with the Etro company's character, its people and their appreciaton for art, theater and different cultures. Etro's **BRAND IMAGE POSITIONING** strategy was to differentiate their brand through "never following the

- Brand Image Positioning
- Brand Associations

BRANDSTANDS

The advertising image books are direct mailed to 5,000 Etro customers in the U.S., and are given out in the stores.

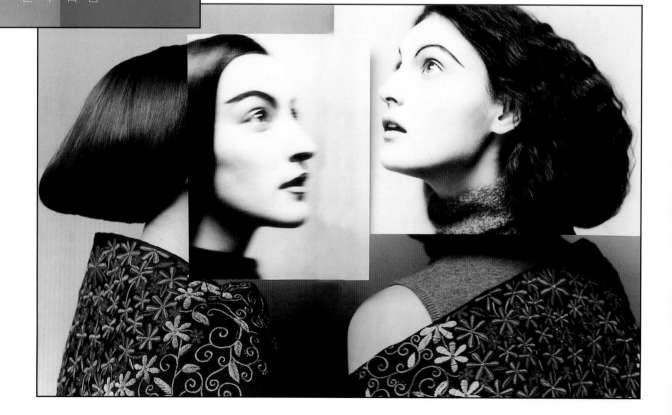

fashion of the moment," and through designing "unconventional and unexpected" advertising.

Kean Etro, the family member in charge of advertising and promotion creative, defined the company in more personal terms: **"Etro means tradition and innovation... an eye back to the past and the mind moving fast toward the future...** what the company has been creating, since 1968, is the simple and logical result of the family's passions for art, culture and whatever is beautiful."

Perpetually outside the fashion trends and dictates, its rich designs are a constant surprise. "Inspiration comes from the most different sources," said Etro. "It can come from an art exhibition, from a trip to a foreign country or from a different culture, it can come from the past as well as from a perception of the future. We've been

All the masks were created by the Italian artist Ferruccio Ascari, who used cardboard to create both the flat and three-dimensional masks.

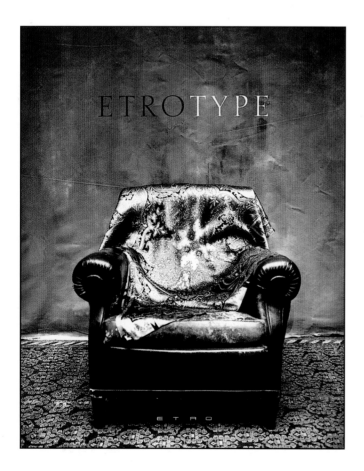

How to make a "burlesque" spirit elegant. Etro's BRAND ASSOCIATIONS have connected their brand with man/animal/ nature/world as a whole values; and with the theater/masks/actors' personalities of the characters we all play.

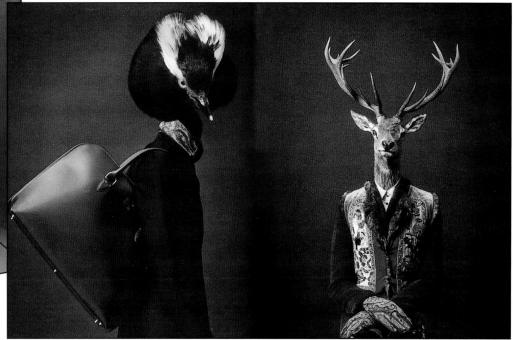

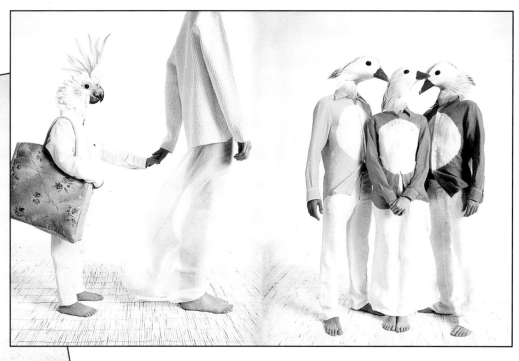

inspired by Africa, by microchips, by the concepts of nature and wilderness, by the perfect shape of a circle or by the Middle Ages."

So it's perhaps inevitable that just as **the company never follows the fashion of the moment, its advertising also is a thing apart— unconventional and unexpected.**

Every year Etro creates an advertising image book—a new campaign that's another opportunity for imagination to run rampant and to compel the viewer to stop and spend time with "the page." The Ritratti campaign (F/W '97–'98 and S/S '98) stemmed from Etro's fascination with the animal component in man. **"We used animal heads to explain,** in the most impressive way, that **human beings are part of nature,** just as well as the animals… **the animal component of a man is his most instinctive and immediate side, which makes him feel closer to nature, a part of the world as a whole."**

What happened next was literally a complete about face—the famous masks that immediately identified an Etro ad. "We decided to use masks for the Spring-Summer '99 ad campaign, keeping in mind what the masks meant in the antique Latin theatre," said Etro. "The Latins, in fact, used masks on the stage to help the actors express the

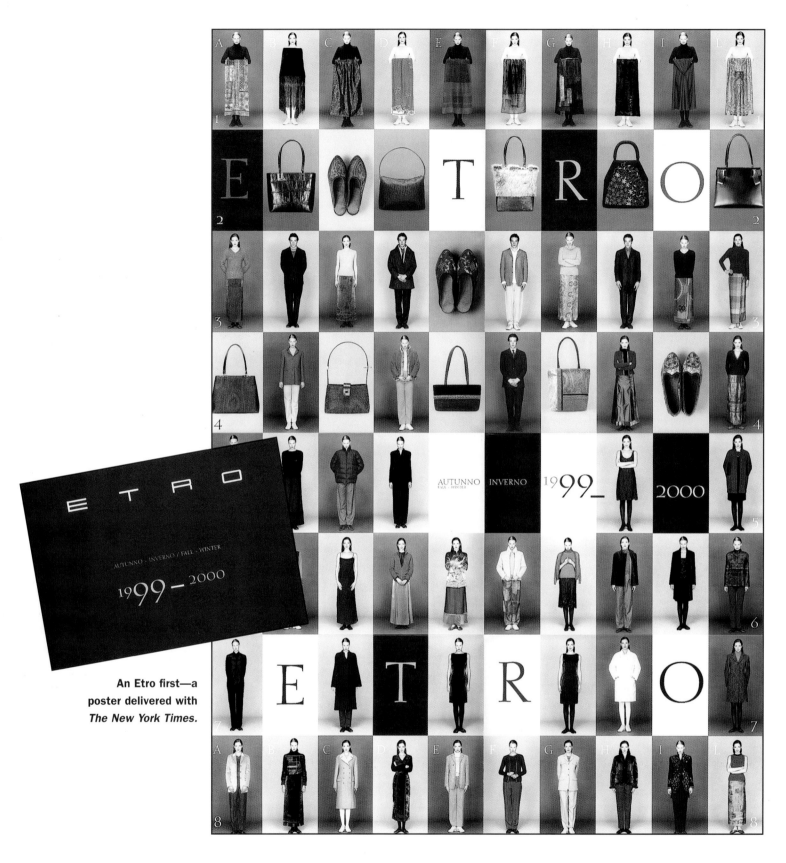

An Etro first—a poster delivered with *The New York Times*.

personalities of the characters they played, and not just to hide their faces. In the same way, by hiding the models' faces under the masks **we wanted to underline the concept that anyone's personality can be expressed through their clothes."**

The Etrotype campaign was a total switch once again. On the one hand it appeared to be a series of straightforward black-and-white photographs, most of whom are of Etro's friends or associates. But like everything else the company touches, there's a lot more complexity here than meets the eye. Etro explained: "The idea to work with real people comes from the German photographer August Sander who, in the 1920s, shot portraits of real people; we have been inspired by his work, and decided to shoot real people to try and recreate an atmosphere. Also, all the people we shot for that campaign chose personally clothes they wanted to wear, and this was a way

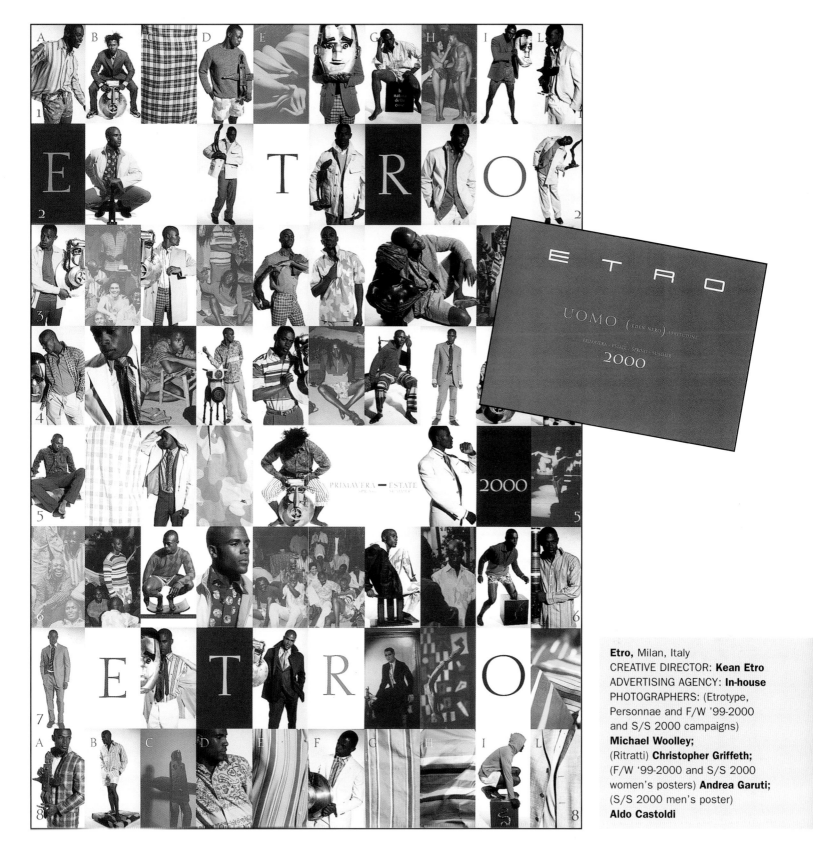

Etro, Milan, Italy
CREATIVE DIRECTOR: **Kean Etro**
ADVERTISING AGENCY: **In-house**
PHOTOGRAPHERS: (Etrotype,
Personnae and F/W '99-2000
and S/S 2000 campaigns)
Michael Woolley;
(Ritratti) **Christopher Griffeth;**
(F/W '99-2000 and S/S 2000
women's posters) **Andrea Garuti;**
(S/S 2000 men's poster)
Aldo Castoldi

to help them express their personalities too."

In 1999 the company ventured into what it terms its first public mailing (packaging its mailing with another product)—a poster inserted in selected zip codes of *The New York Times'* deliveries.

The company moved in other directions related to its physical expansion. Etro had been increasing its international presence, having opened free-standing boutiques in Florence, Berlin, London, New York, Paris and Rome.

While Etro's strongest presence was in Milan, its home city where it has three boutiques, there are about 60 franchising points of sale throughout the Far East.

The company had also formed partnerships with top U.S. retailers including Barneys, Bergdorf's, Neiman Marcus, Saks, Fred Segal, Louis Boston, Gorsuch, Stanley Korshak, Wilkes Bashford and Ultimo.

A Style of Her Own

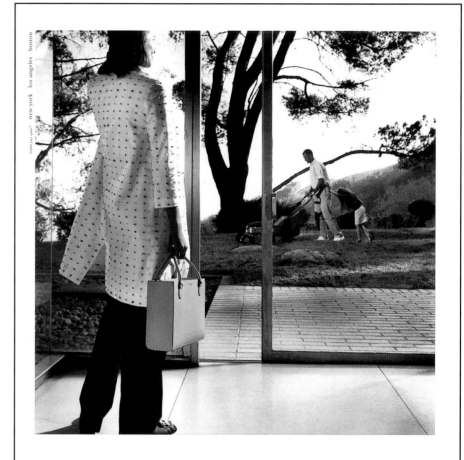

kate spade
NEW YORK

shoes handbags paper

SINCE 1993 WHEN KATHERINE (KATE) Noel Brosnahan, a former *Mademoiselle* magazine accessories editor, founded her handbag company with her husband, Andy Spade, an advertising agency creative director, the luxury goods wholesaler and retailer was on a roll. Neiman Marcus bought a 56% share of the company for $33.6 million. Kate Spade products were carried in Saks Fifth Avenue, Neiman Marcus, Bergdorf Goodman, Nordstrom, Bloomingdale's, Barneys and other fine specialty stores. In addition, there were Kate Spade stores in New York City, Beverly Hills and Boston. The company was also well represented in Japan with freestanding retail stores and in-store shops.

The first collection consisted of a half dozen boxy, no-nonsense nylon tote bags—a style that was to redefine the handbag market. The collection, considered by fashion insiders as the original tote bag, continued to be the company's signature. Additional handbag styles followed, but a personal tradition that characterized the original collection (which was still part of the line), remained in place. Each bag was named after a friend or family member who helped get the business started.

The company's growth continued with the introduction of paper and social stationery, a line of shoes and a limited line of apparel pieces. And a licensing arrangement with Estee Lauder for a line of Kate Spade cosmetics was announced. The first Kate Spade beauty products were launched in the U.S. fall 2001.

Kate Spade designs revolve around personal style and lasting utility. Though quietly refined, everything nevertheless has an element of surprise, reflecting the designer's view that it's more interesting to enjoy fashion on one's own terms, including an element of surprise that expresses one's individuality.

Accompanying the new product developments within the company was an increase in advertising, beginning with the launch of an image campaign in Fall 1999 and continuing in a "similar but different" vein in Spring 2000. The latter was a celebration of personal style and how it relates to everyday life. According to Andy Spade, the company's creative director, the objective was "to be interesting and gracious."

This is a **POSITIONING** of **BRAND IMAGE** with a philosophical concept that appeals to a

- Brand Image Positioning
- Benefits Branding

BRANDSTANDS

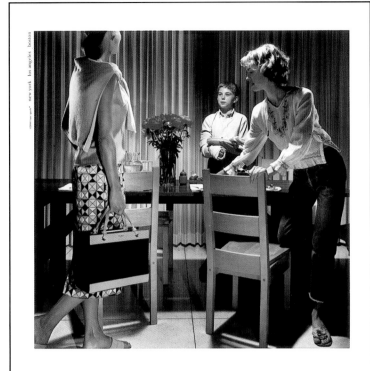

kate spade
NEW YORK
shoes handbags paper

kate spade
NEW YORK
shoes handbags paper

In terms of design Spade has always felt less is more.

kate spade
NEW YORK
shoes handbags paper

select class of consumers, that may cross-over their demographics.

The ads underscore the company's philosophy that there is no typical Kate Spade customer. She could be a mother, daughter, waitress, actress, editor, nurse or politician. The models were carefully chosen to represent a variety of ages from their 20s to their 60s to show the brand's cross-generational appeal.

"The intention was to create a moment in time and allow the reader to make a connection to her own life," said Spade. "The Kate Spade brand is positioned as something everyone can relate to. It takes values and ideas from our past and puts them into a modern context. The brand image isn't about fashion, but about life."

For the clean, straightforward images,

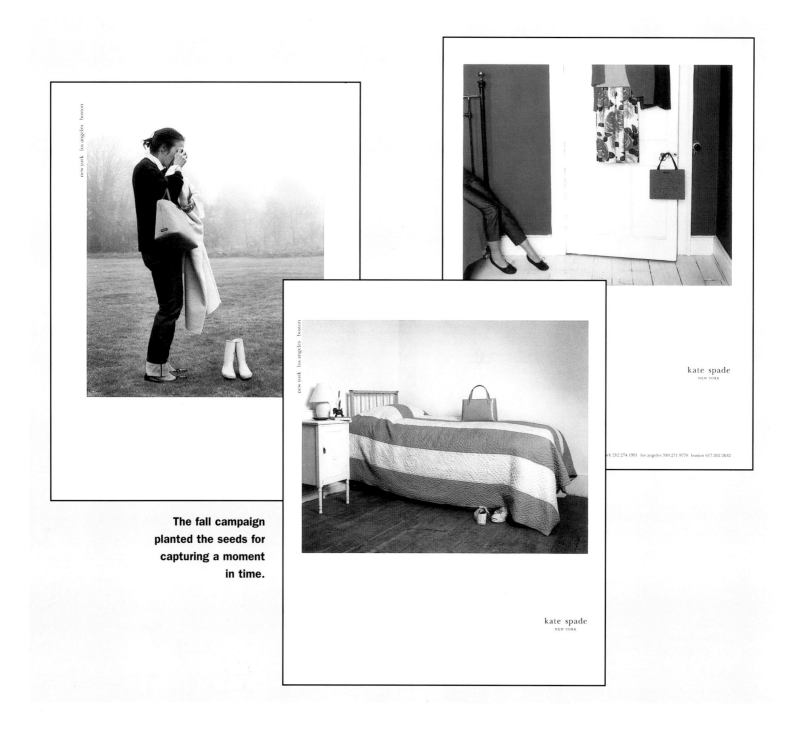

The fall campaign planted the seeds for capturing a moment in time.

strong lighting was used in order to heighten the sense of drama. Product is not the focus of each image but is instead incorporated into the everyday aspect of each scenario. "The photography is modern, patterned after still lifes from a film," he said. "It wouldn't work without the contrast." These ads also capture a story that the customer may want to read over again. They are "attention-keepers" that require more than a quick look.

The campaign was inspired by "Kate's and my childhoods," said Spade, who also credited the legendary covers done by Norman Rockwell for *The Saturday Evening Post* in that each cover told a story with an element of humor that drew the viewer into the image.

Media for the campaign included *Harper's Bazaar, Vogue, The New Yorker* and *Art Forum*. According to Spade, the advertising incorporated a mix of traditional and other media. (Kate Spade promoted its own stores separately with print, direct mail and special events.)

Whatever form the company's advertising took, one thing's fairly certain, it was likely to include an element of surprise.

Kate Spade, New York
AGENCY: **In-House**
CREATIVE DIRECTOR: **Andy Spade**
ART DIRECTOR: **Amir Zia**
PHOTOGRAPHER: **Alexei Hay,** New York

A Continuous Evolution

Le Monde d'Hermès was the personal pet of Hermès International's Chairman, Jean-Louis Demas, who also served as the publication's editor-in-chief and, noted Mommeja-Hermès, "has always loved the magazine." The lavish publication was designed specifically for Hermès' best customers. Produced in several languages, it was mailed to 300,000 top customers all over the world.

Reportage

Under the pewterer's nimble fingers the sheet of metal metamorphoses
into a drinking cup or pitcher, its essence shining through the pure, smooth sheen.

handful of craftsmen lavish time and skill on the pure metal (95 % pewter with 5 % antimony for the necessary hardness). Meticulously, with movements learned over long years, with absolute precision, they make molds – chucks –, then turn and chase, weld, chisel, engrave and burnish. A drinking cup, an ice bucket or champagne bucket, a vodka glass, a vase and a pitcher – all these forms invented by the young designer Nedda El Asmar – are fashioned here for Hermès. The pure design and rounded lines, the warm, silky feel, the elliptical edges completed by a fine strip of metal – a half-band *bâte* – recall the curves and comfort of a saddle, the suppleness of a harness...
The allusion is discreet, the illusion complete: pewter comes out of the shadows and shines brightly in the galaxy of Hermès. *Joëlle Hengel*

*The blank, a single
sheet of pewter, is turned
and chased while
held around a mold
(previous page).
Then the handles, the
spouts and the edges
take form and are welded
on. The piece is then
burnished into brilliance.*

MENTION "HERMÈS" and often the first thing that comes to mind is "scarves." But the couture house is a lot more than that. From its beginnings in 1837 as maker of the finest leather harnesses in Paris, Hermès as we know it is, in the words of Laurent Mommeja-Hermès, Hermès of Paris CEO, "all about a continuous evolution of the House that respects its past."

And as he described it, evolution applies to the direction the company's marketing is taking as well. "Direct mail is becoming very important for Hermès in order to show a more complete personality of specific departments," he explained.

The main vehicle, Le Monde d'Hermès,

- Brand Associations
- Commitment Branding

BRANDSTANDS

Fall-Winter 1999-2000

Portraits of women in Hermès

Gay and poised, Marie-Anne is an antique dealer in a small town on the Flemish coast. Félicitas, natural-ly reticent, shares her life between New York where she works as a model, and the country, where she is be-coming a mother again. Delphin[e] full of life who adores her city, Pa[ris] taneous Paola is Spanish, and a da[...]

Each one becomes a characte[r] ing her own truth and intimacy different photographer. We are o[...] décor seems to belong to their [...] simplicity of cuts suggests guilele[...] the voluptuous materials, sensu[...] these clothes, they appropriate [...] Félicitas, Delphine and Paola, [...] and experience so varied, interpr[...] deploying them in a plurality of [...]

The Hermès "H" which acts as the establishment's signature, literally hangs on a thread on the cover.

Hermès' **BRAND ASSOCIATIONS** feed the consumer's image of the highest quality leather with the most elegant scarves for the rich and famous.

which began in 1978 as an annual publication, was produced twice yearly. Referred to by Momméja-Hermès as **"the catazine"** (a combination of catalog and magazine that in the U.S. is generally referred to as a "magalog"), Le Monde d'Hermès was a stunning melange of editorial, illustration and photography.

In 1999 the company added a new direct-mail piece, the first in its history devoted sole-ly to women's wear. Hermès Fall-Winter 1999-2000 "Portraits of Women in Hermès" paid homage to four very different women, Marie-Anne, Felicitas, Delphine and Paola—and how they interpret Hermès styles according to their individual temperaments.

Created exclusively for the U.S. market, "Portraits of Women" was conceived when Momméja-Hermès was looking at a spring-summer issue of Le Monde d'Hermès. He was immediately struck by the photographs. "I saw these pages of women's ready-to-wear and thought what a good idea it would be to share with more people the fact that Hermès is a couture house that has a woman's line with a specific point of view for women to reflect each woman," he said. "I wanted to show that t**hese women don't** *wear* **Hermès. They are** *being dressed* **by Hermès.** Physically, each woman is wearing these clothes in a different way."

The catazine turned out to be so reflective of what the company is about that Hermès produced it not only as an individual mailing piece, but also included it as part the Fall-Winter 1999-2000 issue of Le Monde d'Hermès. Momméja-Hermès, who was instrumental in determining the company's marketing strategy, described the catazine as "being distributed in the U.S. in a very target-ed way." It was delivered to subscribers of The New York Times in selected zip codes and shrink wrapped with W and Harper's Bazaar.

Another sign of the evolution of the House of Hermès was a new store that opened in 2000 at Madison Avenue and 62nd Street. While Hermès has had a presence in New York since almost the beginning of the 20th century (when it was available at Bergdorf Goodman and Bonwit Teller), there was no free-standing Hermès store until 1983. As the company continued to grow, certain mer-chandise categories were expanded. "Our men's wear is now a full and complete line and needs more exposure," said Momméja-Hermès, "which it now has in the new store. Our knitwear has also become more impor-tant and our watch collection is much more extensive than we show in the United States."

Félicitas by Mark Borthwick

Each woman reveals her own personality under the gaze of a different photographer.

"When I feel proud, beautiful and comfortable, I'm ready to jump for joy or to set off running."

"When you feel well, you're invulnerable."

Just the trick:
a reversible two-piece
suit to wear as the
fancy takes her: belly
covered or belly bare.

HERMÈS

LE MONDE D'HERMÈS 1999 VOL. I

Under our muffled steps, the luxury of thick sand.

Antoine de Saint-Exupéry

Constance

These photographs in Le Monde d'Hermès were the inspiration for the new "Portraits of Women" catazine.

"We wish to have our feet on the ground but our head among the stars."

Mies van der Rohe, June 1924

"The inhabitants of these climes are the only ones who are able to see all the stars in the firmament" said the natural scientist Alexander von Humboldt. It is true that on the plateaus of the Andes, bestriding the equator, man lives in osmosis with Mother Earth, which he venerates and names Pacha-mama, but also with the sky and stars. Everything here is out of the ordinary: nature, the men, the animals. The altitude: between 3,200 and 4,500 meters. The latitude: from 2° North to 6° South. The weather is so changeable that you can experience all four seasons in as many hours: torrid, dry 40° C heat is followed by glacial rain, violent winds and snows. All this against a spectacle of white peaks, volcanoes and equatorial forest. Amidst bears, pumas, jaguars and deer. Such are the paramos, the high steppes of the Ecuadorian Andes.

110

Hermès has a **COMMITMENT BRANDING** strategy that reflects the customer's joy of owning, wearing and displaying this luxury brand.

CAVALIERS DES NUAGES
Riders of the clouds

In a flurry of brocade, mounted soldiers and women form a circle spun with gold and silk. The court of François I is making merry. The monarch is 23 and over six feet tall; he promotes the arts of the Renaissance, likes to entertain and be entertained and, above all, he adores the joys offered by the battlefield. Victory at Marignano transfigures him; defeat at Pavia is still far away. Till then, let the feast continue! May the riders turn, more brilliant than the stars.

REF. 022G27S COL.06

JOUEZ AVEC VOTRE CARRÉ HERMÈS

This little (4" x 4") scarf booklet includes acetate pages in the centerfold that demonstrate how to tie a scarf.

FORMULA 284

FORMULA 250

LEK MED DIN HERMÈS-SCARF - متعة استعمال وشاحات هرمس - ΠΑΙΞΤΕ ΜΕ ΤΟ ΦΟΥΛΑΡΙ ΣΑΣ HERMÈS - JOGUE COM SEU LENÇO HERM

Hermès International, Paris
CHAIRMAN/CEO: **Jean-Louis Demas**
ADVERTISING AGENCY: **In-house**
EDITOR-IN-CHIEF: (Le Monde d'Hermes) **Jean-Louis Demas**
IMAGE CONSULTANT: **Stephané Wargnier**
ART DIRECTOR: **Fred Rawyler**
PHOTOGRAPHERS: **Joanna Van Mulder** (Marie-Anne); **Mark Borthwick** (Félicitas); **Tim Richmond** (Delphine); **Frédéric Auerbach** (Paola); **Luc Pérénom** (cover)
Hermès of Paris, Inc., New York
PRESIDENT/CEO: **Laurent Momméja-Hermès (**2 ACCENTS)
ADVERTISING DIRECTOR: **Christine De Saint-Andrieu**

A Process of Renewal

AS ONE of the best known names in fine Italian shoes around the world (O.J. Simpson notwithstanding), having been displayed at the Museum of Modern Art in New York and cited in many textbooks on the history of fashion, it would seem that Bruno Magli could continue to do what it has been doing successfully for nearly 70 years.

Not exactly.

Like many companies with an established name, the certainty that a fine handcrafted product arising from a grand tradition as being enough to compete successfully today, was no longer enough. Not content to rest on its laurels as a leader in luxury leather footwear for well-shod men and women throughout Europe, the U.S. and the Far East, Bruno Magli was continuing what advertising director, Alberto Lanzoni, termed "a process of renewal"—a change that has broad-reaching ramifications, particularly for its women's shoes, from product to target customer to brand image to advertising. (Seventy-five percent of Bruno Magli products are women's shoes; men's shoes account for 15%; accessories, 10%.)

The renewal process had its roots in 1992 when Rita Magli, the wife of Morris Magli joined the company. Lanzoni described her presence as "a turning point for everything concerned with style," as she had always been interested in the company and felt it was becoming old-fashioned. So given carte blanche by her husband, Rita Magli started making gradual but radical changes in the product, combining ideas and old motifs from the company's vast archives with trendier ideas.

With a fresher, more fashion-relevant product in hand, the company set about to renew its image, utilizing various photographers for new impact campaigns. Changing the product and its image were not the result of an isolated decision but instead the beginning steps in a larger plan that also involves remaking the image of its stores and its advertising communications. The latter included a twice-yearly catalog, mailings and advertising, targeted to a dynamic working woman who appreciates elegance, style, and class. With its refreshed product and advertising, the company was working hard to build its customer base and attract a younger customer.

The **repositioning of brand image** is now a part of the ongoing process of maintaining and building brand equity. When the marketing objective is to expand the customer base to include younger customers, repositioning the image is a must.

- Brand Image Positioning
- Brand Associations

BRANDSTANDS

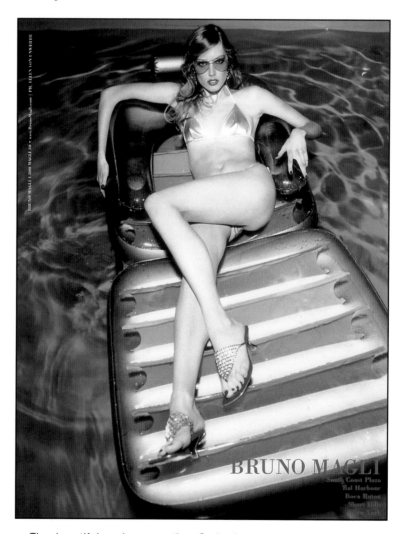

The beautiful and provocative Spring/Summer 2000 campaign was created to help. It definitely pushed the envelope in terms of image. Lanzoni credited its success with the decision to change photographers.

Like any good advertising department, the department at Bruno Magli's Bologna headquarters was filled with fashion magazines that were constantly being scrutinized for ideas. "We came across Ellen von Unwerth's

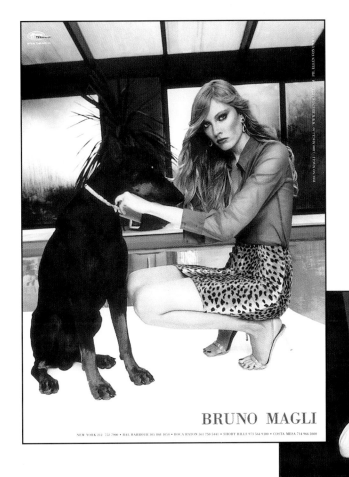

photography, which we found to be quite sexy and fashionable," said Lanzoni. "We contacted her agent and commenced our new adventure."

First, there was a meeting in Paris where von Unwerth was shown samples of the shoes—helping to choose the right styles and the right models.

A month later it was back to Paris to shoot.

In entrusting total creative freedom to Unwerth, Bruno Magli had given her only one caveat: The attitude had to be **sexy.** Other than that, Unwerth was told she could do whatever she wanted with the various scenarios she conceived in order to freely expand her fantasy and creative flair. "We never tried to push Ellen in a certain direction but always left her free to choose," noted Lanzoni. If, as in this case, the major attribute is "sexy," then it must be a **DIFFERENTIATED a**nd fashionable Bruno Magli sexy.

Other than shots for two ads in the city, everything for the other ads and the catalog was set in an exotic villa complete with zebra walls, a golden bathtub, gold mirrored bathroom walls, mirrored bedroom walls, and a pool. A far cry from the usual.

According to Lanzoni, it took two people an entire day to set up the "pool set"—turning the house "upside-down, changing everything from lights to plants.

There was plenty of intrigue. "The woman model was beautiful and the man model was quite attracted to her. They both stayed in the bathtub for one of the last shots when, pretending to slip due to the presence of soap, he pulled the woman against himself and kissed her. (Snap, snap, snap!)"

Brand image positioning often involves "positioning" the customer into fantasies and desires that create unique associations with the brand and its products.

The results were stunning—so much so that Bruno Magli began splashing the images across the pages of numerous fashion magazines including *Elle, Harper's Bazaar, W, Shuz* and *Esquire* for the

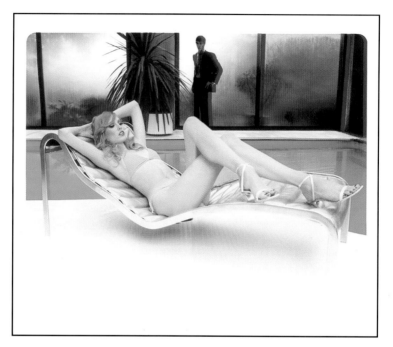

U.S., *Figaro Japon* and *Miss* for Japan, as well as many Italian magazines.

Not surprisingly, the Spring/Summer 2000 catalog was a knockout as well. Approximately 80,000 copies were printed. They were distributed to stores (Bruno Magli is sold in 44 countries); 20,000 catalogs were mailed directly in Japan; 15,000 were mailed within the U.S.; 10,000 were given in Italian stores, and 5,000 were mailed to selected consumers.

Since the company was so thoroughly immersed in this process of renewal, it was important to know if that included the Internet. "At the moment we do not think that selling our shoes via the Internet is right for the image," Lanzoni responded. Nevertheless, he didn't rule out that at some point the Internet

Bruno Magli S.P.A., Bologna, Italy
CREATIVE HEAD: **Rita Magli**
ADVERTISING DIRECTOR: **Alberto Lanzoni**
EXECUTIVE ASSISTANT TO RITA MAGLI: **Chiara Vandolfi**
PHOTOGRAPHY: **Ellen Von Unwerth**
ART DIRECTION AND DESIGN: **Lee Swillingham, Stuart Spalding**
WEBSITE: **www.brunomagli.it**

might be a more appropriate vehicle for selling Bruno Magli designs. In the meantime, he added, "The website has been done for image needs but it's been done two years ago and maybe it's time to renew it."

Renew it? That seems to be the M.O. for everything that Magli's Lanzoni and most brand managers need to do these days.

A Special Spirit

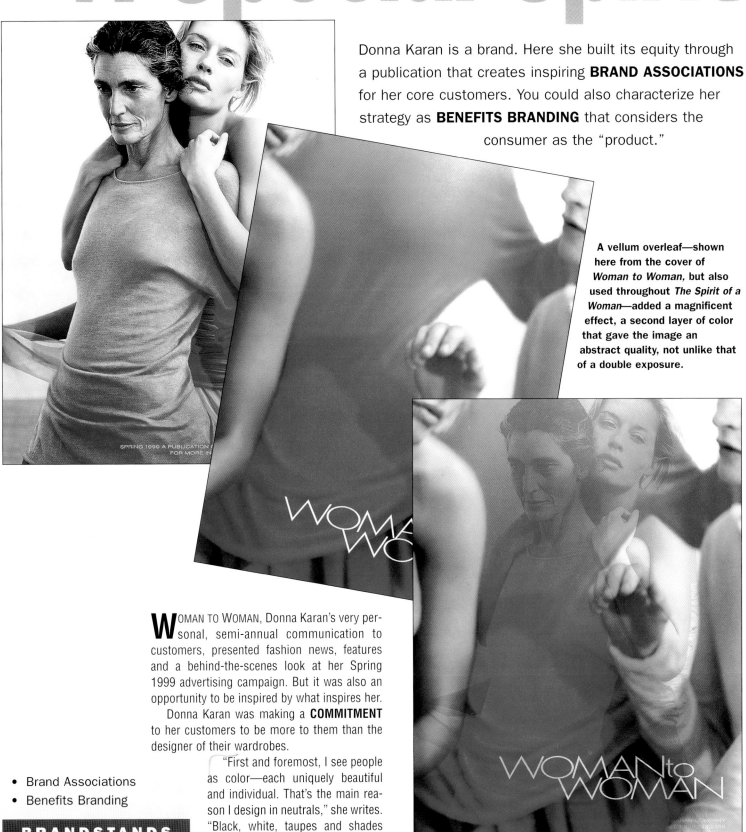

Donna Karan is a brand. Here she built its equity through a publication that creates inspiring **BRAND ASSOCIATIONS** for her core customers. You could also characterize her strategy as **BENEFITS BRANDING** that considers the consumer as the "product."

A vellum overleaf—shown here from the cover of *Woman to Woman*, but also used throughout *The Spirit of a Woman*—added a magnificent effect, a second layer of color that gave the image an abstract quality, not unlike that of a double exposure.

WOMAN TO WOMAN, Donna Karan's very personal, semi-annual communication to customers, presented fashion news, features and a behind-the-scenes look at her Spring 1999 advertising campaign. But it was also an opportunity to be inspired by what inspires her.

Donna Karan was making a **COMMITMENT** to her customers to be more to them than the designer of their wardrobes.

"First and foremost, I see people as color—each uniquely beautiful and individual. That's the main reason I design in neutrals," she writes. "Black, white, taupes and shades create perfect backdrops for a

- Brand Associations
- Benefits Branding

BRANDSTANDS

The center spread unfolds gatefold-style to 40" x 12."

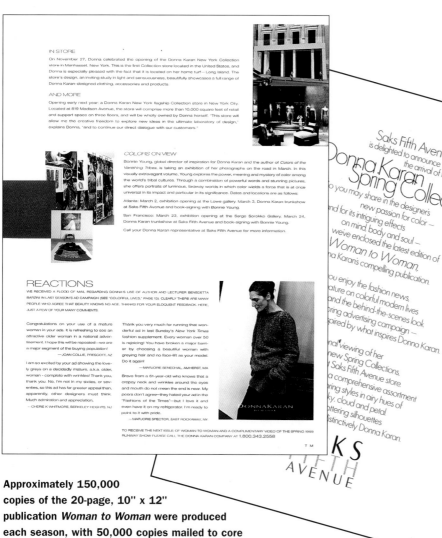

Approximately 150,000 copies of the 20-page, 10" x 12" publication *Woman to Woman* were produced each season, with 50,000 copies mailed to core customers from the designer's database. It was also mailed to Saks and *Town & Country*'s lists. Plans were in progress to produce *Woman to Woman* four times a year. One new issue would be devoted to Holiday; the other to overall well-being and personal health, emotional as well as physical.

woman or man's personality. Like a frame to a painting, neutrals ensure that the person is the first thing you see."

"Donna understands information as well as image," said Trey Laird, executive vice president of creative services. "With *Woman to Woman* we try to build a platform around Donna having a dialogue with her customers."

In it, she talked about everything from shoes to sea breezes. There were also features, such as "Colorful Lives," which spotlights the older woman, Benedetta Barzini, who had appeared in Donna Karan's ads previously.

Produced twice a year the publication was usually partnered with a retailer. Saks, the Spring partner, held a special dinner for their New York store's Platinum group customers. In addition, Donna Karan made a personal appearance, helping customers with different ways they can put her clothes together.

Other events exclusively at Saks included trunk shows and an exhibition of photographs by Bonnie Young, global director of inspiration for Donna Karan. Young's work, which explored color among the world's tribal cultures, was at stores in eight cities across the country.

Helping the customer to know how to wear Donna's clothes provided attributes that build the brand. Building a brand involves every aspect of **BRAND MEANING** to the customer.

According to Laird, retailers were able to purchase *Woman to Woman* to distribute to their customers. "People who get it really enjoy it. They want to know how to wear Donna's clothes."

Karan was involved with every aspect of

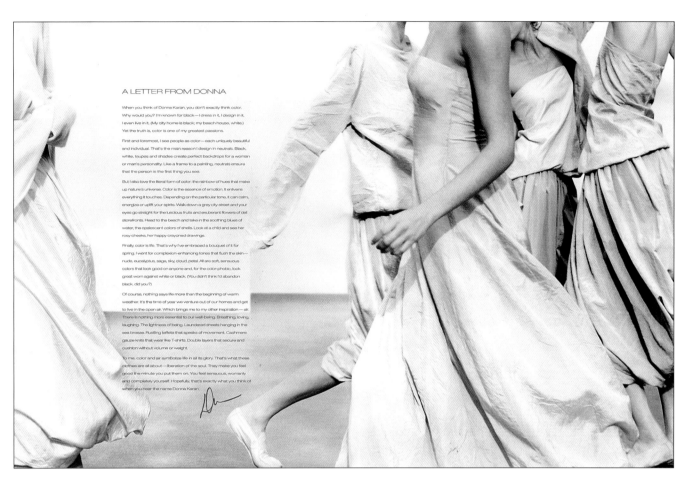

A LETTER FROM DONNA

When you think of Donna Karan, you don't exactly think color. Why would you? I'm known for black—I dress in it, I design in it, I even live in it. (My city home is black; my beach house, white.) Yet the truth is, color is one of my greatest passions.

First and foremost, I see people as color—each uniquely beautiful and individual. That's the main reason I design in neutrals. Black, white, taupes and shades create perfect backdrops for a woman or man's personality. Like a frame to a painting, neutrals ensure that the person is the first thing you see.

But I also love the literal form of color: the rainbow of hues that make up nature's universe. Color is the essence of emotion. It enlivens everything it touches. Depending on the particular tone, it can calm, energize or uplift your spirits. Walk down a grey city street and your eyes go straight for the luscious fruits and exuberant flowers of deli storefronts. Head to the beach and take in the soothing blues of water, the opalescent colors of shells. Look at a child and see her rosy cheeks, her happy crayoned drawings.

Finally, color is life. That's why I've embraced a bouquet of it for spring. I went for complexion-enhancing tones that flush the skin—nude, eucalyptus, sage, sky, cloud, petal. All are soft, sensuous colors that look good on anyone and, for the color-phobic, look great worn against white or black. (You didn't think I'd abandon black, did you?)

Of course, nothing says life more than the beginning of warm weather. It's the time of year we venture out of our homes and get to live in the open air. Which brings me to my other inspiration — air. There is nothing more essential to our well-being. Breathing, loving, laughing. The lightness of being. Laundered sheets hanging in the sea breeze. Rustling taffeta that speaks of movement. Cashmere gauze knits that wear like T-shirts. Double layers that secure and cushion without volume or weight.

To me, color and air symbolize life in all its glory. That's what these clothes are all about—liberation of the soul. They make you feel good the minute you put them on. You feel sensuous, womanly and completely yourself. Hopefully, that's exactly what you think of when you hear the name Donna Karan.

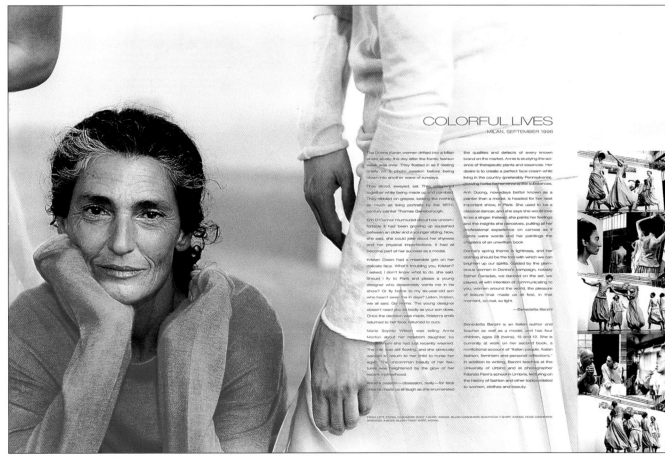

COLORFUL LIVES
MILAN, SEPTEMBER 1998

The Donna Karan women drifted into a Milan photo studio the day after the frantic fashion week was over. They floated in as if resting briefly on a photo session before being blown into another wave of runways.

They stood, swayed, sat. They whispered together while being made up and combed. They nibbled on grapes, looking like nothing so much as living portraits by the 18TH-century painter Thomas Gainsborough.

Erin O'Connor murmured about how uncomfortable it had been growing up squashed between an older and a younger sibling. Now, she said, she could joke about her shyness and her physical imperfections. It had all become part of her success as a model.

Kristen Owen had a miserable grin on her delicate face. What's troubling you, Kristen? I asked. I don't know what to do, she said. Should I fly to Paris and please a young designer who desperately wants me in his show? Or fly home to my six-year-old son who hasn't seen me in days? Listen, Kristen, we all said. Go home. The young designer doesn't need you as body as your son does. Once the decision was made, Kristen's smile returned to her face, returned to ours.

Marie Sophie Wilson was telling Annie Morton about her newborn daughter, Ivy Rose, whom she had just recently weaned. The milk was still flowing, and she obviously wanted to return to her child to nurse her again. The uncommon beauty of her features was heightened by the glow of her recent motherhood.

Annie's passion—obsession, really—for face creams made us all laugh as she enumerated the qualities and defects of every known brand on the market. Annie is studying the science of therapeutic plants and essences. Her desire is to create a perfect face cream while living in the country (preferably Pennsylvania), growing herbs for her mineral-like substances.

Anh Duong, nowadays better known as a painter than a model, is headed for her next important show, in Paris. She used to be a classical dancer, and she says she would love to be a singer. Instead, she paints her feelings and the insights she perceives, putting all her professional experience on canvas as if colors were words and her paintings the chapters of an unwritten book.

Donna's spring theme is lightness, and her clothing should be the tool with which we can brighten up our spirits. Guided by the glamorous women in Donna's campaign, notably Esther Canadas, we danced on the set, we played, all with intention of communicating to you, women around the world, the pleasure of leisure that made us all feel, in that moment, so real, so light.

—Benedetta Barzini

Benedetta Barzini is an Italian author and teacher as well as a model, and has four children, ages 28 (twins), 15 and 12. She is currently at work on her second book, a nonfictional account of "Italian people, Italian fashion, feminism and personal reflections." In addition to writing, Barzini teaches at the University of Urbino and at photographer Fabrizio Ferri's school in Umbria, lecturing on the history of fashion and other topics related to women, clothes and beauty.

FROM LEFT: CORAL CASHMERE BODY T-SHIRT, $9000; BLUSH CASHMERE BOATNECK T-SHIRT, $10000; ROSE CASHMERE SWEATER, $18000; BLUSH TWIST SHIRT, $21000.

SEA BREEZE

Warm weather arrives and you're down by the water—in spirit, if not in body. These barely-there blues, with names like sky and cloud, capture the serenity of open skies and clear blue water. Airy linens, featherweight organdies and gauzy knits underscore the feeling in easy proportions that gently swirl around the body. SMOCKED DRESSES and PANELED or RIBBON SKIRTS have a movement all their own. Wear blue tonally, splash it with white or ground it with navy. It's a look that inspires motion and lightens the spirit, just like an ocean breeze.

PREVIOUS PAGE LEFT: CLOUD BLUE CASHMERE BOATNECK, A19300, CLOUD BLUE CASHMERE TANK, A19002, CLOUD BLUE/SKY PANEL SKIRT, A19131, SKY STRAPLESS TUCKED DRESS, A19723, SKY DOUBLE CARDIGAN JACKET, A19319. PREVIOUS PAGE RIGHT: CLOUD BLUE CASHMERE BOATNECK, A19300, CLOUD BLUE CASHMERE TANK, A19002, CLOUD BLUE/SKY PANEL SKIRT, A19131. OPPOSITE PAGE: CLOUD BLUE CASHMERE BOATNECK, A19300, SKY JERSEY TANK, A19228, SKY/CLOUD BLUE ORGANZA/CHIFFON RIBBON SKIRT, A19103. THIS PAGE: FROM LEFT, SKY/CLOUD BLUE SMOCK DRESS WITH COTTON JERSEY LINING, A19732L, SKY TAFFETA CREWNECK TWIST DRESS, A1976, CLOUD BLUE CASHMERE BOATNECK, T-SHIRT, A19000, CLOUD BLUE/SKY PANEL SKIRT, A19131, CLOUD BLUE CASHMERE BOATNECK, T-SHIRT, A19000, SKY JERSEY TANK, A19228, SKY/CLOUD BLUE ORGANZA/CHIFFON APRON SKIRT, A19112L, SKY LINEN WITH CASHMERE SLASHNECK, SWEATER, A19030, SKY SILK/LINEN DOUBLE SKIRT, A19123.

the publication from the get go. Said Laird, "You'll get a voice mail from Donna in the middle of the night, "I was just thinking about *Woman to Woman…*"

Her thoughts, it seems, were virtually nonstop. Ideas for everyday. Ideas for special situations. This is the essential quality of **BRAND CONCEPT MANAGEMENT**. Donna Karan was building brand equity by making her philosophy a complement to her customers' values and attitudes.

The Spirit of a Woman, a book of photographs by Peter Lindbergh is sensuous, some might say even spiritual. The unbelievably beautiful book came about for a couple of reasons. "Donna has always been a big promoter of women, and the strength women have, all different women," said Laird. "When we were going over the pictures from the shoot, someone said 'this really captures the spirit of a woman,' and we thought we should put them all in a book. Donna said, 'Absolutely, that's what I want to do!'"

According to Laird, books of this scale are done only once every few years when "she wants to do something really special, something out of the box." To those who have seen *The Spirit of a Woman,* that's an understatement. It's belongs on a coffee table. Permanently.

Donna Karan, New York, NY
CHIEF DESIGNER & CHAIRMAN OF THE BOARD: **Donna Karan**
AGENCY: **In-house**
EXECUTIVE VICE PRESIDENT OF CREATIVE SERVICES: **Trey Laird**
CREATIVE DIRECTOR: **Trey Laird**
ART DIRECTOR: **Hans Dorsinville**
COPYWRITER: **Kathleen Boyes**
DESIGNER: **Christopher Twele**
FASHION DIRECTOR: **Lynn Kohlman**
PHOTOGRAPHER: **Peter Lindbergh,** Paris
PRINTER: **George Rice and Sons,** Los Angeles, CA
RETOUCHING AND SEPARATIONS: **Brunel Industries**

The book has a foreword by the late Liz Tilberis, who was a close friend of Donna Karan. *The Spirit of a Woman* (52 pages, 11" x 14") is available at Rizzoli bookstores in eight different markets. All proceeds benefit the Ovarian Cancer Research Fund, which the late *Harper's Bazaar* editor-in-chief headed.

The "Spirit of a Woman" may have contributed as much to long term customer loyalty as the spirit of that season's Donna Karan Collection.

FROM ONE WOMAN TO ANOTHER

DONNA KARAN'S CLOTHES ARE ALL ENCOMPASSING APPEALING TO WOMEN OF EVERY AGE SIZE AND WALK OF LIFE AS YOU WILL SEE FROM THE PHOTOGRAPHS IN THIS BOOK THERE IS POETRY TO THE EASE AND FLOW OF DONNA'S CLOTHES, TO THE SUBTLETY OF HER COLOR, TO THE FEEL OF HER FABRIC THERE IS AN AURA OF SENSUALITY AND WONDER THAT SURROUNDS HER DESIGN DONNA KARAN, THE DESIGNER HAS AN AMAZING ABILITY TO MIX COMFORT WITH A WONDERFUL FEMININITY SO THAT — SIMPLY BY WEARING HER CLOTHES — ONE FEELS THAT SHE HAS BEEN BLESSED WITH ROMANCE HER CLOTHES ALSO MAKE A WOMAN FEEL CONFIDENT AND COMFORTABLE IN HERSELF WHILE STILL EXPRESSING DONNA'S ENORMOUS LOVE OF FASHION

THE MOST FASCINATING THING HOWEVER IS THAT DONNA'S CLOTHES RELY ON THE WOMAN TO COMMUNICATE A MESSAGE SHE IS LEFT TO MAKE HER OWN PERSONAL STATEMENT THERE IS NOTHING I FIND MORE SATISFYING OR MODERN THAN THAT

DONNA KARAN, THE WOMAN IS A CONSTANT IN MY LIFE AND BELIEVE ME ONCE THE FOCUS OF HER ATTENTION SWINGS YOUR WAY YOU'RE NEVER FORGOTTEN OR LEFT OUT THERE IS ENDLESS SUPPORT AND CONSIDERING THE MILLIONS OF THINGS SHE DOES HER FOCUS IS TRULY AMAZING DONNA HAS BEEN A HUGE SUPPORTER OF THE OVARIAN CANCER RESEARCH FUND THE ORGANIZATION FOR WHICH I SERVE AS PRESIDENT SHE HAS COMMITTED TIRELESS ENERGY TO HELPING US RAISE MONEY THROUGH EVENTS AND SPECIAL PROJECTS AND HER GENEROUS SPIRIT HAS ENABLED US TO REACH OUT TO WOMEN ABOUT A DISEASE THAT STRIKES OFTEN WITHOUT WARNING OR CAUSE

THE SPIRIT OF A WOMAN IS ONE OF DONNA'S MANY BIG-HEARTED CREATIONS ITS PROCEEDS WILL BE DONATED TO THE OVARIAN CANCER RESEARCH FUND

I THANK DONNA FOR BEING A FAITHFUL CONSTANT IN MY LIFE AND FOR POSSESSING A PURE DIRECT VISION AND AN INVIGORATING EXUBERANT ENERGY THAT PERMEATES EVERYTHING THAT SHE DOES

LIZ TILBERIS
JANUARY 1999

LIGHTNESS OF BEING

THIS BOOK CELEBRATES THE
APPRECIATE THE BEAUTY OF

IT BEGINS WITH A BOUQUET
FLOWERS IN STORE FRONTS T
SKY AND WATER AND OF CO

EVERYTHING I DO RELATES
PHOTOGRAPHED BY THE AMA
BECAUSE WHO HAS EVER MET
YOUR BODY WHAT YOU FEEL IN

ONE CAN'T CELEBRATE THE E
NEVER HAVE TOO MUCH OF
FEATHERLIGHT CASHMERE G
THAT PULL ON AND OFF WITH
NOBODY WANTS TO BE WEIGH

WE ALL SEEK THE LIGHT — THE STATE OF BEING UNENCUMBERED, ENLIGHTENED, AN INSPIRED WAY OF LOOKING AT THE WORLD IT IS THE PROMISE OF A NEW DAY, A CHANCE TO RENEW OUR VISION LIGHT ILLUMINATES HUMANITY A LOVER'S SMILE, A SHARED LAUGH ENTWINED HANDS TO SEEK LIGHT IS TO LOOK FOR THE BEST IN OTHERS, AND IN THE PROCESS, FIND THE BEST IN YOURSELF LIGHT ALLOWS THE SPIRIT TO SHINE

NO ONE SHINES BRIGHTER THAN LIZ TILBERIS LIZ RADIATES OPTIMISM AND WARMTH TRANSFORMING EVERYONE SHE MEETS A MOTHER, AN EDUCATOR, A COMMUNICATOR, A LEADER LIZ NOW SHEDS LIGHT ON THE BATTLE AGAINST OVARIAN CANCER AN INSIDIOUS DISEASE THAT THREATENS WOMEN EVERYWHERE IT IS A PRIVILEGE TO CALL LIZ MY FRIEND SHE IS THE CONSUMMATE ROLE MODEL —ONE OF THOSE RARE INDIVIDUALS WHO REACHES OUT AND MAKES A DIFFERENCE LIZ IS AN INSPIRATION TO US ALL

DONNA KARAN

BodyCULTURE catalogs were distributed in the stores and to a top customer list, Careaga estimated at around 40,000 worldwide. The U.S. portion had grown beyond the initial 5,000.

The American Plan

- Attributes Branding
- Commitment Branding

BRANDSTANDS

LONG KNOWN as a European hosiery company, Austria-based Wolford had its eye on America. Although this manufacturer of hosiery, bodywear and swimwear had more than 240 boutiques in 16 countries, until the late 1990s it had had very little visibility in the U.S. Wolford set out to change all that. "We plan to expand our retail presence throughout the country," said Ellen Careaga, CEO of Wolford Boutiques, the retail arm of Wolford America.

In 1999 Wolford acquired nine boutiques in the U.S. from the company that had pioneered developing the brand here in late 1990.

Acquiring the boutiques was a vital component of a larger retail development plan for the U.S. Wolford's objective was to expand the number of company-owned boutiques and to develop additional independent boutiques through retail licensees. A related objective was to expand wholesale distribution. Wolford products appeared in specialty and department stores that included Neiman Marcus, Saks Fifth Avenue, Bergdorf Goodman and Holt Renfrew.

The company was always breaking new ground in the area of product innovation. Beginning in 1999, it launched its first full-scale lingerie line, the bodyCULTURE collection of lingerie and hosiery. Another innovative concept, developed in conjunction with Philip Starck, was StarckNaked, a multifunctional garment which can be worn in a variety of ways.

Irrespective of the type of product, Wolford went to extreme measures to **ensure the** ATTRIBUTE **of quality. The company's motto is "devoted to women," any woman who values quality.** Careaga described the company as practically obsessive about maintaining its standards and its **COMMITMENT** to the customer. "More than 15% of production time is for quality control and the number of times they examine a product. They even unwrap it when it's already in the package to examine it again," she pointed out. Hosiery, which is made by hand, typically retails for $38 to $42.

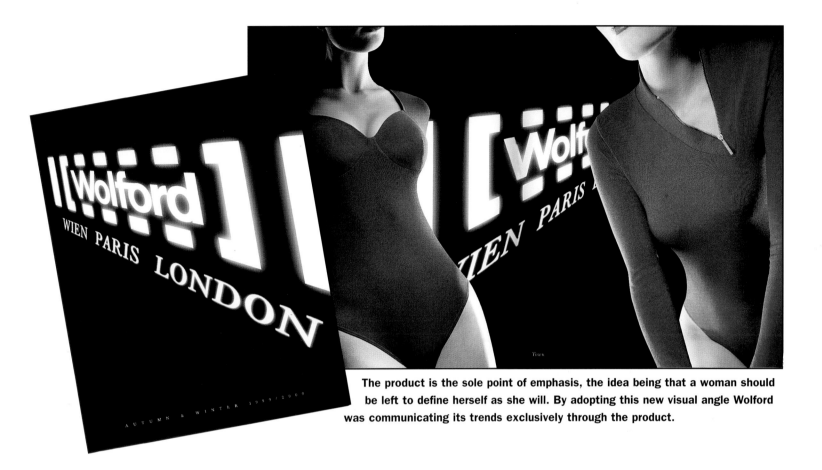

The product is the sole point of emphasis, the idea being that a woman should be left to define herself as she will. By adopting this new visual angle Wolford was communicating its trends exclusively through the product.

The company's strategy for growth also included changes in its advertising. According to Careaga, they were moving into more direct marketing and co-op advertising. There was also a shift in creative focus. Personalized images of models—the face, the styling, the accessories, even the body itself in the case of hosiery shots, was sometimes taken away, giving way to a freedom in which the product alone was the focal point.

This **change in image** had evolved over the last few years, and at each juncture the production values were exceptional. All of the work was done in house in Austria, including the photography. "They're an amazing group," said Careaga.

"We do a media mix of direct mail and print, 70 to 30 in favor of direct mail. The amount of advertising we do will probably grow as the number of stores grows," she said. The advertising schedules often include the *New York Times*, *Chicago Tribune*, *Town and Country*, *Hampton*, *Mode* and *Ocean Drive*.

The company also employed newspaper inserts, inserted regionally in New York and Los Angeles, with Chicago as an addition.

An important element in the direct-mail program had been "Welcome to the World of Wolford," an extravagant showcase for both the product and the stores. "They do it every year," said Careaga. "We've sent out over 50,000 worldwide, plus distribution to stores."

Closer to home was the Wolford catalog that was distributed to over 65,000 customers worldwide. The U.S. version of the materials were in English only whereas the international pieces are multilingual. "We tailor some of what to use in the U.S.," Careaga explained. "We did a version of it for the U.S. to include basics as well as what the new trends are."

Wolford gets a lot of mileage out of its stunning photographs. The images in this mailer were picked up from the Spring-Summer 1999 catalog.

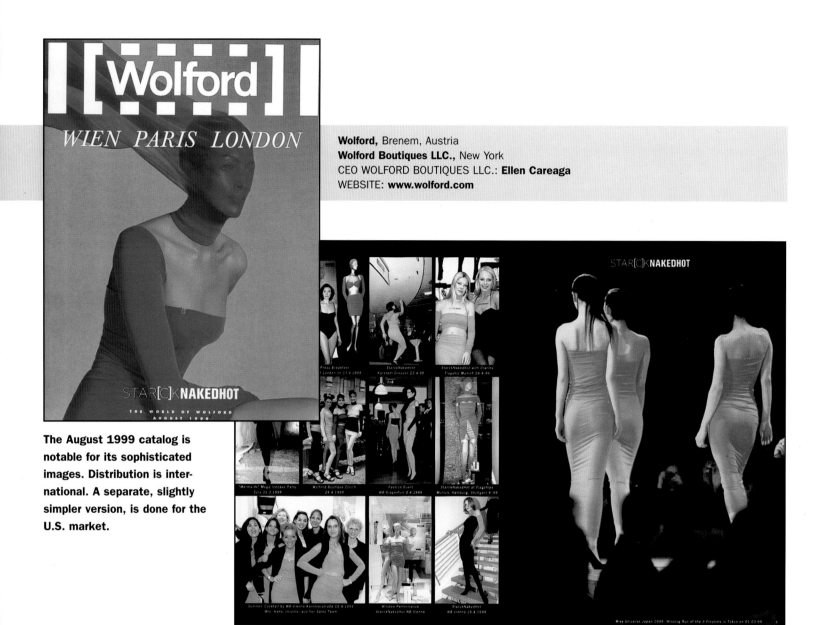

Wolford, Brenem, Austria
Wolford Boutiques LLC., New York
CEO WOLFORD BOUTIQUES LLC.: **Ellen Careaga**
WEBSITE: **www.wolford.com**

The August 1999 catalog is notable for its sophisticated images. Distribution is international. A separate, slightly simpler version, is done for the U.S. market.

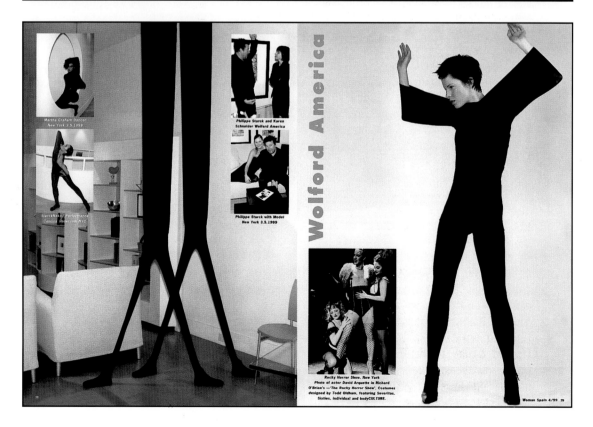

Growing Younger

Trinity Rings. The collection from $575.
www.cartier.com - 1-800-cartier

Magazine ad showcasing trinity rings.

THE HOUSE OF CARTIER, founded in Paris in 1847, is one of the world's leading luxury-goods companies and has served as crown jeweler to 19 royal houses. It designs, manufactures and distributes all of its own products.

Part of the jewelry's appeal comes from **BRAND ASSOCIATIONS**—the symbolism associated with the pieces. One of the most famous items available at Cartier is the trinity ring created by Louis Cartier in honor of his friend, French playwright Jean Cocteau. The white gold represents friendship, the yellow gold loyalty and the pink gold love. The success of these pieces was due to the history of the pieces and legends people can relate to.

Like many long established retailers, Cartier was seeking new customers. Their **BRAND IMAGE POSITIONING** strategy began with creating new collections that would appeal to a new, younger customer. "The Collection Paris Nouvelle Vague and the 21 Chronograph, demonstrate Cartier's passion for innovation," maintained Nathalie Guedj, the company's Vice President of Marketing, who was responsible for the implementation of brand strategy, product and communications In the U.S. and Canada. Many of the pieces in the Nouvelle collection were designed to be worn by Cartier's **primary target customer,** the 35-to-55 year old woman. The **secondary target** was women in their 20s and 30s who are very aspirational and trendy.

The Collection Nouvelle Vague was launched worldwide in June 1999. It was inspired by the artistic elements that make Paris unique—such as cobblestone streets and the Eiffel Tower. "The images are extremely seductive and because of its strength we made the decision to advertise only in the major fashion books: *Vogue, Harper's Bazaar, Elle* and *W*. We ran one to four pages per book," said Susie Weisinger, president of Plaza Advertising, the jeweler's in-house agency. "The Nouvelle Vague is visually so strong a collection that you think you've seen it more often than it has actually run."

The other new collection, 21 Chronograph, was targeted to younger customers. The secondary customer for the watch was the existing Cartier customer who wants a leisure or weekend watch. "Men are buying watches much more actively today," Weisinger explained. "As Tim Braun of Neiman Marcus said: "It is not unusual for a man to have a collection of four to five watches. It's their equiv-

- Brand Associations
- Brand Image Positioning

BRANDSTANDS

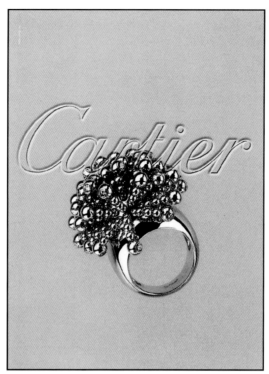

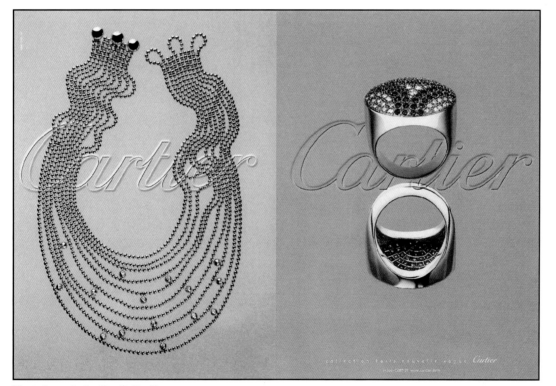

Magazine ads for the Collection Nouvelle Vague.

alent of a bracelet, the one piece of jewelry that is acceptable across the board."

When it came to advertising the new collections, Cartier drew upon what has worked for any number of collections for the past few years—the visual anchor that is its logo. **"Our real strength at Cartier is our logo—everyone can identify with it," said Weisinger. "Our goal is for everyone to associate it with him or herself."**

In the mid '90s Cartier introduced a new advertising concept that featured only the Cartier logo and a product, which are inter-

twined, the idea being that the Cartier name says it all, insofar as copy is concerned.

While it has continued to evolve, the advertising was still based on the customer's concept of the Cartier brand name in everything from high-end jewelry to pens. The objective was to convey that the brand has a spirit of innovation and modernity.

The initial campaign, in which the logo and the product were shown on a white background, has never been changed completely; it continued to evolve. The next year, color came into play. Since then, with certain tweaking, the advertising kept the same feel. "We choose specific photographers for specific product categories," Weisinger explained. "Pierre Rainero in Paris gives the direction. That's the unifying thread."

For Cartier, using the logo as a strong graphic element has been a given. What was changing though was that having secured their position in the upscale market, the company was now **trying to capture a share of the next tier:** the aspirational twenty- and thirty-somethings.

Cartier concluded that there was a real opportunity to **target different segments** of the population. In addition to its traditional consumer—men and women 35 to 55 years old. The company had done focus groups to learn what the Cartier woman wants. "What we found out is that today's woman purchases luxury products as a reward for herself. She's saying to us, "I'm not waiting for some-

Cartier, (USA), New York
VICE PRESIDENT OF MARKETING: **Nathalie Guedi**
AGENCY: **In-house) Plaza Advertising**
PRESIDENT: **Susie Weisinger**

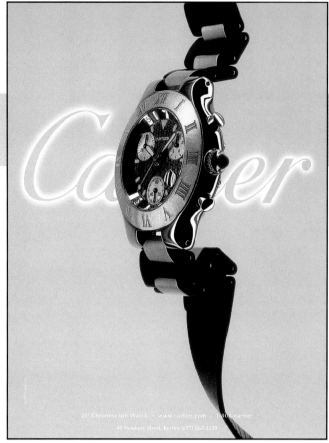
Magazine ad for 21 Chronograph.

one to buy me that special piece of jewelry or bag. I'm buying my own bags and jewelry," said Weisinger. "This is something that goes across all age ranges."

As an experiment, to see how it would play with a younger market segment, Cartier added to its media mix by producing a :30-second television spot. It ran on the season's finale shows of "Will and Grace," "Frasier" and "Friends" and on the E-channel as well as on local stations in San Francisco.

In addition to its regular advertising, Cartier produced a catalog every year, which was distributed in all the Cartier boutiques worldwide. The boutiques sent the catalog to all of their customers.

It's an ambitious and impactful program, yet as Weisinger was quick to point out, the jewelry arena is overcrowded. "All the prestige brands are fighting for the same back cover in the luxury magazines. It's become much more challenging to stand out today. Creatively, we are in a new generation of advertising, it is fascinating when you think about the computer effects you can use today as you're creating an ad.

On the business side of things, media buyers have become very savvy. Media buying has become a scientific process with an element of guesswork attached to it. There are now fabulous opportunities in each new crop of magazines that has come in. They go after the young trendsetter and figure out what they're wearing and buying on their own and who will not be dictated to. As an advertiser, you have to be aware of these more narrowly targeted publications and to know when to get in on the ground floor in order to negotiate better rates with the publications the twenty- and thirty-somethings are reading."

Through it all, Cartier appeared to have its finger on its brand concept management. It continued to prevail with an impactful **BRAND IMAGE POSITION** that was growing, not only in terms of styling, new customers and new media. It also updated its physical store image. The New York Fifth Avenue flagship store was totally overhauled and expanded!

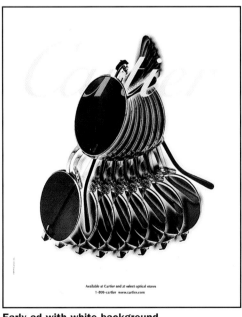
Early ad with white background.

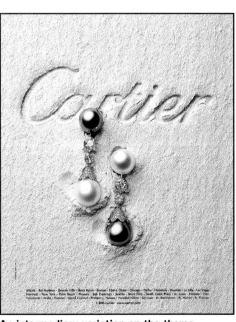
An intermediary variation on the theme.

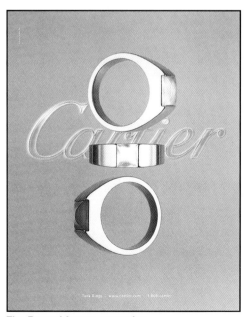
The Brannd Image campaign.

U.S.P.s for BUILDING BRANDS

- **Unique Selling Proposition...**
 developing a product difference

- **Unique Styling Persona...**
 positioning the customer

- **Unique Service Personality...**
 Evaluating LTCV —
 LifeTime Customer Value

- **Unique Strategic Positioning...**
 Building positive perceptions that
 competitors can't match

Manufacturers

Survival of the Fittest

PEOPLE TALK ABOUT CONFUSION in the workplace—and they don't mean just the vicissitudes of the new economy, ensuring e-mail privacy, or how to download the latest software. There's also confusion about what to wear. For men particularly, it's hard to know what's suitable anymore as business casual takes on different meanings in different types of workplaces.

And consumers aren't the only ones in a quandary. Today, everyone's still in a flurry over how to deal with the casual Monday to Friday. At the same time, corporations are attempting to rewrite dress codes toward less traditional dress, manufacturers are attempting to rework their lines, and retailers are seeking to strike the right balance, as sales of tailored clothing fluctuate in proportion to the on-going interest in business casual.

a product, they started looking around to get some ideas about how best to do it.

Knowing the customer is understanding the customer's experience with your product category. The Hart Schaffner & Marx brand cuts through the man's "confusions about what to wear." **It positions the brand experientially** as a "wardrobe consultant" who provides information he can use to fix his attire.

Other parties were looking for ideas too. *Esquire* magazine for one. According to Jerry Marxhausen, HS&M senior vice president, *Esquire* was interested in getting input from the company about the casual dressing situation for their own editorial. "We said we're thinking of doing that ourselves," says Marxhausen. "Originally we were looking to do a direct mail piece to our retail base to reach their consumers. Then we thought we could take it to the national level on top of the in-store effort. The October 2000 issue would the be perfect time!"

Hart Schaffner has an in-house agency that, together with an outside photographer, had already done a great deal of the creative work on a piece for their retailers. Marxhausen explained that the end result of that effort, an 18-page advertorial in *Esquire's* pivotal October 2000 issue, was actually a compilation of ideas from their own people, the photographer and *Esquire's* help from an editorial standpoint.

"The special section, "Survival of the Fittest," was a guide to suitable attire for the new economy that presents humorous, irreverent slices of corporate life, along with detailed information for how to dress well at

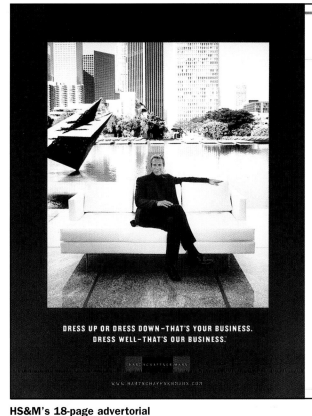

HS&M's 18-page advertorial in *Esquire* "deciphered" the what-to-wear-to-work dress codes that were causing men some concern at the closet.

One apparel company, Hart Schaffner & Marx, made a major contribution toward making sure everyone gets it "right." The vehicle was an inspired advertising and marketing campaign for its tailored clothing at both the national and retail levels.

Long before Hart Schaffner got the word out, the company had been doing its homework—in the workroom. With the product line in place, and knowing that they needed to market an attitude as well as

work. "We wanted to take it off the highbrow shelves and bring it down to reality," said Marxhausen.

The campaign fulfilled two objectives—to target a younger customer (while holding on to the traditional one) and to support retailers in targeting corporations struggling with changing dress codes. "We were trying to posture apparel in a more comfortable and more easily understood role in the minds of the retailer and the consumer," he noted. The notion of

These spreads also ran as ads in the *Wall Street Journal* every week for four successive weeks in October 2000.

"dress up, dress down, dress well," is to convey a younger, more modern attitude, yet still relate to that man who wants to wear a tailored suit or a sport coat with different pants.

The consumer's **BRAND ASSOCIATIONS** are closely related to his values and attitudes about business dress. Hart Schaffner & Marx is associating their brand with an emerging attitude of their customer base and a younger customer segment—

casual comfort can co-exist with mix or matched tailored apparel.

In addition, starting the first week of October, an ad was run in the *Wall Street Journal* every week for four weeks. The ad encouraged people to log onto the website. "The response blew us away!," said Marxhausen.

Another key element of "Survival of the Fittest" was a direct mail campaign to retailers for the pur-

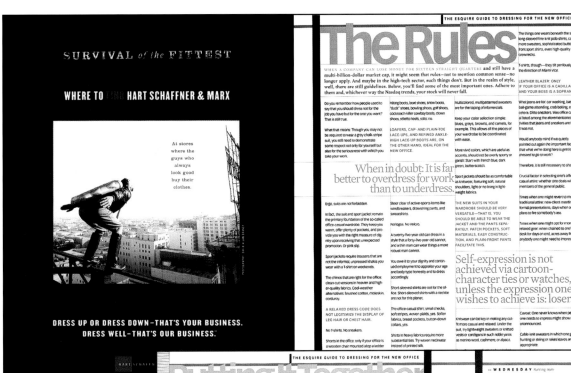

Here is B to B and then B to C brand awareness through IMC in action ... Hart Schaffner was using Integrated Marketing Communications in this co-branding strategy with *Esquire*.

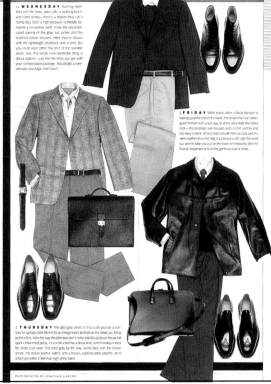

pose of their promoting the idea of casual dressing to their customers. "Fifty copies of the *Esquire* piece in a Plexiglass tray with a letter from me went to every single door that carries Hart Schaffner & Marx," said Marxhausen. "For Dillards, that was 300 stores alone!" With the letter were three photos that could be supplied as posters mounted on foam core. It was suggested that the retailer use those posters as focal points for display. Additionally, if in their market they wanted to use the *Esquire* piece as the focal point at seminars with local organizations, Hart Schaffner would furnish any materials free. "We've had tremendous response from all over the country," said Marxhausen. "We've sent out tens of thousands of reprints. The retailers said the point-of-sale posters and hand-out piece made them look professional."

Here is **BRAND CONCEPT MANAGEMENT** that uses an **integrated mix** of: national advertising; co-op advertising for newspaper, direct mail and outdoor; B-to-B advertising; magazine advertorials; point-of-purchase; and visual merchandising displays.

This is **SPIRAL BRANDING**. It insures that the target customer gets a message that is reinforced throughout his pre- and post- purchase experience.

Indeed, the program covers all the bases. The company is also offering retailers the opportunity to increase impact and customer awareness by participating in co-op advertising. Both print ads and billboards that can be tagged with the store name are being made available.

Clearly, there was nothing casual about this program!

Hart Schaffner Marx, Chicago
PRESIDENT: **Richard Biegel**
SENIOR VICE PRESIDENT: **Jerry Marxhausen**
DIRECTOR OF ADVERTISING: **Linda Monty**
AGENCY: **In-House**
WEBSITE: **www.hartschaffnermarx.com**

Stepping Out

Thanks for the memories… Keds has the advantage of good **BRAND ASSOCIATIONS** with fun, relaxed, comfortable times. Building on their strong brand equity, Keds changed its merchandise and marketing communications direction.

AFTER 85 YEARS with a firm toe-hold on the classic white sneaker market, Keds was expanding its product line—and enhancing its image accordingly. The question was, when you have a product that's practically a commodity, why fix it if it ain't broke?

Keds had been influenced by the fact that fashion had been moving in a more casual direction, with casual Fridays spilling into the rest of the work week. As corporate dress codes became accepting of dressing down, many working women were shedding their pumps and pantyhose for casual shoes.

According to Terri Rawson, VP, marketing, Keds was responding to today's women by taking the brand beyond what is still primarily a seasonal warm-weather shoe into other casual shoes with year-round appeal. "Looking at Keds' past, **it's amazing what an emotional attachment women have with the brand.** The product with its little blue label is typically **associated with warm weather, spring and summer, wonderful things and very wonderful memories.** We've always done great sneakers, but when you look at the casual workplace there's a **huge market opportunity to evolve the brand and its image."**

Keds management sat down and reflected on who Keds is and how it could respond to casual styling women want today. The challenge was to create fashion-right styles while staying true to the brand's heritage. The result was a new line of casual footwear in a variety of styles and colors that can be worn **"every wear."**

Can you have a foot in both camps successfully? Rawson stated, "The consumer thinks of Keds as seasonal—primarily as a warm-weather sneaker. Our new product strategy is a year-round proposition, and the consumer will be able to consider Keds as a casual footwear option every day. **The marketing challenge is to force a reassessment of the brand without disconnecting the consumer.** We need to deliver a compelling message, one that will **inspire the consumer to think differently about Keds, yet remain believable for the brand."**

Right on the heels of the new **BRAND**

- Brand Associations
- Brand Image Positioning

BRANDSTANDS

POSITIONING, therefore, was a new advertising campaign. The first work for the brand from Toth Design and Advertising, the copy theme, **"Keds Every Wear,"** was more than a play on words. It **communicates the new all-occasion positioning**—that Keds is a brand to be considered for any casual wearing situation 365 days a year.

The creative strategy was to use a visual story to deliver the new fashion-relevant brand message and support the brand's expansion. It was important to convey a message that every woman could relate to, making the ad image not only accessible but attainable, since part of Keds' image is that it's a brand that is attainable. Key to executing the strategy was selecting comfortable settings with familiar surroundings that every woman can identify as somewhere she's either been or visualized.

Considerable attention was paid to casting models who didn't project an idealized form of beauty or who were immediately associated with a particular age. "Since we are really relevant to all women, we needed to put an image out there that any woman could feel comfortable looking at," Rawson explained.

"We had to create a compelling, visual story that communicates the brand's fashion relevance while remaining true to the Blue Label's heritage. In short, we had to deliver a new brand message without alienating our core audience, which can be very tricky."

The images had been compiled into ministories. They were running as two and three page consecutive spreads in fashion and lifestyle magazines such as *Glamour, InStyle, Marie Claire* and *Martha Stewart Living.*

Keds broke with marketing tradition when it launched the new campaign. Rather than follow the usual route taken by apparel companies, which traditionally break their new campaigns for spring in March issues of magazines, Keds passed on strutting its new stuff in the jam-packed March issues. "We wanted to make sure everyone saw the ads!" Rawson exclaimed. "Waiting for the April books has worked very well for us."

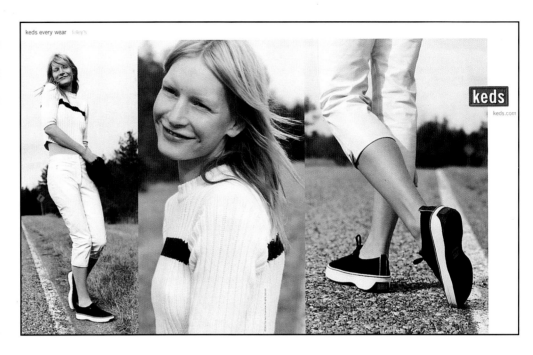

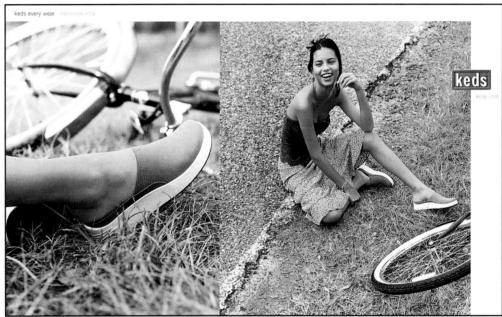

Brands that have survived through many generations must continually evolve if they want to remain relevant to the ever changing consumer. Keds' **BRAND IMAGE RE-POSITIONING** campaign has helped the consumer view their shoes as "every wear" for "all occasions"—more than warm weather wear.

The Keds Corporation, Lexington, MA
VICE PRESIDENT MARKETING: **Terri Rawson**
ADVERTISING AGENCY: **Toth Design and Advertising,** Concord, MA
STYLIST: **Polly Allen Mellen,** New York
PHOTOGRAPHER: **Regan Cameron,** New York

Tested Tough

F OUNDED IN 1938, Columbia Sportswear Company had grown from a small regional hat distributor to become one of the world's largest outerwear brands and the leading seller of skiwear in the United States. More than 10,300 retailers in 30 countries distributed its products.

In 1970, when her husband who was then president of the family's business, suddenly died, Gert Boyle (the 77 year-old matriarch and Chairman of the Board) enlisted help from her son Tim, then a college senior. Together they led the company from near bankruptcy to a world leader in the active outdoor apparel industry.

> Columbia Sportswear products do what they say they do—my mother wouldn't lie! **ATTRIBUTES BRANDING** has built belief in this brand with a sense of humor.

That grit and determination continued to play out, albeit in an altogether different way, shortly after Columbia hired a small advertising agency, Borders Perrin Norrander, to create a campaign **promoting the technical features of its products.** Subsequently, the company asked the agency to come up with a new **BRAND POSITIONING CAMPAIGN**—one that would **sell merchandise and help build long-term equity in the Columbia Sportswear name.**

The rest is history.

The company's Mother Boyle ad campaign with its tough mother image had, like Gert Boyle herself, been running strong since 1984. While the look of the campaign had evolved over the years, the message remained the same: "Mother Boyle makes tough products that get you outdoors."

The funny, offbeat TV advertising starring the Boyles characterized Mother Boyle as a testy taskmaster with incredibly high standards. The ads featured "Mother" practically having son Tim jump through hoops to test the versatility and toughness of Columbia garments. This **uniquely quirky campaign brought widespread attention to the company and continued to anchor its marketing program.**

As a result, Mother herself became a bit famous. According to Jack Petersen, Borders Perrin Norrander director of client services, her character had been created so large, it had assumed almost mythical proportions. "The campaign frequently elicits questions as to does Mother Boyle really exist? Is she as the advertising portrays her? Will she ever retire? The answer

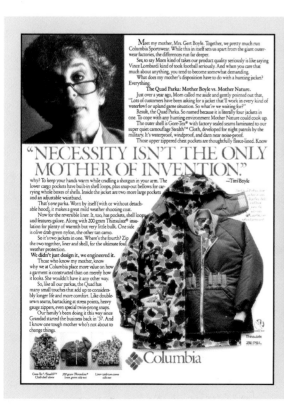

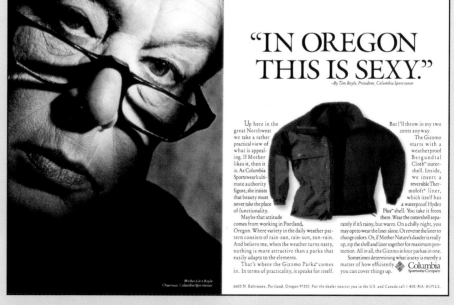

1984 (left). The campaign in its infancy (Gert was younger too). From the Fall '92 campaign (above)—more copy than currently but no less tough.

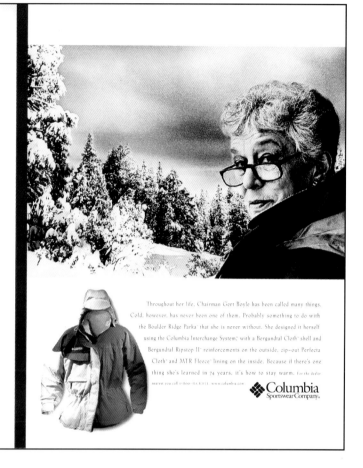

FRIGID PERHAPS.

COLD NEVER.

The current campaign has made a subtle shift toward lifestyle—sometimes putting Mother Boyle in an environment; other times with an action shot.

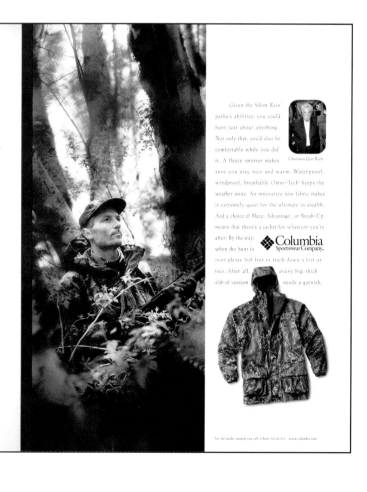

IF YOU'RE A VEGETARIAN YOU CAN USE IT TO SNEAK UP ON CELERY.

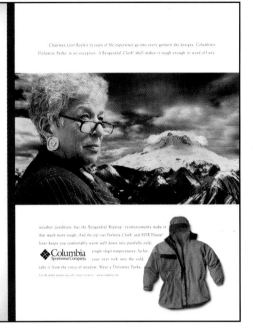

WHEN YOU
ARE AS OLD AS
THE HILLS,

YOU TEND TO
KNOW WHAT
TO WEAR
IN THEM.

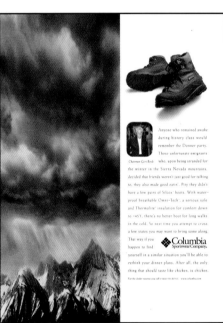

THREE
REASONS TO
OWN A
GOOD PAIR
OF WINTER
BOOTS.

1) THE. 2) DONNER. 3) PARTY.

TWO ZIPPERS
UNZIPPED
MAKES YOU
COOL AND
COMFORTABLE.

THREE
MAKES YOU
A PERVERT.

to the first two questions was 'yes.' As for the third, she's 77 years old. Will she ever retire? Sure when hell freezes over, but that's when we'll need her most!"

The print ads ran in a mix of consumer books that included *Sports Illustrated, Glamour, GQ, Men's Journal, People, Rolling Stone, Sierra, Family Life, Snowboarder, Working Mother* and *National Geographic Adventure* as well as various hunting publications.

The schedule for the TV spots, in which Mother Boyle and son Tim demonstrate the toughness of Columbia Sportswear's products, was a combination of cable (MTV, VH1, ESPN), and network with a spot overlay in northern tier markets. The network buy was primarily late night to reach the important 18-34 young male audience.

Columbia Sportswear had mastered the art of communicating **lifestyle and lifestage** messages. Action-ready mother and son exemplify the **BRAND IMAGE POSTITIONING** and the value of their "tough wear" products and the adventurers who wear them.

The ads were seen in many different languages by people all over the world. **Although their distinctly American humor sometimes had to be altered to fit some foreign markets, the message that "mother's looking out for you" were understood by everyone.**

The company ran about 10 to 12 new print ads each year, with the split between print and TV about equal. Outdoor advertising accounted for approximately 10-15% of the budget.

While Mother Boyle's tough mother image continued to play out in all kinds of amusing ways, subtle changes were nevertheless taking place in the campaign. "It's a little bit more aspirational," said Dan Hanson, director of marketing. "We've started to **infuse the campaign with more lifestyle action images,** along with putting Gert in the **lifestyle environment.** It was a very subtle shift.

Another factor in the campaign's evolution was that with the success of the company's footwear and sportswear lines in the spring and summer months, a larger proportion of its creative and spending was gradually moving toward spring-summer.

Everyone was curious to know more about Gert Boyle. After all, she was 77 years old. Did she come to work or was she just some kind of figurehead whose involvement was confined to showing up on the set for shoots?

Hanson set it straight. "She's here every day that she's not traveling. And if she is traveling, she's on company business. She's 24/7 365 days a year!"

That's taking the brand's **U.S.P.** to heart.

SHE'D GLADLY RETIRE WHEN HELL FREEZES OVER, BUT THAT'S WHEN WE'LL NEED HER MOST.

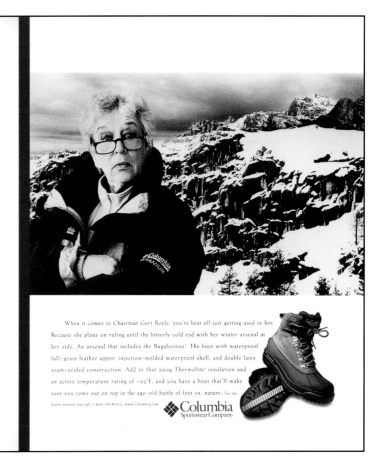

When it comes to Chairman Gert Boyle, you're best off just getting used to her. Because she plans on ruling until the bitterly cold end with her winter arsenal at her side. An arsenal that includes the Bugabootoo. The boot with waterproof full-grain leather upper, injection-molded waterproof shell, and double latex seam-sealed construction. Add to that 200g Thermolite insulation and an active temperature rating of -25°F, and you have a boot that'll make sure you come out on top in the age-old battle of foot vs. nature. For the dealer nearest you call 1-800-MA BOYLE. www.columbia.com

Columbia Sportswear Company.

"Sled Dogs"

Once again, Tim endures harsh elements and his merciless mother to illustrate the authentic outdoor qualities of Columbia Sportswear's products. Mother Boyle throws son Tim to the dogs to test the warmth and durability of Columbia's Ballistic Parka. Filmed in the Cascade Mountains with a team of sled dogs, Tim was repeatedly buried in the snow for hours in order to get the perfect shot. Now that's tested tough!

Columbia Sportswear Company, Portland, OR
CHAIRMAN OF THE BOARD: **Gert Boyle**
PRESIDENT/CEO: **Tim Boyle**
DIRECTOR OF MARKETING: **Dan Hanson**
AGENCY: **Borders Perrin Norrander,** Portland, OR
DIRECTOR OF CLIENT SERVICES: **Jack Peterson**

General Merchandisers

POSITIONING the STORE BRAND IMAGE

- Give the store a **U.P.V.—Unique Point-of-View** that adds meaning to it as a brand

- Create private labels—designer and lifestyle names that present a **U.S.P.—Unique Selling Proposition**

- Integrate **Store Design** into **Store Brand Image**

- Use **Visual Merchandising** for **Info-tainment** and **Sell-o-tainment** that also tells the **brand story**

Eight-page insert: Front and spread.

Soup to Nuts

ONE OF THE RETAILERS out there who consistently produces innovative advertising, Target Stores' ad campaigns are far removed from just about everything else around. And not just in the clever way they look.

To begin with, **there is not just one look, but a multitude of dazzling campaigns, all running at once—a creative strategy that in and of itself is highly unusual.** At any given time, it seems the somewhat maverick division of Target Corporation had at least two, usually more, different full-blown print ad campaigns out in full force, sometimes even translating to TV. Just as unusual, the campaigns are frequently the work of different advertising agencies.

- Brand Image Positioning
- Spiral Branding
- Destination Branding

BRANDSTANDS

What's behind the savvy premium discount chain's **approach to advertising? "There's a logic to it really that comes right out of the store's merchandising culture,"** said Minda Gralnek, fashion creative director. "Target's offerings are vast. We have all these different merchandise categories."

That's certainly a fact that anyone who has ever shopped a Target store can attest to. But apparently consumers are finding it worth it, in fact even desirable. With today's time-deprived consumer increasingly invested in the one-stop-solves-all method of shopping, their buying patterns are changing radically. Gralnek acknowledges the shift, noting, "There was a time when you didn't want to buy motor oil where you bought fashion. Now it's the smart thing to do."

Something else that has been pretty smart was using different ad agencies for different merchandise. There seems to be no shortage of subject matter for different campaigns, so spreading the work around seemed to make perfect sense from a creative point of view. "We have so much work under the roof of Target," explained Gralnek. "And an expert at motor oil isn't necessarily great at fashion!"

A number of great campaigns, many of which are award winners, have emerged from this thinking. **As different as they are though, there are common denominators—high**

Target's **SPIRAL BRANDING** strategy is a symbol of how much customers can surround themselves with Target products. The advertising is pervasive in its reach, its media and its creative styles.

Pop Art campaign.

People are looking for time-saving solutions to ease their hectic lives. Target presents an answer with their smart **DESTINATION BRANDING** strategy.

quality, sound strategy and creative flair.

Of the various print campaigns, two—Pop Art and Fashion and Housewares—are notable for the stylish way they mix retail and brand advertising together with such style. Generally speaking, most retailers' ads are either item-driven or image-driven. It's difficult to do both effectively. Yet here is Target with not one, but two, incredibly effective "hybrids" that by showcasing merchandise also help to support **Target's overall brand message of "Expect more. Pay less."**

According to Gralnek, the concept of "expect more" was something Target always tried to convey in all their advertising. **"We're witty and smart, and our customers are witty and smart, and there's our points of differentiation. We don't run an ad our competitors could run; we run an ad that's unique about us.** We want people to think it's a nice place to get toilet paper, white socks—and that we have exciting things happening in our store. Both campaigns celebrate that.

In the Pop Art campaign. where you put Bounce next to stretch pants, you're celebrating what's unique about Target: You can go to another off-price store and get stretch pants, but you can't get all the things you need at once, even chic basics."

As for the far out "Fashion and Housewares" campaign, it's a wonderful example of how a good idea can be continually updated to remain contemporary. Running for years, the concept was based on an unlikely mix, if ever there were one. Barbecue skewers as a hair accessory? An oil filter for a collar? What were they thinking? As Gralnek told it, the skewers were perceived as "Asian-like Zen kind of things." As for the oil filter, the agency saw that as "very Elizabethan." The bride? "Kind of flower child hippie chic."

How do they come up with these ideas?

She explained. "We show different agencies different trend items coming up. We show them Polaroids or real products. Sometimes they go to stores and look around to get ideas."

Do they every run out of ideas? "Sometimes we have so many ideas we want to do them all!"

Three ads from the Spring 2000 Fashion and Housewares campaign.

Target, Minneapolis, MN
FASHION CREATIVE DIRECTOR: **Minda Gralnek**
AGENCY (Pop Art Campaign): **Peterson, Milla, Hooks,** Minneapolis
AGENCY (Fashion and Housewares): **Kirshenbaum Bond & Partners,** New York

One of the early Fashion and Housewares ads from
the continually evolving campaign.

Customer Relationship Marketing

MANSOUR'S

a family tradition of *style*

Mansour's believes...

in *Family*.

in *Loyalty*.

in *Integrity*.

in *Pride*.

in *Self-Discipline*.

in *Teamwork*.

Mansour's was founded in 1917 as a 2,000 sq. ft. dry goods store on Bull Street in LaGrange, Georgia. Today, the LaGrange store encompasses a full city block, and the family-owned company includes locations in Columbus, Albany and Macon, Georgia. The story of Mansour's adds a new chapter in August of this year with the opening of a 65,000 sq. ft. location in Augusta.

For over 82 years, Mansour's has maintained a strong commitment to customer service. Family members and more than 300 sales associates offer Mansour's customers courteous service and helpful fashion advice.

Mansour's caters to a diverse range of fashion-conscious consumers. Merchandise runs the gamut from some of the best known names in fashion--like Tommy Hilfiger, Liz Claiborne and Ralph Lauren--to very special, unique looks that won't be found anywhere else.

Dedication to a few fundamental principles--serve the customer, take care of employees and give back to the community--has guided the growth of the store through three generations.

On that family tradition, Mansour's continues to move ahead, looking forward to a bright future of prosperity and service.

LaGrange
W. Lafayette Square

Albany
Albany Mall

Columbus
Harmony Place

Macon
Northside Drive

Augusta
Augusta Exchange - Opening August, 2000

1-888-311-2289 / www.mansours.com

WITH SHIFTING population patterns and increased competition from specialty stores, shopping centers, category killers and the Internet, department stores are especially vulnerable to customer attrition. As daunting as this may be, Mansour's, a small family-owned chain with five stores in Georgia, has a lot going for it.

First, there is **COMMITMENT BRANDING: a long-standing commitment to catering to its customers, its employees,** and the **relationship between them.** "We have always emphasized the importance of **one-on-one relationships between our sales associates and our customers,**" said Fred Mansour, president. "We run a full 150 basis points higher (1.5%) than our department store counterparts on store wage cost because we are dedicated to having staff on our selling floors to assist customers."

A few years ago the retailer formed a "Pro Club" for associates who achieve a certain sales level during a given year. At the end of the year it holds a banquet in their honor at the local country club and hands out awards. "They love it!," said Mansour. "I couldn't believe how much they enjoy and appreciate the recognition."

Second, Mansour's goes to great lengths to **give its customers merchandise tailored to their needs.** It not only offers them the core merchandise found in a traditional department store (men's, women's, kids', juniors, gifts, plus sizes, petites, shoes, etc.) but many of the same names found in specialty stores as well.

That's not all. In addition to practicing many of the traditional values associated with department store success, Mansour's is very much a modern-day marketer, having converted its years of personal customer service into a **first-class database,** and a **strong commitment to direct marketing.**

Mansour's has put to use CRM database technology that helps them target their best customers by being more in tune with their individual brand preferences, shopping behaviors and purchasing patterns.

Fred Mansour realized that **building customer relationships** through the use of the database was a necessity **in positioning the company for the future**. Prior to then, the company didn't have the software to track purchases to the level needed. Then, together with Melanie Poole, marketing director and consultant, whose background includes years as sales promotion/advertising director for another department store chain, Mansour set about to mine the gold in their database.

"We have a very strong proprietary customer, so the **most efficient use of our ad dollars is to directly market to our proprietary store card customers** (55,000) because we already have a relationship with those people," says Poole. "It's certainly much more efficient than to buy 3,000,000 impressions for people who may not know who you are!"

Mansour's **BENEFIT BRANDING** strategy lead to personalizing their products and customizing their services.

Mansour's direct-mail program was stepped up because it was **able to directly market to a customer who buys a particular thing or shops a particular sale,** eliminating having to mail every piece to every customer—something that would have been cost prohibitive. Mansour explained, "Our database consists of 55,000 proprietary charge customers. We can access our cus-

This mailer generated particularly strong response.

Jumbo postcard.

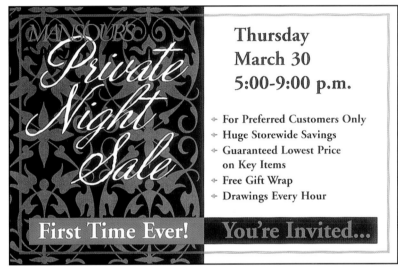

New this year, this event for preferred customers was a big success. Says Poole, "Some stores took it and ran with it. Some people wore tuxedos. We're definitely repeating it!"

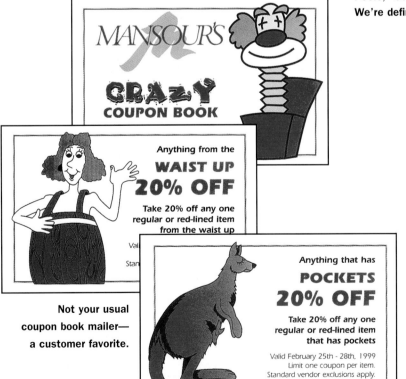

Not your usual
coupon book mailer—
a customer favorite.

J. Renee
Vinyl slide with butterfly accent. Silver/gold, orange or purple. Reg. $66
SALE 49.88

J. Renee
Vinyl and cork slide.
Reg. $86
SALE 49.88
Matching cork handbag.
Reg. $79
SALE 59.88

J. Renee
Vinyl and leather slide with nailhead accents. Denim, silver and natural cork.
Reg. $58
SALE 44.88

Rosalina
Embroidered mesh slide in fuchsia, champagne, royal or white. Reg. $78
SALE 59.88
Matching handbag.
Reg. $125 **SALE 99.88**

VanEli
Two-band mesh and leather sandal in black patent, sand or white.
Reg. $68
SALE 49.88

VanEli
Three-band mesh and leather slide in silver, platino or black patent.
Reg. $66
SALE 49.88

tomers based on an RFM model using several different selection criteria. This has been very effective in **targeting the specific mailers based on the customer's purchase history.** For example, we used to run our entire list to mail out a back-to-school catalog. Now we will target about 2,000 customers who spend regularly in our kids' and junior departments and we are getting better sales results at a lower cost."

The direct-mail program was virtually non-stop, with at least one or two pieces every month. Mansour's six catalogs a year were co-opted with vendors. In addition there were various 2C and 4C postcards, flyers, coupon books and such. Mailings related to special events were distributed to a list of anywhere from 18,000 to 30,000, depending on the event. "Everything runs like a well-oiled machine," said Poole, who did all the direct-mail creative concepts from start to finish.

So where did this "well-oiled machine" plan to operate next?

"Mansour's is looking for opportunities to grow in midsize markets," says Mansour. "We will have a sixth store by Spring 2002. We think that our growth model is very viable. **We think of our customers as our friends."**

Their customers know and trust that Mansour's will be there for them. That kind of attitude can go a long way in keeping and building new relationships.

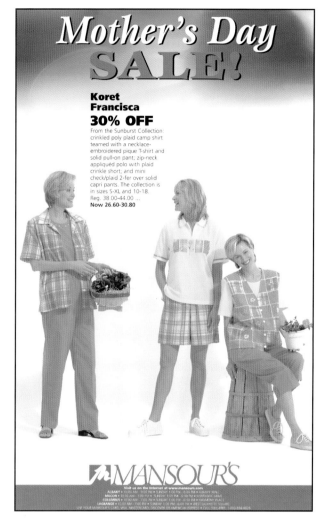

ROP newspaper ads.

Mansour's, La Grange, GA
PRESIDENT: **Fred Mansour**
ADVERTISING MANAGER: **Chad Harrington**
MARKETING DIRECTOR/CONSULTANT: **Melanie Poole**
WEBSITE **www.mansours.com**

150 Years of Harrods

Harrods as it looked in 1891.

Harrods, today (it takes 11,5000 light bulbs to get that glow).

- Brand Image Positioning
- Sprial Branding
- Experiential Branding

BRANDSTANDS

BACK IN THE DAYS when adventurers were rushing to California for gold, and Hettie Bloomer was revolutionizing women's dress, London tea merchant Charles Henry Harrod had ambitious plans of his own. He took an interest in a little corner grocery shop that was to become the most famous department store in the world—an elegant, eccentric, quintessentially British institution regarded with affection by the British public, tourists and the rich and famous alike. They had another reason to feel warm and fuzzy about the store. A jam-packed 150th anniversary celebration with all the pomp the English are famous for.

"Every week we have an event of a sort to keep the whole anniversary going," said Peter Willasey, a press officer for Harrods. "I don't exaggerate when I say every day there is something going on." The year-long campaign, "Harrods 1849-1999 Celebrating 150 years" is designed to capture the public's imagination, and **POSITION its BRAND IMAGE** even higher.

The festivities began on a Sunday, February 14th. "It was intentional," said Willasey. "The store isn't open on Sunday and on Valentine's Day lots people are in London. In the evening we had a big fireworks display

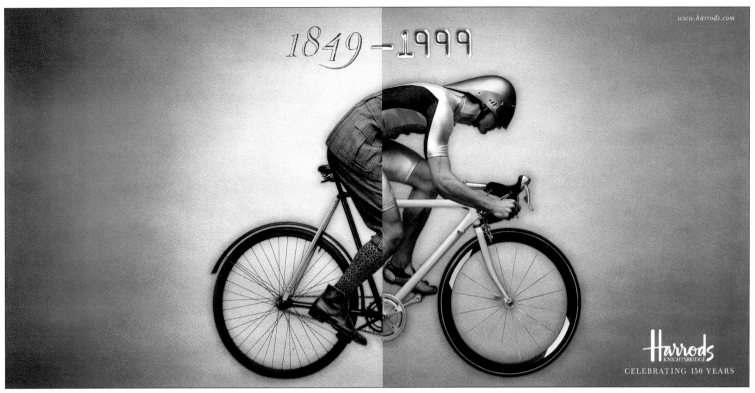

www.harrods.com

1849 – 1999

Harrods
KNIGHTSBRIDGE
CELEBRATING 150 YEARS

The same visuals are used throughout. Print media includes fashion, shelter, lifestyle and men's interest magazines.

From Harrods
News (a "millennium" ago).

from the roof of the store, a thank-you to all lovers around London from Harrods."

From that point on, the celebration—a collaboration between Harrods large in-house agency and its advertising agency, Leagas Delaney, London—had continued virtually nonstop. Throughout the year, Harrods was conducting some **SPIRAL BRANDING** from special customer events, fashion shows and charity initiatives to a series of parties and product launches. Because Harrods carries such a variety of merchandise, the events were far-ranging, encompassing everything from a 150th anniversary hat show (timed for the preWimbledon, prehorse racing events where hats are de riguer) to the launching by a patron of the Guerlain fragrance house of a new fragrance created exclusively for the 150th.

According to Willasey, "One of the nicest events will be a special gala dinner for the British Red Cross. The theme will be dream tables. We'll ask celebrity clients and key suppliers to create their idea of a dream table."

The big-ticket event, at which no two tables were alike, was expected to draw high attendance with proceeds going to the British Red Cross.

The 150th celebration also makes a **COMMITMENT** to Harrods' employees. "We're always mindful of our staff," commented Willasey. "Every single one of our 6,000 staff and our concessions staff were invited to a

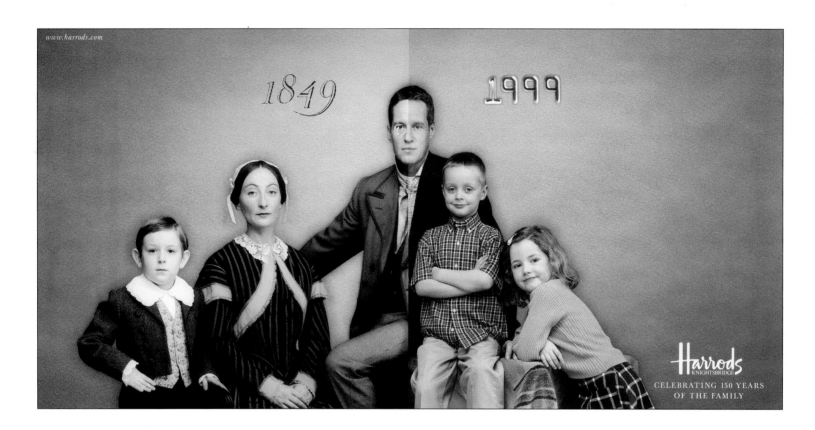

party. Not all at once! We had a series of parties over several weeks."

While the program was steeped in tradition with its recollection of 150 years of innovation, it's not all about looking back. A key element was the launching of 150 limited edition products, many of which are commemorative and exclusive. **Harrods worked closely with its suppliers in commissioning new merchandise**, from limited edition jewelry to hand-picked tea (one of the first products to be stocked back in 1849).

The theme that extended through all the campaign elements, from materials for the media and the special store guide to print and out-of-home advertising, was done from a historical perspective. In the case of advertising, it was always a combination of past and present images featuring an early innovative product with its modern-day counterpart. The same split images were used in subway stations, on billboards and in a large number of magazines.

Collectively, they were constant **EXPERIENTIAL BRANDING** reminders of what was for Harrods (and admirers of retail excellence everywhere) truly a historic event.

Three of the 150 new items Harrods created for their anniversary.

Out-of-home advertising repeats the print campaign's split image.

Harrods, London
AGENCY: **In-house**
ADVERTISING AGENCY: **Leagas Delaney,** London
WEBSITE: **www.Harrods.com**

Ready for Class

- Experiential Branding
- Spiral Branding
- Brand Associations

BRANDSTANDS

Because the dates for school openings vary, newspaper inserts in markets that have earlier openings such as Texas and Arizona run the beginning of August. In markets with later openings such as California, Nevada, New Mexico and Minneapolis, they run a later weekend in August.

MACY'S WEST, one department store whose advertising is consistently innovative, had done it again. Case in point: "Ready for Class"—the retailer's campaign for back-to-school 2000.

The concept was a plain-language communication anyone can understand. But on another level, it touched something deeper—the feeling kids get when the novelty of summer has worn off, and they're eager to return to their "real" life. Said Meredith Brogan, vice president, creative director, "The idea that drove the creative was the teens actually like to go back to school because that's when they get together with their friends. So all the scenarios were a play on what's going on personally, but titled with a class subject."

EXPERIENTIAL BRANDING requires ideas that are based on a knowledge of customers emotions. These ideas suggest appeals and strategies that drive the creative execution. Brands that connect with the customer's experience and **ASSOCIATIONS** add intangible values that encourage loyalty. It takes more well-designed research and innovative planning to position a brand as one that delivers experience.

On another level, this seemingly simple concept embodies the message that Macy's too was ready for back-to-school with a storeful of items with, well, class. What a hard-working idea!

So how did Macy's do it? Well, never let it be said that Macy's doesn't do its homework. Planning for an important selling period such as back-to-school is typically a long and involved process—in this case seven months of input, planning, creative brainstorming and research.

The store actually has a department called "campaign development" that's responsible for scheduling a series of meetings and pulling together information for the major periods such as Mother's Day, Father's Day, Valentine's Day, back-to-school and holiday. In addition to functioning as a catalyst, the group researches special areas such as GWPs, and "guerrilla marketing" (non-traditional media—for example, hiring people to wear special T-shirts and hand out material in store).

Planning starts far ahead of many other retailers. The initial brainstorming meeting for back-to-school 2000 actually took place December 18th, 1999 (while most of the rest of the world was in the middle of holiday mania).

The meeting is quite an assemblage in that it pulls together marketing, creative, campaign development, the sales promotion management group and media. "They do a recap of last year—both quantitative and qualitative," said Pat Holt, creative director for ROP and magazine. "What were the sales, what were the elements, some feedback on the event and how it went. Then we start discussing the next year and are there any other elements we want to look at to bring into the equation."

Next is the divisional meeting which includes the whole spectrum—some 20 to 25 people consisting of merchants, DMMs, people from visual merchandising, special events and the store's organization. "Each area talks about the year before, and any plans they have for the new year. It's an early sharing," she explained. Much of the same information from the earlier meeting is conveyed, but at this point, creative often has some rough creative concepts. Out of that meeting comes a responsibility list.

Research was important to the effort. Typically Macy's doesn't do a lot of focus groups on creative concepts but the important junior customer for back-to-school is a special breed. "The feeling was creatively that this was an audience we wanted to get a better feel for," Holt explained. "Clearly we know that with the junior audience you need to be fairly up front. You can't pretend to know what they're thinking."

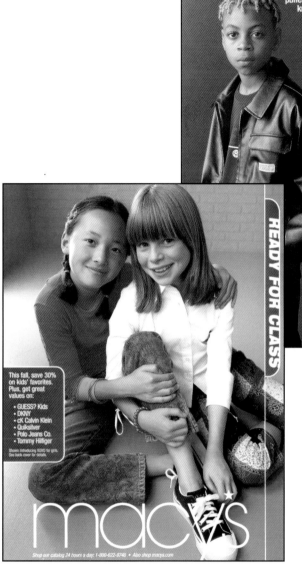

File tabs—the campaign's primary graphic—
served as a great device for the location of
different categories in the 16-page catalog. The
subjects could be easily skewed to younger
back-to-schoolers.

Macy's "file tab" idea is
more than a graphic
tactic. It is **LIFESTYLE
MERCHANDISING**—
where the categories in
this case, are described
by school subjects. But,
even more important,
are designed to be in
tune with the feelings
and interests of the
back-to-schooler.

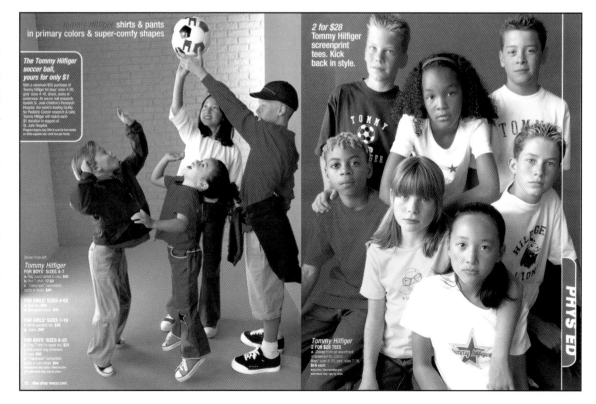

A 16-page section in the all-important August issue of *Seventeen* was notable for its great use of slice-of-life copy.

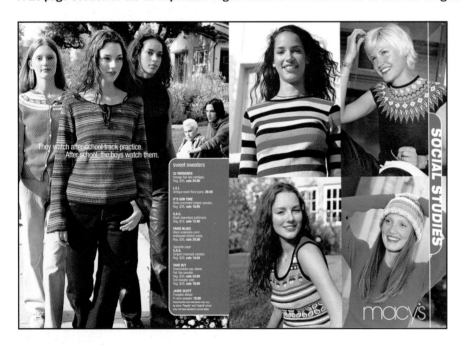

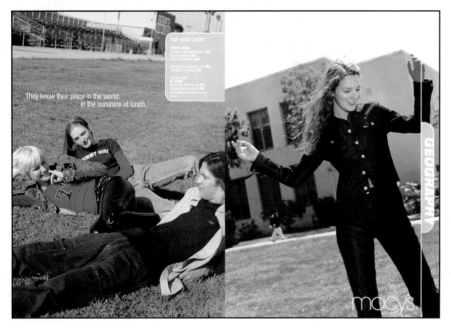

According to Brogan, Macy's did teen focus group studies in which four different creative executions were tested. Through the focus groups Macy's learned that a direct reference to back-to-school per se really didn't cut it. Instead the creative group sought a way of indicating the time period without being boring. Another thing that came though in the focus groups was how much teenagers appreciate humor.

A cross functional group made up of representatives from different media was pulled together. Creative, which had meanwhile done more finished work, then made its pitch. A brainstorming followed, which examined how the creative could be used in different areas. "We pretty much go forward with development at that point," said Holt. "We're usually locking into the calendar and know what the media plan is."

"Ready for Class" utilized a variety of media in many markets throughout August. The campaign consisted of newspaper ads, magazine, newspaper inserts, broadcast, new media and direct mail. **Integrated marketing communication is funded on the concept that only a UNIFIED MESSAGE in a matched-to-consumer mix of media is the way to communicate**. If the media plan is well developed, then seeing it, hearing it and reading it, helps to remember it. And the addition of non-traditional (guerrilla) media was now part of the plan.

The schedule for these various elements was typically staggered, reflecting the variance in the dates of school openings from market to market. The catalog, for example, was distributed as early as the end of July for Texas and the southwest, the first week in August for other markets.

Literally hundreds of color and B/W ROP ads were run to reach the parents of younger children. According to Holt, ROP, unlike TV, for example, isn't used as a major medium for the young men's

The TV spots played out the file tabs of actual subjects by doing the subjects in a lifestyle oriented way. Humor was a key component.

A mini-drama at a school locker signaling the end of a relationship was tabbed "History."

or junior audience. The TV spots, like the other advertising, were staggered by market, running in the second, third and fourth weeks in August.

The creative for all the advertising, both for younger kids and for teens, reflects the careful planning that had taken place every step of the way. There was tremendous consistency—in photography, color and graphics, particularly the ingenious use of file tabs to indicate specific school subjects. Said Holt, "It's rare that we find a campaign that works for both the junior and the younger market."

Creative consistency based on kids' and teens'

lifestyles described as school subject areas add relevance and some inside jokes. The customer is surrounded by a **SPIRAL BRANDING** that also positioned Macy's West as "ready for class."

Macy's West, San Francisco
AGENCY: **In-house**
VICE PRESIDENT/CREATIVE DIRECTOR: **Meredith Brogan**
CREATIVE DIRECTOR ROP & MAGAZINE: **Pat Holt**
CREATIVE DIRECTOR DIRECT MAIL: **Kelly Keenan**
CREATIVE DIRECTOR NEW MEDIA: **LaTonya Lawson**
CREATIVE DIRECTOR BROADCAST: **Lisbon Okafor**

This full-page newspaper ad ran sideways.

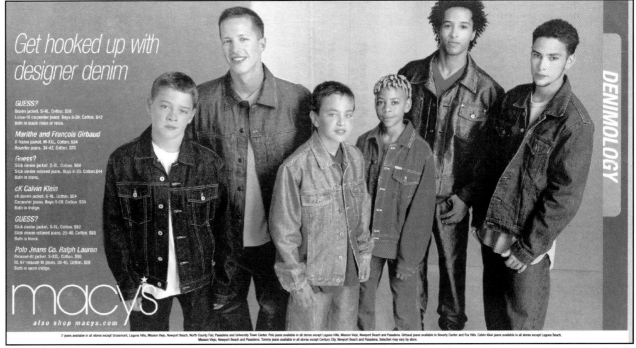

What BRANDS can do to grow BRANDWIDTH

OBJECTIVE:
Attract Attention

STRATEGY:
Create Product Brands
with U.S.P. and U.P.V.

OBJECTIVE:
Arouse Awareness

STRATEGY:
Select Appeals that Position
the Brand's Difference

OBJECTIVE:
Activate Anticipation

STRATEGY:
Simulate Brand Experience

OBJECTIVE:
Ask for Action

STRATEGY:
Promote Trial and Experiment

Home Furnishings

Strategies for Success

Grand opening invitations. The company is known for its aggressive brand attribute strategy for launching new stores.

AS 24/7 INCREASINGLY becomes a way of life for many, the need for being organized is practically an imperative. Fortunately, there is no shortage of retailers around us to help us get it together.

Given the popularity of specialty stores devoted to storage and organization products, it's somewhat surprising that the category wasn't even around years ago. It wasn't until 1978, when The Container Store opened a store in Dallas, that this retail niche came into being. Since then, the category has seen amaz-

- Brand Awareness
- Attributes Branding
- Commitment Branding

BRANDSTANDS

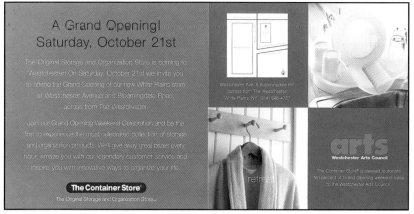

A collection that will astound you...

The Container Store® and the Dallas Museum of Art cordially invite you to preview the world's most celebrated collection of storage and organization products.

Join us in celebrating the **Grand Opening** of our new Dallas store located at Alpha Rd. and the Tollway (across from Nordstorm at the Galleria).

Friday, July 30th 6:30 pm - 10 pm

Enjoy lavish hors d' oeuvres, perfectly chilled champagne, and dancing to live entertainment.

A celebration that will ama...

Another opening. Another success.

The Container Store®
The Original Storage and Organization Store

The Grandest Opening

Join The Container Store on Saturday, July 18th & Sunday, July 19th, for the unveiling of a masterpiece – our new flagship store at Northwest Highway and Central Expressway, across from NorthPark Mall.

Twenty years ago in Dallas, The Container Store opened the first store devoted to products that save time, save space, and simplify your life. Now, our two original Dallas stores, Preston Forest and Mockingbird, become one incredible masterpiece at this new flagship location.

We are pleased to partner with our friends at the Dallas Museum of Art for our Grand Opening Weekend. You'll get your first peek at our masterpiece, and the Dallas Museum of Art will receive ten percent from every purchase.

Northwest Hwy. & Central Expwy. SW Corner (Across from NorthPark Mall)
Store Hours: Monday - Saturday 9 am to 9 pm, Sunday 11 am to 6 pm

Bag stuffers.

July 18th, You're Invited To Unveil A Masterpiece.

The Container Store®

Northwest Hwy. & Central Expwy. SW Corner (Across from NorthPark Mall)

ing growth and expansion. In fact, it is one of the fastest growing segments of the housewares industry.

The Container Store has helped to lead the way. As of early 2001, the privately held company had 22 stores across the country as well as a thriving national mail-order business. Historically, the company had experienced a very calculated and strategic growth rate of 20 to 25 percent, with plans to open more locations. In addition, it launched a new e-commerce website.

The company attributed **the driving force behind its success to a well-defined marketing plan, strict merchandising focus** and **exemplary customer service.** It relied primarily on two media—outdoor and direct mail.

New outdoor messages appeared as often as nine times a year. "We look at outdoor as a wonderful vehicle for **building our brand** and **driving traffic to our stores,"** said Colleen Monroe, director of advertising. "Typically, our billboards are located in close proximity to our store locations, so that they can **serve as an extension of our store.** The outdoor messages that we post **mirror our company's marketing plan and always help to support the stores' current campaign season."**

Direct mail likewise served a key role. The pieces were used as **a vehicle to show the various uses of the often multifunctional products.** "Our direct mail pieces also mirror our company's marketing

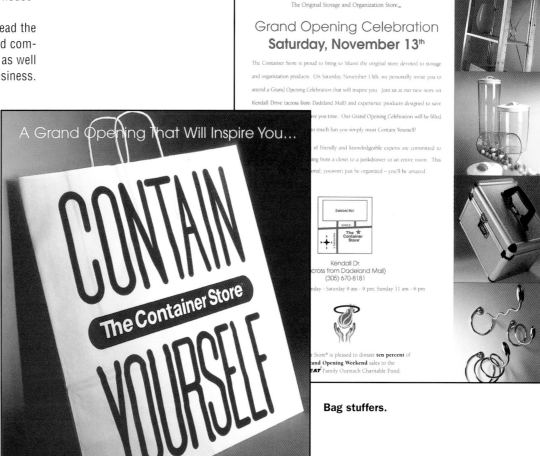

Bag stuffers.

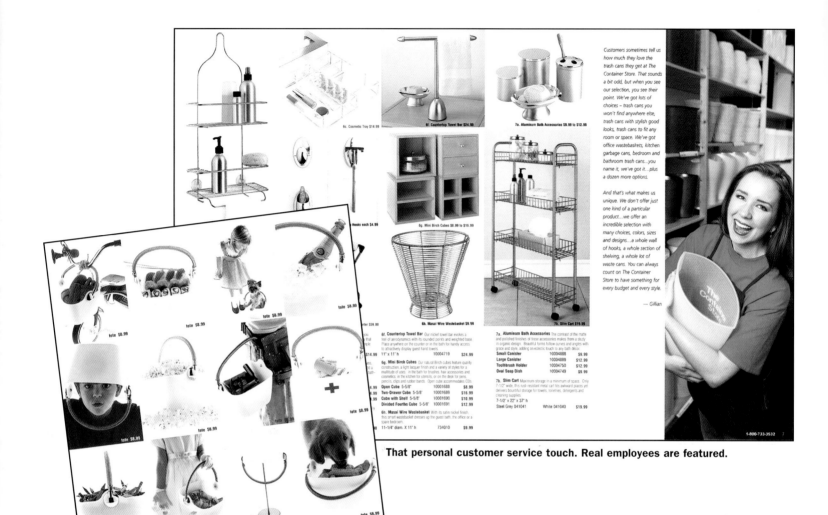

plan," said Monroe. "We use direct mail to support various marketing campaigns, such as holiday, with our Gift Wrap Wonderland catalog, or our Annual 30 percent off elf Sale." The company did a number of these campaigns throughout the year with the focus on everything from travel to college.

Direct mailings were very strategic, as the company had an extensive customer database from which to draw. "We know that **this list is very targeted and is made up of people who have told us that they want more information from our company,"** Monroe explained. "This obviously makes our direct mailings extremely effective." Distribution varied depending on the type of direct mail piece. A single catalog mailing could reach up to 2 million customers.

The Container Store is known in the industry for its unique formula for launching new stores, using a powerful mix of advertising, public relations and other strategic marketing tools in advance of every store opening. The goal for the launch of a new store is that it will immediately perform as a "top store" within the company's chain from the first day the store opens.

This company is a model for **COMMITMENT BRANDING.** They are committed to being a good corporate citizen in the new

communities they enter. And they are committed to superior customer service through their quality employee training program. According to Monroe, **the strategy includes partnering with a non-profit organization made up of its targeted customer base and committing 10 percent of the Grand Opening weekend sales to that group.**

"We also typically will use outdoor messages on nearby billboards to let area cus-

Covers of catalogs with a specific category focus.

THE ULTIMATE GUIDE™
TO KITCHEN AND PANTRY ORGANIZATION
The Container Store®

The Container Store®
The Ultimate Closet Planning Guide

the ultimate shelving guide
The Container Store®

The Container Store®
Hungry For An Organized Kitchen?
Loop 410 & San Pedro

The Container Store®
We Can Help You Get At Least One Car In Your Two Car Garage!
I-25 & C-470 (next to Park Meadows Mall)

The Container Store®
Flat Out Fabulous
Our First Annual 25% Off Shelving Sale
Corner of 360 & Hwy. 183

The Container Store®
Laundry Solutions That Won't Hamper Your Style.
Loop 410 & San Pedro

The Container Store®
Wrinkle Free Arrivals
Be An Organized Traveler
Northwest Hwy. & Central (across from NorthPark Mall) • Beltline Rd. (west of Tollway)

The retailer is big on billboards.

The Container Store®
Residence Advisor
We're the dorm room experts.
Loop 410 & San Pedro (across from North Star Mall)

Billboards often support specific direct-mail campaigns.

The Container Store®
O Come All Ye Houseguests
Organize Before The Holidays
Alpha Rd. & the Tollway (across from Nordstrom at Galleria North)

tomers know that The Container Store is coming," she noted. In addition, a variety of direct mail pieces, such as catalogs, weekend shopping invitations, etc., may be used **to educate a new market about the company and its products and services.**

Internally, The Container Store **credited its people as the reason for its success.** The retailer put so much **emphasis on personal service** that every first-year, full-time salesperson receives about **185 hours of training (in a retail industry where the**

average is seven hours).

In the mid 1990s the company made the decision to bring its advertising in-house. **The Container Store has a very unique and quirky culture and it was thought that company employees that actually live and breathe that culture would be in a better position to effectively communicate the brand's messages to its customers.**

The Container Store, Dallas, TX
VICE PRESIDENT SALES AND MARKETING: **Melissa Reiff**
DIRECTOR OF ADVERTISING: **Colleen Monroe**
AGENCY: **In-house**
WEBSITE: **www.containerstore.com**

Your sneak preview of the world's most dazzling collection of
gift wrap
and gift packaging ideas has arrived.

The Container Store®

Gift Wrap Wonderland

Delight in the Dazzle
of our Gift Wrap Wonderland

Don't let this be your idea of a white Christmas.

The Container Store®
Gift Wrap Wonderland

All the Comforts of Home

- Attributes Branding
- Experiential Branding

BRANDSTANDS

ALL OVER the country, home sales were booming. Likewise, home furnishings sales were going through the roof, producing a multibillion dollar industry that continued to skyrocket. So it was not surprising that retailers specializing in furniture and housewares were chalking up major growth.

Few retailers, however, captured the imagination and pocketbooks of American consumers like Crate & Barrel. Known for its straightforward, well-designed merchandise that people can use every day, Crate & Barrel has grown from a 1,700-square-foot space in

an elevator factory in Chicago to over 85 stores. This includes a strong catalog program, gift registry and website.

What's the key to Crate & Barrel's success?

Many would say it's the comfort factor. Even with the company's remarkable growth, the original spirit has endured. (The first store was renovated by nailing crating lumber to the so-called walls. With only two

weeks left before the holidays, the crates and barrels in which the first merchandise had been shipped were turned over and used for display fixtures.)

Today the crates and barrels are gone, but Crate & Barrel is still known as a place where the atmosphere is casual and where people feel comfortable—a warm, unpretentious feeling that carries over to the catalogs.

Crate & Barrel is comfortable with a multichannel strategy that fosters **ATTRIBUTE BRANDING**. From the store, to the catalog, to the Web, "everything starts with the merchandise."

All the creative is done in-house by what the in-house ad director calls "a lean and mean team in which everyone works together. We always say at Crate & Barrel that **everything starts with the merchandise.** Whether it's glassware or furniture, the buyers are very invested in every aspect of their products. Many buyers have been here 25 years and that involvement really shows in the catalog."

The catalogs were started in 1973. Considered among the best in the industry, they account for approximately 10% of the company's revenue. Seven catalogs are done a year. Each edition is mailed to millions of customers with additional catalogs available in store. A tremendous amount of advance planning goes into every catalog, and it takes a minimum of six months to complete each one.

EXPERIENTIAL BRANDING is at work when Crate & Barrel **builds a brandstand experience** for their customers to "sense" what these products will "feel" like in their homes. Through the visual merchandising and "atmospherics," in the store and in print, Crate & Barrel delivers design and comfort.

Their catalog represents a subtle yet significant change from earlier ones, said the ad director. "It's more environmental. You see environments with a lot of natural light that makes them very lifelike. You can look at a little scene in a kitchen and imagine that you would find it in your own home. There's a lot of white light, and the photography is very

clear and clean. **That really reflects our brand** and goes along with the whole feeling of our store when you walk into it. We got a very large response out of this one. One woman called in to order and said she'd turned down the corner of almost every page."

Furniture has become an important part of the product offering, and appears throughout the catalog. Again, **the catalog reflects the store.** The company has found that when furniture and housewares are together under one roof, housewares does about 20% more business.

In April 1999, Crate & Barrel launched a website—a natural extension for a company with such a strong direct marketing business.

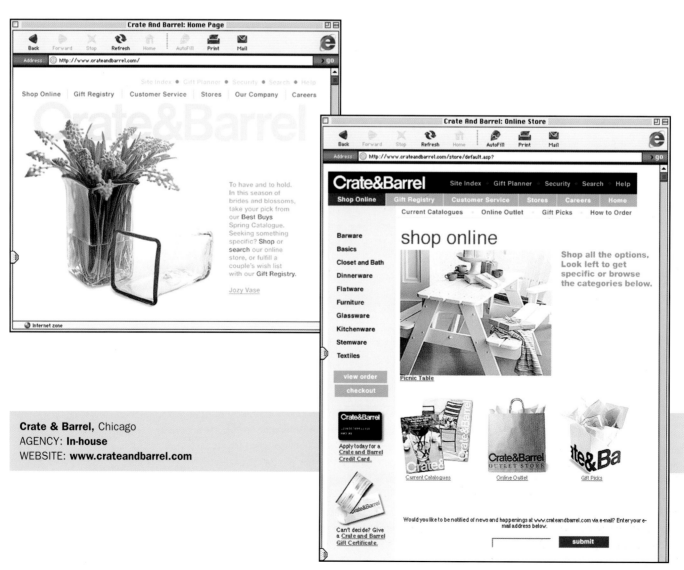

Crate & Barrel, Chicago
AGENCY: **In-house**
WEBSITE: **www.crateandbarrel.com**

Remodeling A Brand

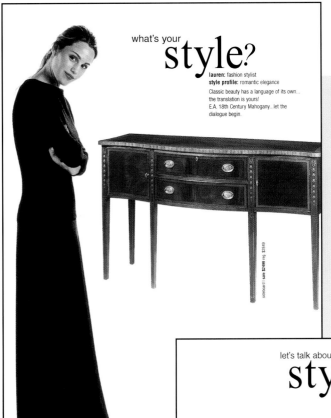

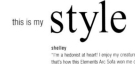

FOR YEARS, the name Ethan Allen conjured images of home and hearth, early America, colonial ways and such. Like the country with which it is so strongly identified, the furniture manufacturer and retailer changed dramatically, retooling its image and its product line away from its early American heritage to a more contemporary mix. The objective: to attract a broader consumer audience.

True to its heritage, the company knew a thing or two about pioneering new directions. Ethan Allen went from a housewares distributor in the depths of the Depression to an international furniture company with a retail network encompassing more than 310 company-owned and retailer-operated Ethan Allen Home Interiors. With close to 100% brand awareness, it's practically a household word.

In this new economy, brand equity is no longer measured by "brand awareness" alone. Traditional as well as newcomer brands now are learning that the consumer's recognition of the brand name does not mean she is buying it.

In 1954, the millionth Ethan Allen piece, a maple chest, was presented to President Eisenhower.

In 1962 the company pioneered the concept of gallery stores by establishing a retail system of special freestanding and department store shops. Just as important—for the company and the industry—Ethan Allen products were shown in complete room settings, providing consumers with a better understanding of how their homes could look.

- Brand Associations
- Brand Image Repositioning
- Destination Branding

BRANDSTANDS

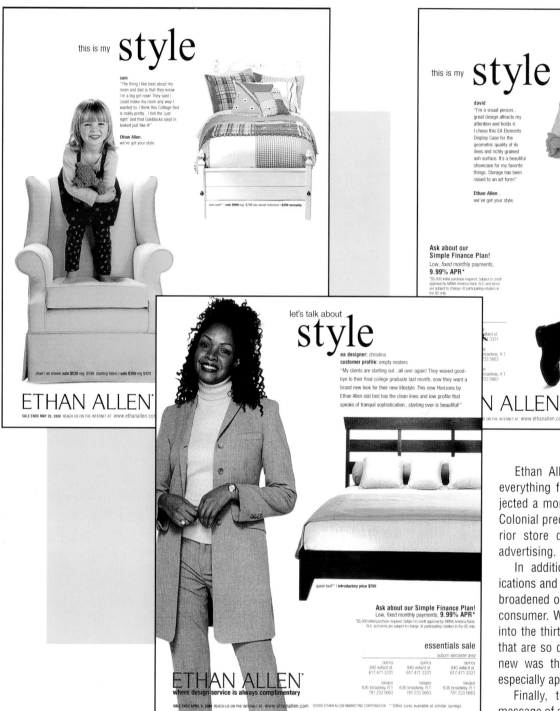

But times and tastes change, and America was not as sold on purely traditional any more. In the Early Nineties, the company embarked on a major project—redefining its product line from its early American heritage to a contemporary mix. Four lifestyle categories emerged—Formal, American Country, Classic Elegance and Casual Contemporary. At the same time, Ethan Allen unveiled an identity program aimed at updating its image and promoting the new collections. An understanding of lifestyle, with its attitudes and values is vital to the profiling of different customer segments. **BRAND IMAGE POSITIONING** is a strategy that helps customers identify their own lifestyle directions with **associations connected to the brand.**

Ethan Allen's "remodeling" effort spanned everything from a new store facade that projected a more contemporary message than its Colonial precursor to a new logo, updated interior store designs, and print and television advertising.

In addition, said VP Corporate Communications and Advertising, Lenora Kirkely, "We've broadened our price points to attract a younger consumer. We've dipped down with those lines into the thirty-something crowd—the Gen Xers that are so difficult to get into any store." Also new was the policy of providing financing—especially appealing to younger budgets.

Finally, to further extend the company's message of affordable style to parents and kids, who could be future consumers, Ethan Allen entered the booming kids market with the launch of its E.A. Kids Collection in June 1999.

With the company having completed the decade-long rebuilding of 90% of its product line with contemporary consumers in mind, it was ready to take its "new" brand to the next step.

"Over the last 10 years we've been trying to let people know that we have changed, but we needed to be a little bolder about that statement by making our advertising presentation a little more contemporary," said Kirkely. "We want to establish Ethan Allen as the most stylish place to come for home furnishings, the place for people who no longer want just the cookie cutter room."

According to Kirkely, Ethan Allen's in-house

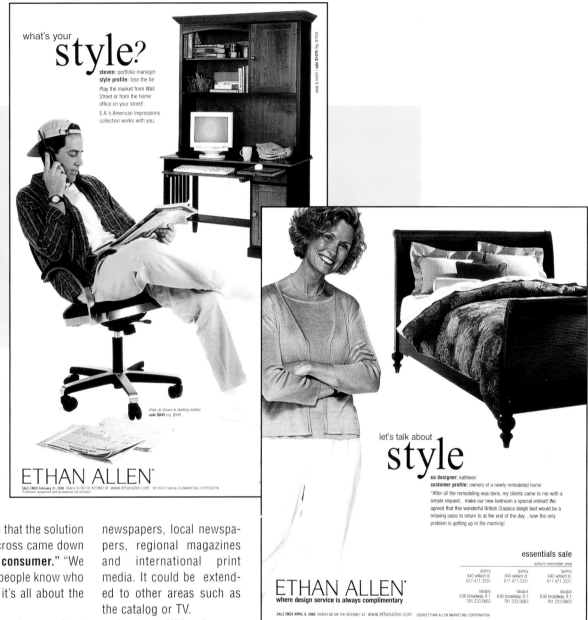

what's your
style?
steven: portfolio manager
style profile: lose the tie
Play the market from Wall Street or from the home office on your street!
E.A.'s American Impressions collection works with you.

chair as shown in starling leather
sale $649 reg. $949

ETHAN ALLEN®
SALE ENDS February 21, 2000 REACH US ON THE INTERNET AT: www.ethanallen.com ©1999 ETHAN ALLEN MARKETING CORPORATION
*Electronic equipment and accessories not included

let's talk about
style
ea designer: kathleen
customer profile: owners of a newly remodeled home
"After all the remodeling was done, my clients came to me with a simple request... make our new bedroom a special retreat! We agreed that this wonderful British Classics sleigh bed would be a relaxing oasis to return to at the end of the day... now the only problem is getting up in the morning!

essentials sale
auburn worcester area

quincy	quincy	quincy
840 willard st.	840 willard st.	840 willard st.
617.471.3331	617.471.3331	617.471.3331
saugus	saugus	saugus
636 broadway, rt.1	636 broadway, rt.1	636 broadway, rt.1
781.233.5663	781.233.5663	781.233.5663

ETHAN ALLEN®
where design service is always complimentary

SALE ENDS APRIL 9, 2000 REACH US ON THE INTERNET AT: www.ethanallen.com ©2000 ETHAN ALLEN MARKETING CORPORATION

agency came to the conclusion that the solution for how to get the message across came down to **"what are the needs of the consumer."** "We struggled with how do you let people know who you are when the fact is that it's all about the customer."

The "what's your style" concept came about in house. It was the first Ethan Allen campaign honed into a style statement that let people know that there's a style for them or one that Ethan Allen can create especially for them. The store-as-a-brand can best build equity by providing a personalized product along with customized services. This is customer relationship management that tells customers that your business is all about them. For the specialty retailer, **DESTINATION BRANDING** is a must. And the destination can be online as well as in-store.

"We started the campaign internally with Ethan Allen employees here—people that represented different Ethan Allen customers," says Kirkely. "With these ads, not only do we establish that this person is someone people can relate to, but we can start to change the perception of Ethan Allen." The campaign was opened up to include people outside the company.

The new campaign ran primarily in national newspapers, local newspapers, regional magazines and international print media. It could be extended to other areas such as the catalog or TV.

In an additional move toward exploring new ways to reach potential consumers and service current clients, Ethan Allen launched a revamped website. For the first time, consumers were able to order Ethan Allen furnishings directly, take care of customer service issues and request design assistance from their local Ethan Allen Home Interiors online. "The website is really an extension of a store in that it's a way we can continue to service our customers," said Kirkely.

The site grew to include more functions—an e-commerce element for ordering upholstery online for example.

Well, you know what happens when you start to remodel.

Ethan Allen, Danbury, CT
VP CORPORATE COMMUNICATIONS AND ADVERTISING: **Lenora Kirkely**
AGENCY: **In-house**
WEBSITE: **www.ethanallen.com**

Miscellaneous

Brandwidth Connection for **Multichannel Integration**

- Give customers multichannel **seamless service** to build a brandwidth connection

- Make the in-store, web, catalog brand message wider by **Integrating** your **Marketing Communications (IMC)**

- Use direct interactive media to personalize the brand's **commitment** to customers

- Enhance the customer's **brand associations** through virtual visual merchandising and virtual special events.

A Singular Sensation

- Brand Image Positioning
- Experiential Branding
- Attributes Branding

BRANDSTANDS

SEPHORA, the international beauty chain, was a revolutionary concept in beauty retailing and as sephora.com, a leading site for beauty on the Internet.

A truly unique specialty concept, Sephora helped to change the way beauty products are sold worldwide. From its origins in 1993 as a breakthrough bricks-and-mortar store in Paris, the company, in just seven years, emerged as the leading beauty retailer in France and the second largest in Europe.

Acquired by Möet Hennessey Louis Vuitton in 1997, Sephora arrived in the United States in mid-1998 with the first New York and Miami stores. The company continued an aggressive expansion plan in the U.S. and entered the Asian market.

From the beginning, Sephora's visionary concept clearly was to defy the traditional "selling methodology." **"We're building long-term brand equity** for Sephora through defining a very unique client experience," said Betsy Olum, Senior Vice President for Marketing. And very unique it was. From the moment you stepped into Sephora's stun-

ning black interior, complete with red carpet and soothing music, you knew right away this is a whole new thing.

BRAND CONCEPT MANAGEMENT could well be defined as creating a "whole new thing" designed to build **LONG-TERM BRAND EQUITY.** If brand equity is to be evaluated it is through a measure of its frequent and repeat purchasers—who believe it's good enough to recommend to their friends.

Instead of being waited on by beauty consultants from behind the counter, Sephora customers were invited to immerse themselves in an experience of "freedom, beauty

Beauty Report

Fall 2000

RUNWAY SEX APPEAL

GLOBAL SKINCARE SECRETS

YOUR FALL HOROSCOPE

NIGHT AND DAY MAKEUP

WIN THIS COVER LOOK!

and pleasure." What followed was a hands-on, self-service shopping environment where shoppers were free to touch, smell and experience each and every product. Small wonder that the average customer spent 45 minutes in the store! Shoppers were also free to choose the level of assistance they wanted—from their own individual experience to detailed expert advice.

Moreover, unlike the standard brand-by-brand display, at Sephora products were arranged alphabetically and by specific categories. For example, there's a Top Ten Fragrance Wall featuring the latest bestsellers, and a Lipstick Rainbow of 365 shades—one for every day of the year. A Cultural Gallery featured exhibits on beauty and beauty products with a new display each month. And this was just the tip of the iceberg.

The strong acceptance of its concept encouraged the company to bring Sephora to a wider audience. In October 1999, the company launched Sephora.com, the only beauty site on the Internet with physical store locations.

The website provided shoppers access to the same products as those in Sephora stores. Visitors to the website could make purchases,

treatment zone

THIS FALL, TRAVEL THE GLOBE (WITHOUT THE JET LAG) AND STOCK UP ON THE SECRET SKIN SAVERS THAT ARE TRADEMARKS OF GORGEOUS WOMEN FROM AROUND THE WORLD

photographs by david hamsley

Passport to Perfect Skin

MASK

(WU) Morning! Mask

Beauty destination: France
National skincare secret: Caudalíe Ultra-Mild Wine Soap, $15
Why it's worth the trip: Rich in grapeseed extract, it gives your body the same glow as you get from drinking French wine.

Beauty destination: Japan
National skincare secret: Komenuka Bijin Facial Cleansing Powder, $36
Why it's worth the trip: Leave it to the country that redefined minimalism to give you these tiny packets full of dirt-destroying grains.

Beauty destination: India
National skincare secret: Joseph Kurian Marma Soothing Hand & Nail Cream, $19
Why it's worth the trip: This intense herbal hand helper rejuvenates skin plus strengthens nails.

Beauty destination: China
National skincare secret: Wu Morning! Jet Lag-Hang Over Mask, $48
Why it's worth the trip: Think of it as Chinese takeout for your face—it's quick (only takes 60 seconds) and it delivers (gives skin a snap-out-of-it sensation).

Beauty destination: Switzerland
National skincare secret: Juvena Q10 Night, $55
Why it's worth the trip: Think that rosy Swiss-Miss glow is a result of Alp air and beauty sleep? That and this triple-action, fine-line fighter applied at bedtime.

Beauty destination: Italy
National skincare secret: Cali Oliva Salata Moisturizing Body Scrub, $18
Why it's worth the trip: This crushed walnut and olive oil skin slougher takes you a step closer to being as touchable as Sophia Loren.

Beauty destination: Israel
National skincare secret: Emergin C Topical Vitamin C Serum, $60
Why it's worth the trip: High concentrations of age-reversing vitamin C created to undo the sun damage of too many beach-baking days spent at the Dead Sea.

6

7

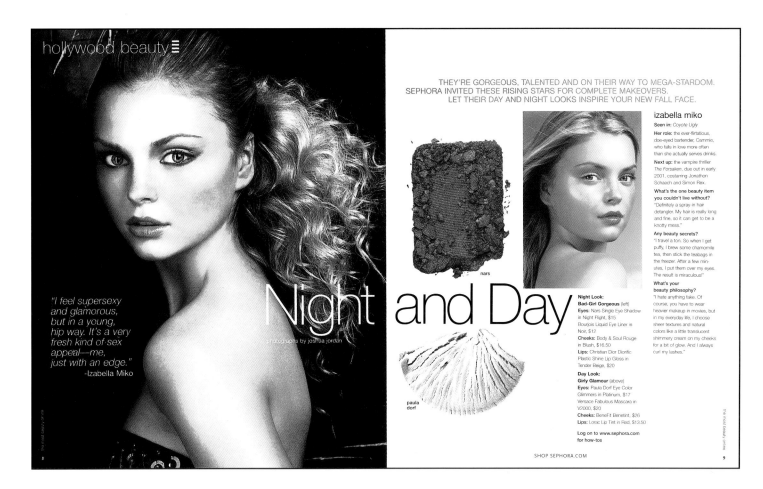

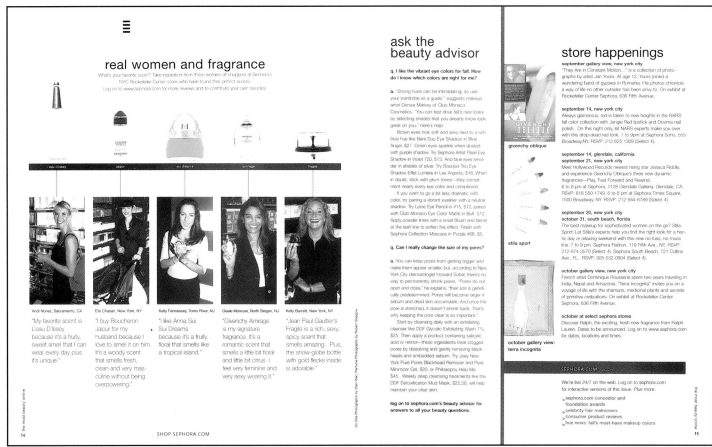

A list of store events in magazine is designed to drive traffic to the store.

BEST LIPS

Gwyneth Paltrow
Hollywood's starlet of the millennium captures this season's glossy lip look perfectly. To celebritize your pout, go for a glam, glossy finish in a rich coral shade.
Try: Christian Dior Diorific Long-Wearing True Color Lipstick in Cancan Orange, $22, topped with Cargo Lip Gloss in Hong Kong, $15.

BEST EYES

Naomi Campbell
Go for Naomi Campbell's sexy supermodel gaze by applying a burgundy shade over lids and just beneath lower lashes. Brush on two coats of mascara. Then wink!
Try: Urban Decay Eye Shadow in Roach, $14.

Ashley Judd
Ashley Judd's soft lilac shadow is a year 2000 forget-me-not. To get her floral fantasy look, brush a violet powder shadow across lids, into crease and above.
Try: Lorac Eye Shadow in Wisteria, $16.

Christina Aguilera
Christina Aguilera's sparkly smolder is what every girl wants. To copy her "come-on-over" eye effect, rim eyes in a glittery dark shadow.
Try: BeneFit Swingin' Sweetie Eye Sparkle in Hustle, $14.

BEST NO MAKEUP
Cameron Diaz
Cameron Diaz is a natural angel. To steal her understated pizzazz, swipe mouth with sheer color.
Try: Stila Lip Glaze in Fruit Punch, $24 (created for Diaz's Angel character) by Stila founder Jeanne Lobell.

BEST CHEEKS
Julia Roberts
Starring as the cheeky Erin Brockovich this year gave pretty woman Julia Roberts reason to blush—beautifully.
Try: Hard Candy Cream Blush/Highlighter in Babydoll, $28.

BEST SKIN
Michael Michele
Ever radiant Michael Michele gets our award for the smoothest (operator) in the ER. To get her glow, cleanse with an exfoliator and rinse.
Try: Caudalie Grape-Seed Buffing Cream, $34.

BEST MOM LOOK
Madonna
The maternal girl popped up at a bash for her new CD in baby-inspired pastel eyes and pink lips.
Try: On eyes, Urban Decay Eye Shadow in Pallor, $14. On lips, Club Monaco Lip Gloss in Cherub, $13.

MOST FEMININE
Ashley Judd
A true southern lady, the demurely blushed and lusciously lipped Ashley Judd is the belle of every ball.
Try: Try Vincent Longo Duo Day/Play Blush in Ultra, $18, and Versace Hydrating Lipstick V2016, $20.

MOST GLAMOROUS
Charlize
Dressed...
Theron...
For star...
shimme...
Try: Vin...
Eyesha...

BEST HAIR-LONG

BEST HAIR-SHORT

The November/December issue of Sephora's magazine.

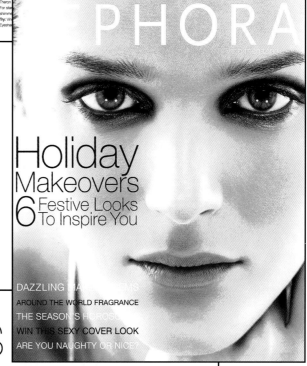

PHORA

Holiday Makeovers
6 Festive Looks To Inspire You

DAZZLING ...
AROUND THE WORLD FRAGRANCE
THE SEASON'S HOROSCOPE
WIN THIS SEXY COVER LOOK
ARE YOU NAUGHTY OR NICE?

makeup mania

Glam Rocks

Emerald
Generously coat your lids and nails with the color of money for a rich, rebellious effect.
1. Nars Nail Polish in Zulu, $15
2. Anna Sui Nail Color in #907—glittery green, $13
3. Stila Eye Shadow in Jade, $15

Ruby
Even Dorothy knew the power of rubies. Slick on this sexy shade to add eye-popping sizzle to your party persona.
1. Club Monaco Nail Color in Real Red, $9
2. Nars Lipstick in Shanghai Express, $19
3. BeneFit Swingin' Sweetie Eye Sparkle in Swing, $14

Canary Diamond
For all of your precious—and semi-precious—occasions this season, put a little sparkly, sun-lit gleam on eyes, lips or cheeks.
1. Cargo Lip gloss in Kissimmee, $15
2. Sephora Artist Pearl Cream in #862, $11
3. Givenchy Vernis Miroir in #715, $15

Sapphire
Dust eyes and layer lashes with this deep blue hue for a sensual yet sophisticated stare this holiday season.
1. Vincent Longo Eyeshadow Trio in Forever, $20
2. Hard Candy Single Eye Shadow Loner in Spacey, $14
3. Sephora Collection Mascara in Blue #77, $5

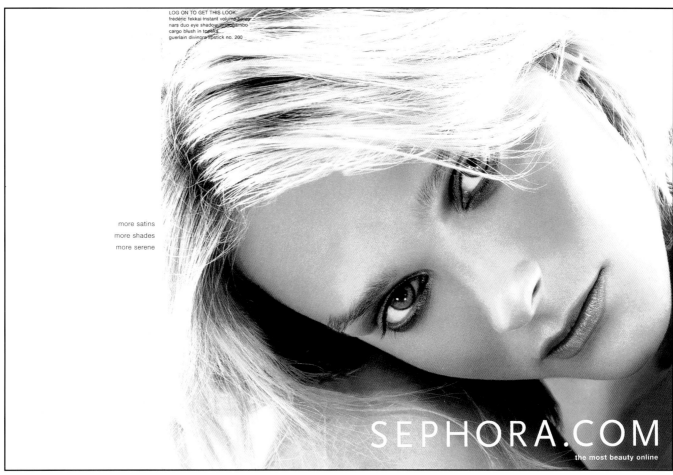

LOG ON TO GET THIS LOOK:
frédéric fekkai instant volume spray
nars duo eye shadow in mogambo
cargo blush in toneka
guerlain divinora lipstick no. 200

more satins
more shades
more serene

SEPHORA.COM
the most beauty online

The 'more, more, more' campaign with Estella Warren and Carmen Kass, includes a "beauty note" in the corner of each image, giving brand product information for obtaining the look worn by the models.

research products, get the very latest beauty news, shop for gifts, get free beauty advice from the experts, and read regular weekly beauty features.

As part of what Olum referred to as "one company one brand one voice," Sephora places strong emphasis on cross-promotions and marketing. "We see Sephora as one strong brand, and all aspects of Sephora's consumer outreach—whether advertisements, direct mail pieces, or promotional events—relate to both the Sephora stores and Sephora.com," she pointed out.

Start-up strategies for building brand equity are a mandate not only for new brands, but for brands that need to reinvent themselves. By creating expert advice and assistance for the online and offline beauty products customer, Sephora is **POSITIONING THE IMAGE OF BRAND** as the unique individual experience offered by a bricks-and-clicks beauty retailer.

"Examples of cross-promotion marketing were the bi-monthly magazine, a major promotion vehicle, available online as well as distributed via free-

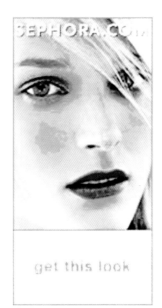
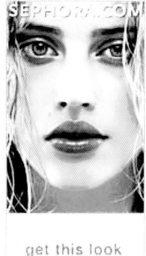

get this look get this look

Banner ads.

get this look

WRAPPER'S DELIGHT
Sephora presents the season's best
in new and notable fragrances,
special holiday gift sets and stocking
stuffers that surprise and delight.
Page 08

PRESENT SCENTS
Nothing is as personal as a gift
of fragrance. Explore the most
exquisite scents from sensual and
exotic to timeless and classic.
Spark a special feeling.
Page 24

LIFE OF THE PARTY
Celebrate the people you love and
the people who make you laugh.
Great gifts for your partner, your
pals, your family and all the kids,
from tots to teens.
Page 30

KISS AND MAKEUP
Look and feel brilliant at every
holiday event with makeup colors
guaranteed to make you dazzle.
Page 40

UNWRAP YOURSELF
Let go of tension and treat your
body, mind and soul to a private
spa experience with our unique
collection of well-being products.
Page 48

SOAKING IN IT
Take the daily ritual to new heights.
Immerse yourself in bath and body
care that make the everyday amazing.
Page 52

GOOD TO GO

Holiday Wrap Party

Sephora is where the pleasure of giving begins.
Celebrated as the ultimate source in beauty,
Sephora makes your world a lovelier place.
Now with Sephora's first catalog, we bring our
store to your fingertips. Sephora's Holiday
Catalog features the best of the best, selected
to simplify your shopping experience. Just in
time for the holidays, we've added more gift
sets, the newest and hottest selling scents,
and the most brilliant concepts in cosmetics.
Be sure to look for the ● symbol, the sign of a
Sephora exclusive. As our client, you're always
invited to visit us online at Sephora.com or
to indulge at any Sephora store nationwide
to explore more than 600 fragrances, 150
treatments and 60 makeup lines. Sephora's
got boundless beautiful ways to get you and
your loved ones glowing for the holidays.

**The 62-page holi-
day catalog was Sephora's first.**

standing kiosks in hard copy form within Sephora stores. The editorial from the magazine guides customers in the stores and website, and gives them insight into the newest looks, hottest trends and celebrity favorites. While the magazine was a lush presentation of products sold in the store, it also offered familiar magazine service fare such as beauty tips and horoscopes.

It's all part of promoting that seamless experience. "To leverage bricks-and-mortar and the web is to bring to life all the content in the magazine," said Olum. For example, she explained that customers could register their e-mail address in-store for whatever promotion was going on at that time. "We try to bring those stories to life in store."

Take a recent feature, like Passport to Perfect Skin. "We bring that experience in store so customers can experiment," she said. "Or they could go to the website. They had a very enhanced experience wherever they went."

Sephora broadens and deepens the customer's experience by providing her with opportunities to experiment with their products. These experiences can become **BRAND ATTRIBUTES** that enhance the customer's reasons to buy the brand and to stay with the brand.

Sepora's inaugural holiday catalog was distributed to more than a million customers. "Holiday will really wrap up the whole year for us," said Olum. "We're shipping 800,000 copies for use in store, and through direct mail targeted 500,00 people in the U.S. Additionally, a version of that catalog is available online."

The catalog organized products into seven general categories, each of which was also being re-created in Sephora stores through "gift trees" and special store sections. Even its design was consistent; the blue and silver colors of the catalog were mirrored in the holiday décor and gift packaging of Sephora stores and the website.

Whereas the magazine was being published every two months, the catalog was to be more seasonal. According to Olum, the idea behind the catalog was to present product in an easy-to-shop manner that communicated the beauty of giving—an idea that's reflected in the in-store environment, the website and the magazine.

"The beauty of giving" is a Unique Selling Proposition (U.S.P.) for the brand that is based on the knowledge that beauty products are high on the gift-giving list. **Sephora brandstands its brand's unique positioning with its in-store, Web and magalog visualization.**

The company promoted the website aggressively with national advertising in key beauty, fashion and lifestyle books throughout the 4th quarter. In addition, ROP ads appeared in key local markets emphasizing the beauty of giving for holiday.

The ads focused on the compelling benefits of the Sephora.com site. The most compelling

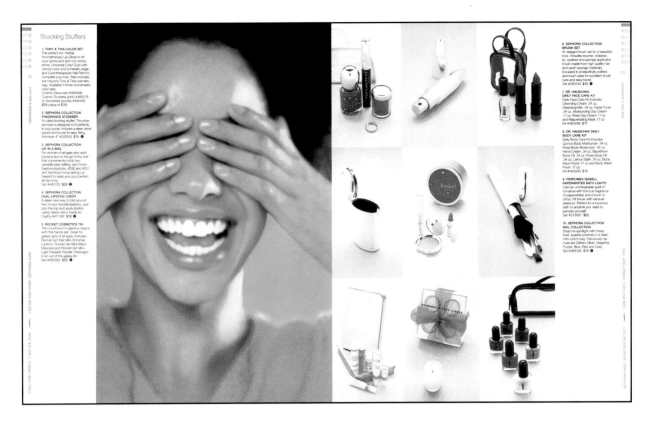

Kiss and Makeup

The holidays are happening in gorgeous living color, so get decked out and put yourself on display. Abandon your workplace neutrals to embrace the drama of the season. As the ultimate color authority, Sephora will transform you into the most brilliant ornament on the scene. The makeup message for these magical moments is colorful yet clean, shiny yet sheer. This season's palette features precious shades in delicate iced pinks and blues, jewel-rich reds and wines, and lively limes with plenty of shimmer to let your inner princess rise to the occasion. Select from our supply of unexpected stocking stuffers, purse sized touch-up kits, sets for the complete makeover and brushes to bring out the artist in everyone. Sephora has you covered with the right look to fit any occasion. The time to dazzle is now. Merriment is what you make it.

creation of a seamless shopping experience, no matter where Sephora customers choose to shop," Olum explains. "We're very much a multichannel company. We can fill all the client's needs by web, developing a relationship with her, always with a focus on the client experience. We're evolving as we see what our customers respond to."

Sephora USA LLC, San Francisco, CA
CEO SEPHORA (U.S. AND ASIA-PACIFIC): **David Suliteanu**
CEO SEPHORA.COM: **Jim Wiggett**
SENIOR VICE PRESIDENT MARKETING: **Betsy Olum**
ADVERTISING AGENCY: **Lloyd (+Co),** New York
WEBSITE: **Sephora.com**

Catering to the Dot-Com Customer

e LUXURY.

Today's style, tomorrow's trends.

Jane,

eLUXURY is your source for
SPRING DREAMING
Get everything you've ever wanted for the freshest season of the year including delicious treats for Easter plus beautiful dining and décor items for your home.

Guaranteed delivery before Easter Sunday when you order by Tuesday, April 10th.

Visit the online
WOMEN'S SPRING FASHION CATALOG

ALTMANN & KUHNE
Easter Egg Chocolate Bon Bons $50

| CREEKSIDE FARMS
Spring Rose Hydrangea Wreath $99 | BVLGARI
Dolci Deco High Teacup & Saucer $215 | | BVLGARI
Home Fragrance Set $108 |

• D'Artagnan's delicious Rack of Lamb
• Baccarat's beautiful Lucky Butterflies

If you no longer wish to receive email put the word UNSUBSCRIBE in the S

eLuxury places considerable emphasis on e-mail marketing.

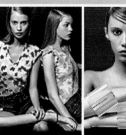

e LUXURY.

Today's style, tomorrow's trends.

Jane,

See what we have for you in our
Spring Fashion Catalog
The names you love and the latest designs you want are all here. Come shop for everything you need to update your wardrobe for spring.

Go to eLUXURY.com now.

Go to the online
WOMEN'S SPRING FASHION CATALOG

CHRISTIAN DIOR
Saddlebag $790
Denim mule $255
Fishnet tights $30

GIVENCHY
Pick-Pocket
Minibag $125

MARC by
MARC JACOBS
Pop Floral Tees $88

BOTTEGA VENETA
Square Plastic
Bracelet $120 each

• T. LeClerc goes neutral, the new look
• Dior's sexy-sweet Dolly Jewelry
• Coach's Signature C Collection
• Tops from Daryl K-189 and Earl Jean

Frequent e-mails keep customers advised on what's new with their favorite brands.

WITH ITS DAZZLING array of high-status brands, products, and luxurious services, the eLUXURY.com objective was to be the Rodeo Drive of the Internet—a unique site that catered to every aspect of a luxury lifestyle.

Launched in June 2000, when the rush to the Web was rampant, eLuxury sought to carve out a unique niche—enabling consumers everywhere to have access to goods and services that, until then, had only been available in a limited number of cities and key locations.

• Brand Awareness
• Commitment Branding
• Destination Branding

BRANDSTANDS

With many dot-com up-and-comers newly goners, eLuxury was enjoying the luxury of not only being a dot-com survivor, but a dot-com success.

How would this e-tailer succeed where others have not? For some of the answers Brandstand listens to Barbara Wambach, who was instrumental in the merchandising and marketing of the site.

Like many new e-commerce companies, eLuxury initially engaged in an all-out advertising blitz. Print was the medium and before you can say "million-dollar-look," page after page of cheeky 4C ads were splashed across virtually all the top fashion magazines.

"When we launched the site, we didn't have any brand awareness at all," noted Wambach, "so it was important to do a massive, broad platform that said 'we're here, come visit.'" **This is a BRAND AWARENESS strategy that does need a mass media plan.** That platform also included newspaper product placement ads right in front of gift-giving periods. There was a very good response rate to the newspaper ads. In lieu of magazine ads, the company continued to do retail-oriented newspaper ads in major newspapers in targeted cities, specifically, the *New York Times,*

The brand awareness-building magazine campaign consisted of consecutive spreads.

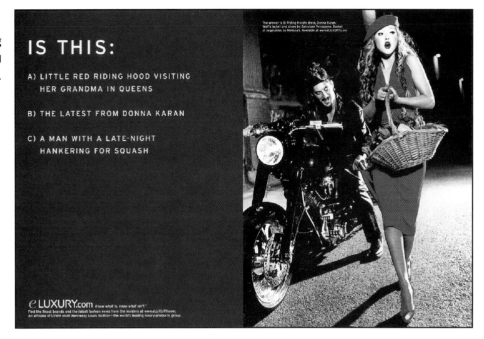

Los Angeles Times, Chicago Tribune, and *Miami Herald.* The ¹/₂ page and ¹/₄ page ads featured one product per ad, and were timed to coincide with special occasions such as Valentine's Day, Mother's Day and the holiday season.

"One of the strategies that worked to our advantage was an initial focus on customer relationships. That was as important when we launched as the brands we carried on our site," said Wambach. **The company paid careful attention to authoritative editorial and exemplary, responsive service from the get go.** "We have secured a very loyal, fairly fast-growing customer base, which proves to those who have invested in our organization that there is a sound future as opposed to some other sites that were focused on highly aggressive marketing, high traffic, and heavy discounting, which don't lead to a long-term customer relationship."

Making a **COMMITMENT** to customers and stakeholders is what makes this brand strategy different from some of the thoughtless dot-com market-sling that characterized the first e-tailing.

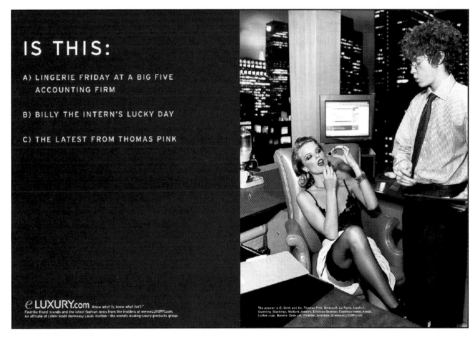

Like any start-up, however, marketing a dot-com company was, as Wambaugh readily acknowledged, a definite learning experience. Simply having authoritative content and lifestyle-oriented editorial features on the site to inform visitors about the specifics of the good life was not enough. As Wambach was quick to point out, "We were not as directed or focused on e-mail marketing, which is talking to a consumer who is interested in shopping as opposed to a customer who is interested in reading."

That has changed. E-mail marketing played a major part in eLuxury's strategy. "All of our marketing breaks into two fronts—acquiring new customers and retention," she explained. "We send various e-mails to various audiences based on content on our site, so we can serve up content and news that would be most interesting to them."

Making websites and catalogs as important

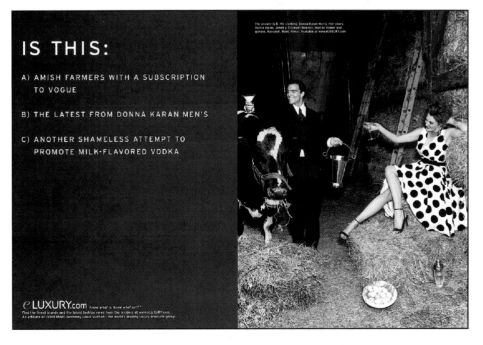

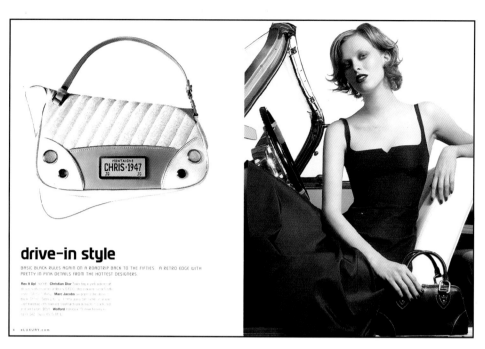

as store **DESTINATIONS** is now the most effective strategy for customer retention. These customers who are now accustomed to a multichannel **seamless** shopping experience want to be surrounded by information and services.

The frequency of e-mails to customers varies. The e-mails are targeted by customer segments according to the brands and categories that are of the greatest interest to these customers. The company places a lot of emphasis on trying to share information that these customers will want to know (for example: the arrival of the new Dior collection is something many eLuxury customers have indicated they're waiting for.) In addition, general messages, such as Valentine's Day gift ideas, are sent once per month.

The company has a strong direct mail program in place for which it uses various rental lists. Prospect mailings have a specific focus—men, women, home and gourmet, etc. In November a direct mail catalog was produced for holiday. There was a considerable amount of copy, which explained what eLuxury was all about. A second, more visually ambitious catalog focusing entirely on women's fashion and beauty, was mailed to 500,000 women in March.

The catalog, complete with supermodels, had 52 pages of pure dazzle. In fact, it really looked more like a serious fashion magazine than a catalog, from the cover photo and throughout the spreads, which integrated the merchandise into the fashion magazine feeling. "The print medium is part of our branding campaign," said Wambach. **"We want to be the destination for style, so we wanted an authoritative piece presented in a way that is also a branding piece."** The catalog, including all photography, was created and directed by Alex Gonzalez, eLuxury's new consultant/creative director of A/R Media, New York.

Supplementing the catalogs were small pieces, more or less in the form of announcements, such as some sale announcements in January.

"Basically, we have been targeting our house file customers with direct mail, more so than prospecting," Wambach explained. The customer retention programs, whether

This catalog places more emphasis on style and specific items.

This mailer is designed for a narrow target—the luxury handbag customer. The circled area features an actual swatch.

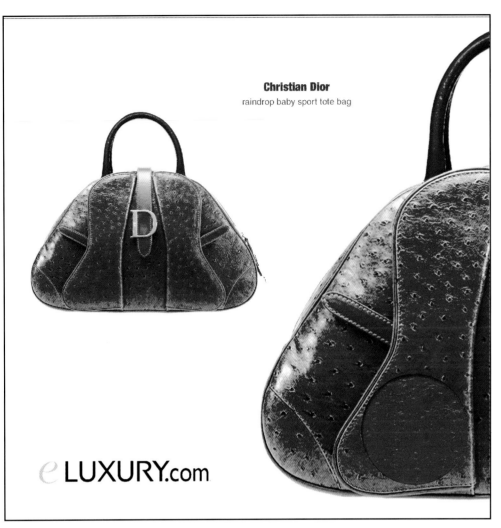

Christian Dior
raindrop baby sport tote bag

*e*LUXURY.com

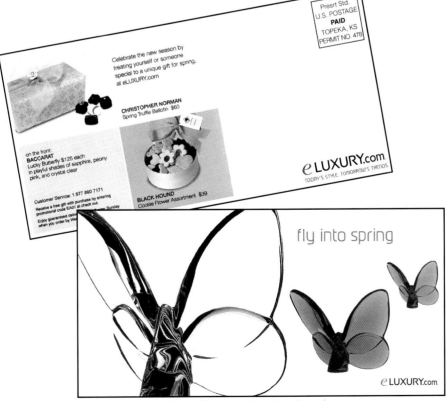

Samples of occasional direct mail postcards.

e-mail or print direct mail, are narrow in scope. The customer relationships the company has forged have led to detailed data such as knowing exactly what customers' favorite brands or favorite categories are. **"We try to serve up what's new in a category, or what's new with a brand, e-mailing all our customers who have bought that brand or categories. Customers like to get e-mail with a fair amount of frequency."**

A very sophisticated handbag mailer however, will have extremely narrow distribution. Most of the handbags are priced in the $1,000 plus range. "This is a very select list we're sending to," said Wambach. "It's for only 1,000 VIP customers who purchase designer handbags at that price point. It's very much a loyalty program." The mailer was so elegant, it was designed with a real swatch. (At those prices, you *should* be able to feel the goods!)

eLuxury, San Francisco
PRESIDENT: **Barbara Wambach**
AGENCY: **In-house** (Consultant) **Alex Gonzalez**
AGENCY (color magazine spreads) **Goodby, Silverstein & Partners,** San Francisco
WEBSITE: **www.eluxury.com**

Pushing the Envelope

- Brand Awareness
- Brand Associations
- Benefits Branding

BRANDSTANDS

RedEnvelope, an online upscale gift company, was based on a concept that distinguishes it from other e-commerce retailers. It get its name from an idea inspired by an old Asian tradition, whereby precious gifts were presented on important occasions with a red envelope—a sign of luck and prosperity. The company revived this tradition in a thoroughly modern way. Each gift comes with the sender's personal message in a distinctive red

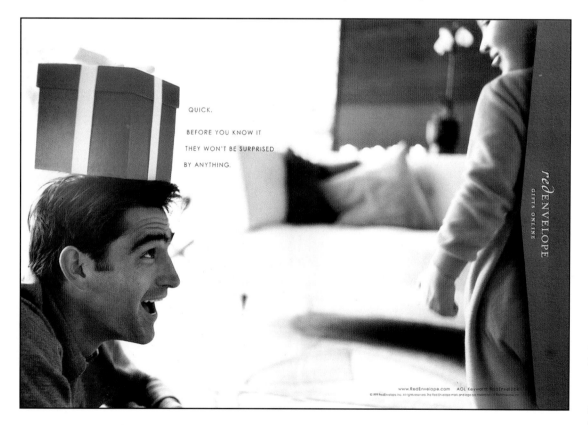

QUICK.

BEFORE YOU KNOW IT
THEY WON'T BE SURPRISED
BY ANYTHING.

envelope. The gift package, a red gift box with a hand-tied bow, further enhances the cachet.

Unlike many online retailers, for whom the gift-giving element is secondary to self-purchase, RedEnvelope positioned itself as only for gifts. "The Williams-Sonoma, Banana Republic, Pottery Barn customer is the consumer we're going after," said Lesa Mucotto, vice president, marketing. "We want to develop educating the public around celebrating

every day, and the moment around key gift-giving holidays. In Asian cultures there's a formality and a celebration around gift giving, and there are wonderful traditions around the world as well that we'd love to bring to the American consumer in terms of items, presentation and ceremony."

Here was a **BRAND ASSOCIATION** strategy that RedEnvelope was using to differentiate itself from other e-tailers. For its upscale consumer market, it was creating **meaning** derived from the consumers' values and attitudes about gift giving.

The company was off to a fast start. In a mere six months, a major marketing effort had taken RedEnvelope from near oblivion to a recognized force in the e-commerce universe. It was critical for RedEnvelope to act quickly and decisively to get itself up and running and marketed to the public before the holidays, given the wealth of new companies jockeying for position. The RedEnvelope name was formally announced and the site was open for business.

There was a new set of challenges—namely to **immediately create BRAND AWARENESS and attract visitors to the site.** With little company identity and facing the holiday season when e-commerce retailers were pulling out all the stops, RedEnvelope made the decision to devote roughly $20 million—no less than a third of its money to advertising.

The company's first impulse was to produce a TV campaign, which would reach its audience faster than outdoor and print ads. But the cost would be prohibitive, so other media was considered to be more effective in the end.

The company enlisted the help of Leagas Delaney, an agency with experience working

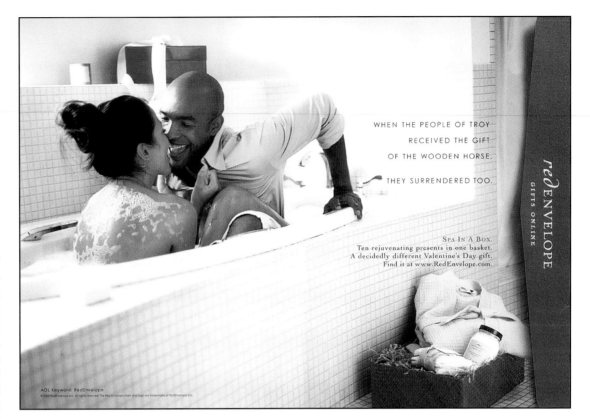

WHEN THE PEOPLE OF TROY
RECEIVED THE GIFT
OF THE WOODEN HORSE,
THEY SURRENDERED TOO.

SPA-IN-A BOX.
Ten rejuvenating presents in one basket.
A decidedly different Valentine's Day gift.
Find it at www.RedEnvelope.com.

redENVELOPE
GIFTS ONLINE

for other web firms. A series of print ads for the holiday season followed. Two elements were a given in every ad—a depiction of the moment after a gift is opened, and showing the flap of a red envelope. "We focused on the magic of the moment of gift giving," said Mucotto. "The red box and red envelope play a very prominent role in the ads. For Valentine's Day and Mother's Day, we're taking more of a product focus."

Here, BENEFITS BRANDING that "makes the consumer the product" is RedEnvelope's strategy. Helping the consumer as gift-giver become the major part of the gift worked so well for **Tiffany's**... in that case it was "color me blue."

The first group of ads appeared on buses, bus shelters, airport kiosks, billboards and in newspapers in the six launch markets— Boston, Chicago, Los Angeles, New York, San Diego and San Francisco. Special double-decker buses, decorated with giant red bows and images from the print and outdoor campaign, started rolling in six launch markets the end of November to increase awareness of the site during the holiday shopping season. The buses drove through shopping districts, along popular commuter routes and nightclub areas, and around airports. The ads appeared nationally in 21 magazines.

Another key element in the strategy was based on partnerships with online hubs plus a select group of more targeted sites such as iVillage.com and those devoted to weddings and babies. According to Mucatto, the company was considering additional partnerships. "We're looking not only for traditional strategic partnerships but in strategic areas in all areas of marketing," she said.

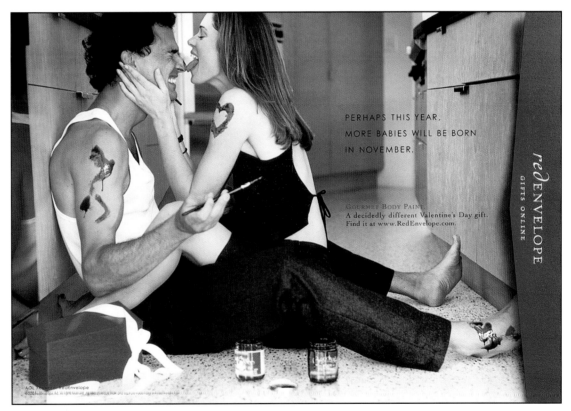

PERHAPS THIS YEAR,
MORE BABIES WILL BE BORN
IN NOVEMBER.

GOURMET BODY PAINT.
A decidedly different Valentine's Day gift.
Find it at www.RedEnvelope.com.

redENVELOPE
GIFTS ONLINE

Ads ran in key upscale fashion, men's, epicurean and shelter publications.

RedEnvelope was also moving beyond being strictly a conventional e-commerce business. For Valentine's Day it distributed its first catalog and was encouraging phone and fax orders. Mucatto pointed out that while the company was an e-tailer, it was well aware of the degree to which the the consumer has redefined shopping. The company was looking at the opportunity a bricks-and-mortar store could present.

DECIDEDLY DIFFERENT
Valentine's Gifts

redENVELOPE

FREE OVERNIGHT SHIPPING
See back cover for details.
www.RedEnvelope.com

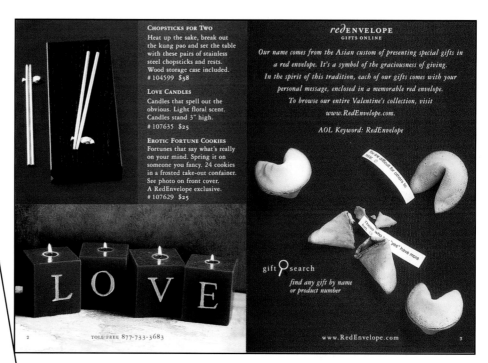

CHOPSTICKS FOR TWO
Heat up the sake, break out
the kung pao and set the table
with these pairs of stainless
steel chopsticks and rests.
Wood storage case included.
#104599 $38

LOVE CANDLES
Candles that spell out the
obvious. Light floral scent.
Candles stand 3" high.
#107635 $25

EROTIC FORTUNE COOKIES
Fortunes that say what's really
on your mind. Spring it on
someone you fancy. 24 cookies
in a frosted take-out container.
See photo on front cover.
A RedEnvelope exclusive.
#107629 $25

TOLL-FREE 877-733-3683

redENVELOPE
GIFTS ONLINE

*Our name comes from the Asian custom of presenting special gifts in
a red envelope. It's a symbol of the graciousness of giving.
In the spirit of this tradition, each of our gifts comes with your
personal message, enclosed in a memorable red envelope.*

*To browse our entire Valentine's collection, visit
www.RedEnvelope.com*

AOL Keyword: RedEnvelope

gift search
*find any gift by name
or product number*

www.RedEnvelope.com

The catalog for
Valentine's Day Gifts, the
company's first, was done
in-house. The 14-page
catalog was mailed to
targeted lists as well as
RedEnvelope's database.

SPA IN A BOX
Escape to the spa, at home.
Woven bamboo box contains
tub teas, all-natural soaps,
mineral salts, and aromatherapy
candle with enticing basil-
nectarine fragrance. Unexpectedly
invigorating, because clean is
sexy. Waffle-weave cotton robe
and slippers included, with
Tranquility CD and "The Art of
Doing Nothing" book.
A RedEnvelope exclusive.
#107233 $195

www.RedEnvelope.com

*Nothing says it better than
flowers. Ours come direct
from the growers, so they're
even fresher than flowers from
the florist. It's guaranteed.
Visit our online store for the
complete collection.*

About Floral Delivery:
Please allow one day for order processing.
Next-Day shipping only.
Orders placed Thursday through Sunday ship
the following Monday. We're unable
to accept orders to Hawaii and Alaska.

ONCIDIUM ORCHIDS
Live orchid with polished
aluminum planter. Lush.
Exotic. Guaranteed to surprise
and delight. #107005 $75

ROSES
Premium red roses with stems a
full two feet long. Available in
bouquets of two or three dozen,
because one is never enough.
#107170 $98-$138

FRENCH TULIPS
Ten blushing tulips. From Holland,
where they were once worth more
than their weight in gold. Stems
a luxurious two feet long.
#106882 $65

www.RedEnvelope.com

RedEnvelope, San Francisco
CEO: **Hilary Billings**
VICE PRESIDENT MARKETING: **Lesa Mucatto**
ADVERTISING AGENCY: **Leagas Delaney,** San Francisco

The Freshest Branding Yet!

ALTHOUGH just about everyone who's engaged in marketing, advertising and promotion seems to be jumping on the branding bandwagon these days, there are still some notable exceptions. Take supermarkets. The vast majority have been slow to acknowledge the importance of establishing an identity despite the fact the industry is extremely competitive.

Typically, instead of branding, supermarket advertising and promotion remains largely price-item driven. One of the few supermarkets that actually does branding is Marsh Supermarkets in Indianapolis, IN, a family-run chain considered one of the Midwest's premier retailers.

Marsh had always stood apart from the cookie-cutter crowd, consistently branding itself as the quality supermarket. This positioning had been reinforced in every area, from choice locations and visually appealing store interiors to quality of service (Marsh was the first grocery store in the world to use high tech scanners at checkout) and, last but certainly not least, the quality of its goods.

BRAND IMAGE POSITIONING is an ongoing program and communications to **differentiate** the brand. This difference is in the uniqueness of product attributes, customer benefits and personalized services. And certainly the **fashion specialty store** appeal in the advertising campaign is different.

So it's hardly surprising that Marsh's advertising also trumpeted the quality message. But this branding campaign put a new spin on quality that went far beyond what might be expected. The result: supermarket advertising the likes of which wasn't anything supermarket customers had ever seen before.

The new campaign came about when Marsh, together with its advertising agency, Columbus, OH–based Ron Foth Advertising, decided it wanted to do something nontraditional and breakthrough. "Marsh is known for freshness," said Ron Foth, Sr., agency president and CEO. "So we sat down and thought about what we could do to take freshness to another level."

ATTRIBUTES BRANDING: They decided to build the campaign around the freshness of Marsh's produce. "Produce is the number-one purchase driver in supermarkets," Foth explained. "It's usually the first thing you see up

- Brand Image Positioning
- Attributes Branding
- Spiral Branding

BRANDSTANDS

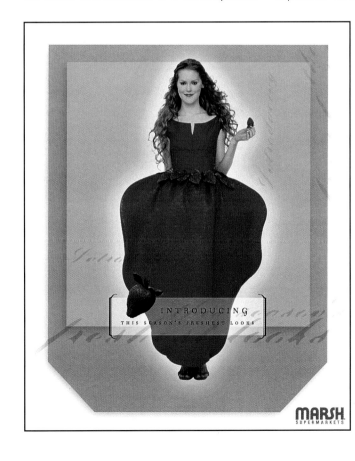

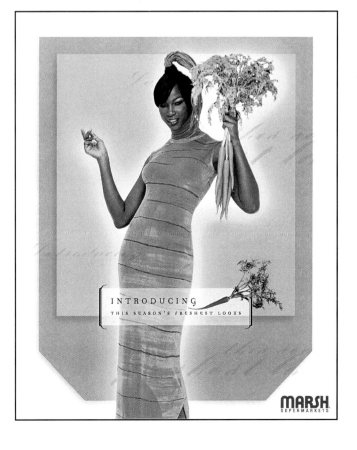

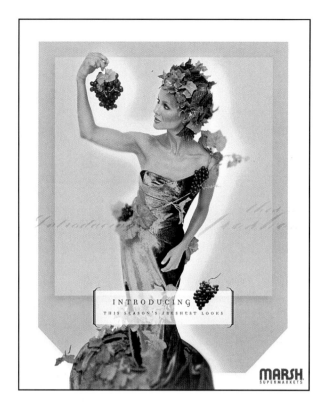

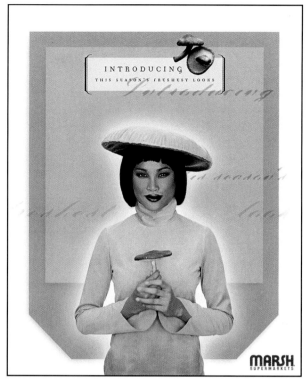

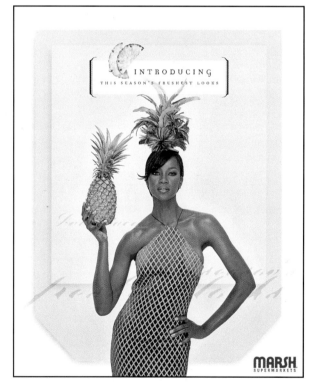

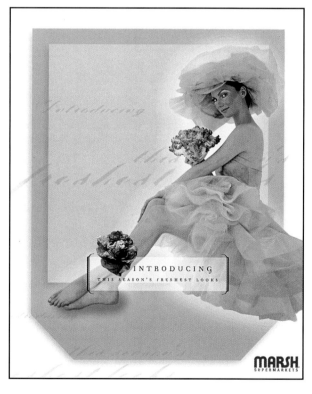

front in the store."

But in the case of the new campaign, this was produce with a twist. "People already know that fruit and vegetables are good for you," said Foth. "But an important element in branding advertising is making an emotional connection, so what we needed to do was use fruit and vegetables in a way that would produce an emotional connection with shoppers."

Giving a special **meaning** to the brand is an effective builder of brand equity. Making the emotional connection with a fashion appeal provides Marsh's brand of "freshness" with a unique selling proposition.

The creative solution: adding fashion to the mix. "Fashion is a subject their target female customer could identify with," noted Foth. Hence, the concept of "stylish produce"—an unusual juxtaposition of high fashion and fresh produce, which Foth pointed out, "all came together with the theme line 'Introducing the season's freshest looks.'"

And fresh they were!

The unusual television, magazine and in-store branding campaign featured fashion mod-

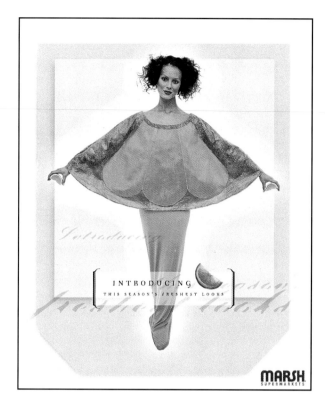

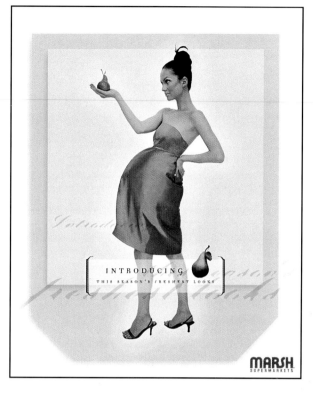

els presenting a variety of fresh fruit and vegetables. The models were dressed in high-style fashions that match the produce.

Brand concept managers develop creative strategies for **SPIRAL BRANDING** that integrate multimedia advertising, sales promotion, special events and public relations to attain their branding objectives.

Everything was done from scratch. The agency had the advantage of long experience in fashion advertising (handling all the broadcast for Saks Inc.'s group of stores). Each of the

looks in the print ads and the TV commercial was closely tied into the merchandising. "We started with the produce itself," said Foth, "then asked ourselves, within produce what are the key features? What would that costume look like? Then we brought in the people who normally work with us with fashion advertising to help us create the fashions—something that was sophisticated and stylish. Then we designed scenarios for each of the shots."

The campaign was launched in mid-July, running throughout the summer produce season. Media included full-page ads in the *Indianapolis Star* and three or four consecutive pages in *Indianapolis Monthly*, the sophisticated city magazine. The TV spot ran in the Indianapolis metropolitan area. The images were carried out in-store with large poster-size boards.

Combining grapes and tomatoes with haute couture may not be the first thing to come to mind for a branding campaign. But in terms of achieving an objective, it's definitely food for thought!

Marsh Supermarkets, Indianapolis, IN
AGENCY: **Ron Foth Advertising**, Columbus, OH
PRESIDENT/CEO: **Ron Foth, Sr.**
CREATIVE DIRECTORS/COPYWRITERS: **Ron Foth, Jr., David Henthorne**
ART DIRECTORS: **Ken Waldron, Gene Roy, David Shultz, Emily Lloyd**
PRODUCER: **Ted Gordon**
EDITOR: **Martin Nowak**
ACCOUNT SUPERVISOR: **Mike Foth**
PRODUCTION COM. **Platinum Productions**, Columbus, OH

The TV spot featured music that was custom scored to sound vibrant and hip. The whole spot felt like one delicious fashion show.

Back to Business

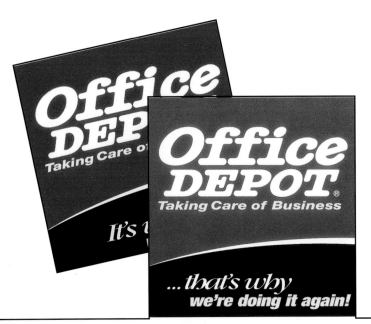

Taking Care of Business

In our stores...
and everywhere else!

Soon, you'll notice the impact in our retail stores. The *Taking Care of Business* theme will appear store-wide: on signage, bags, employee tags and uniforms. Plus, it will be featured on-hold, online and on the walls of arenas and stadiums. In the year 2000, *Taking Care of Business* will be everywhere!

Most importantly, the ideals of this campaign will be felt: in our stores, at our corporate headquarters, in the business community and beyond. Because at Office Depot, *Taking Care of Business* is more than just a catchy slogan. It's a genuine business philosophy that is at the heart of the way we do business.

A special mailer containing a CD of the "Taking Care of Business" music was mailed to the trade to announce the details of the Taking Care of Business' relaunch.

In Print

Taking Care of Business is now being incorporated into every piece of print advertising we produce. Newspaper inserts, catalogs, direct mail pieces, billboards and more will all reflect this new look. Our ads will run in magazines such as PC World, Fortune, Ladies Home Journal and major newspapers across the country.

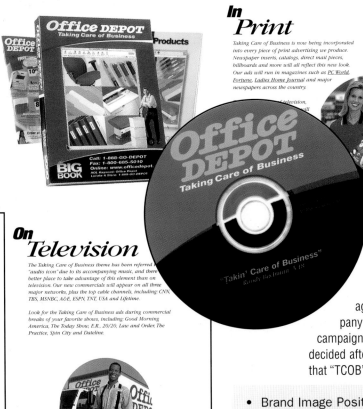

On Television

The Taking Care of Business theme has been referred [to as an] "audio icon" due to its accompanying music, and there [is no] better place to take advantage of this element than on television. Our new commercials will appear on all three major networks, plus the top cable channels, including: CNN, TBS, MSNBC, A&E, ESPN, TNT, USA and Lifetime.

Look for the Taking Care of Business ads during commercial breaks of your favorite shows, including: Good Morning America, The Today Show, E.R., 20/20, Law and Order, The Practice, Spin City and Dateline.

THE YEAR 1986 was a pivotal year for the office products industry. For decades it had been dominated by small independent specialty stores who typically charged the manufacturer's suggested retail price. The arrival of Office Depot revolutionized the industry in terms of sheer volume of goods and discounted pricing far below what had been the norm.

More than ever, the **MARKETING SITUATION** in every industry is constantly changing. These marketplace dynamics affect target markets and the brand loyalties of consumers.

Office Depot had not only helped transform the office products industry, but with more than 850 stores throughout the U.S., Canada, France and Japan, it had also become a major player in warehouse retailing—the world's largest reseller of office products.

The advertising that emerged "Taking Care of Business" (TCOB) was designed to sum up the feeling of shopping at Office Depot, with its huge selection, volume discount pricing and customer service. Then, as is typical with national advertising, new campaigns took over.

The brand requires constant monitoring and evaluation of its **BRAND IMAGE POSITIONING** and meaning to its primary target audience, as well as its awareness and appeal to a secondary target audience.

Office Depot was on a course of aggressive retail expansion, so the company launched what it considered its best campaign ever to help achieve its goals. "We decided after several years of alternative tag lines that "TCOB" was at the heart of our business strategy," said Walter Porras, creative director. The theme is more than just a catchy slogan. For the company, it is a genuine business philosophy.

- Brand Image Positioning
- Brand Associations
- Attributes Branding

BRANDSTANDS

The magazine inserts reached a big audience. Circulation for *Fortune Tech Buyer's Guide* was one million; *PC World's*, 1,250,000.

price and product in inserts, branding through broadcast, etc.). **creative strategy** as in this case, must include a media strategy to attain **marketing objectives.**

The retailer also used direct mail as "a strategic tool to generate sales from our customer base," said Porras. "As an example, we target local businesses to support grand openings, mailing them an announcement inviting them to a retail event." The largest direct mail campaign centered around a catalog "The Big Book," which is sent to more than 17 million customers every year.

Because of the large number of stores that opened in 2000, a major part of direct mail was being devoted to grand openings.

In keeping with its marketing objective to reach all its audiences, Office Depot engaged in ongoing sports-related advertising. "We believe in establishing brand loyalty with our customers through a variety of channels," said Porras. "Our contract partnerships with various sports teams and venues allow us to maintain a constant presence in front of an audience that matches our demographics."

Office Depot's marketing strategy was to reach all its audiences throughout the year with targeted messages and promotions.

According to Porras, the basic creative strategy was to use "simple, direct formats that deliver the message appropriate to that vehicle (i.e.

The scene is the hallways of a school right before school opens. Players are a long-time janitor and a new young man on the job. Talk is of how rundown the school is and that school budgets are kind of tight and how people have to give a little extra of themselves for the sake of the kids. The voice-over comes on "To help local schools this year Office Depot is crediting 5% of your back-to-school purchase to the school of your choice. Office Depot. Taking Care of Business."

The spot opens on a young couple working on their budget, which has been stretched by spending on school supplies. The wife is a teacher who has been buying supplies for her class with her and her husband's money. The husband seems a little stressed and asks his wife if she could kind of hold the line. She explains that teaching isn't about money. Cut to Office Depot where she sees her husband in the next aisle. He's buying supplies too.

Today's branding strategies include **CO-BRANDING** with other brands that reinforce the **ATTRIBUTE** appeals in their advertising and promotion. These brand partnerships provide a synergy that builds brand loyalty from their similar target audiences.

Newspaper inserts were another important vehicle, running basically every week. Inserts also appear occasionally in *Fortune, Tech Buyer's Guide* and *PC World* predominately as a vehicle for showing the breadth of products.

Office Depot also had a softer side, as evidenced in the more emotional creative of its recent back-to-school campaign. Two new television spots presented the retailer's commitment to supporting schools in very human terms.

And "Taking Care of Business" was very much in the picture too, cleverly tweaked in their new commercials as "Taking Care of School Business."

Co-branding is most effective when it makes sense to the consumer values and attitudes. Is "Taking Care of Business" a **BRAND ASSOCIATION** that fits Office Depot and the teams and their arenas?

The company has aligned with a number of teams and arenas. Each team partnership has its own unique package of advertising and promotions.

Office Depot, Del Ray, FL
AGENCY: **In-house** (except broadcast)
CREATIVE DIRECTOR: **Walter Porras**
PRODUCTION COORDINATOR, CREATIVE SERVICES: **Jaimi Bybee**
ADVERTISING AGENCY (broadcast only) **Gold Coast Advertising,** Miami
WEBSITE: **www.officedepot.com**

"Turning on the Fun"

- Experiential Branding
- Brand Image Positioning
- Spiral Branding
- Brand Associations

BRANDSTANDS

BEST BUY, the nation's number-one specialty bricks-and-clicks retailer of consumer electronics, personal computers, entertainment software and appliances really knew how to have fun, while building up a formidable business (and share of market) that moved like wildfire across the U.S. and into Canada.

In 2001, with 419 stores in 41 states, I5 stores in the New York market (New York metro, Hudson Valley, New Jersey), recent acquisitions of the 1,300 door Musicland Stores and Magnolia Hi-Fi 13-unit chain, and expansion plans into Canada (a projected 65 stores between 2002 and 2005), Best Buy

company's new website offered an online selection of the consumer's favorite brands. The synergy created by combining the power of the internet with its existing distribution centers in the off-line world was designed to make BestBuy.com an important electronics destination, 24/7/365.

Through their in-house, "business-within-a-business" advertising agency, BBA (see sidebar), Best Buy grabbed the ultimate consumer's attention and never let go. The synergy of **SPIRAL BRANDING** that illuminates the **meaning of the brand** to the consumer has a direct connection to their lifestyles profile. Engel cited Best Buy's target customer as 59% male (half have children at home); 42% are college graduates. Target age is 14 to 49 (68% are 15 to 39); 51% have incomes between $41,000 and $100,000. "As Engel put it, "Our mission statement is about serving multiple brands, and we are doing just that today. BBA leverages brand and industry knowledge to drive results. We work with state-of-the-art technology and we deliver creative that breaks through the clutter. The image creative we produce has a great kick and is very effective in communicating with customers. Our promotional work has a long and successful track record of driving revenues. Plus, our media buying is extremely efficient."

Best Buy maintains a strong, on-going TV advertising presence, under its "Turn on the Fun" banner slogan. Here, a customer is first shown pressing buttons in an elevator, then, having fun playing with electronic equipment in the store.

had built a $15 billion mega business through its innovative, brand-strengthening advertising/promotional efforts, all focused on just one idea—"Turning on the Fun." According to Julie Engel, senior vice president/Best Buy Advertising, "Our image advertising for Best Buy has established a distinctive brand personality, that of a smart, techno-savvy friend with a sense of humor."

Here is the **EXPERIENTIAL BRANDING** strategy that uses a "turn on the fun" shopping experience to **position its brand image.**

Best Buy had also taken the new economy by storm. The Minneapolis-based public

National image advertising, TV, magazine and radio spots—all consumer-friendly—continually kept Best Buy's message in front of the customer. Best Buy concentrated on newspaper advertising to reach 120 million readers per week with 48 million, full-color print Sunday inserts that ran in 425 nationwide newspapers weekly, accounting for 3.3 billion inserts annually; 130 market versions were created weekly, printed at 12 facilities nationwide in four and a half days. In addition, online inserts appeared in I30 zip-code specific versions at BestBuy.com. "Our research proves that the printed inserts,

which run 28 pages on the average, give us the best and longest reach to our customer," Engel said. Broadcast advertising was purchased on national network and cable. Local broadcast advertising ran on more than 500 stations nationwide. Each month, BBA made 217 million broadcast impressions on their target audience, with total 18 to 49 adult monthly impressions amounting to 439 million and total monthly 18+ adult impressions amounting to 697 million.

But Best Buy didn't stop there. The company came up with another consumer promotion to keep the Best Buy name firmly planted in the customer's mind. It partnered with national manufacturers such as car makers and credit card companies for a high-value gift card and gift certificate award program, giving sweepstakes winners the chance to choose name brand, cutting-edge electronics, cell phones, home entertainment products, personal computers, home appliances, software and music. There were also less expensive, value added gift programs that worked well in gift with purchase promotions. All programs were available on and off line.

Best Buy opened its doors as a one store, family business in 1966 in St. Paul. In 1981, that number had grown to seven stores. When a tornado hit, nearly wiping out the entire business, Best Buy staged their first promotion, aptly called the "Grab &Go" tornado madness sale. The event was held at the Minnesota State Fair grounds and promoted via two-color newspaper ads, TV and radio spots. "The sale was extremely successful because the ads were fun and the turnout was incredible. The event not only kept us in business, but it planted the seeds for Best Buy's shrewd marketing and advertising consumer appeal." explained Engel. "We learned that taking on risk and challenge isn't just a survival strategy; it's a strategy for growing and becoming stronger."

In 1983, Best Buy opened its first 25,000-square-foot superstore in Burnsville, MN, supporting the opening with lots of colorful Sunday newspaper inserts, aggressive "in your face" TV advertising and live, in-store remotes. During the mid to late 1980s, Best

Buy further enhanced its image by boosting its TV broadcast promotional/advertising efforts to 52 spots a year, stressing price and product in all of its local markets, with new commercials every week. "We changed our sales force to a noncommission basis in order to put the customer in control. So, we put the word out via more TV spots. Then, we added visibility with more four-color insert programs," Engel explained.

Best Buy maintained a strong and ongoing national advertising presence during sports and musical events, along with The Olympics and Monday Night Football on the ABC, CBS, Fox and UPN networks. Cable net-

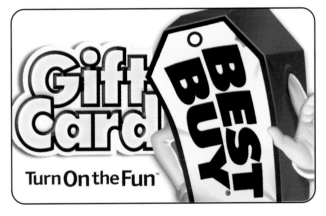

Best Buy's signature mascot, a price tag, appears here on the company's gift cards. Gift card promotional brochures, like those shown here, invite customers to create cards for special days like Father's Day and Graduation. The cards are available on the website and in the stores.

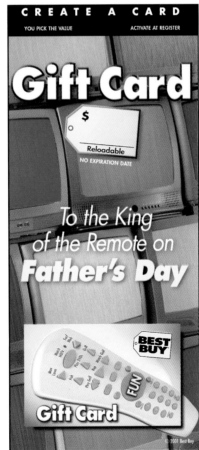

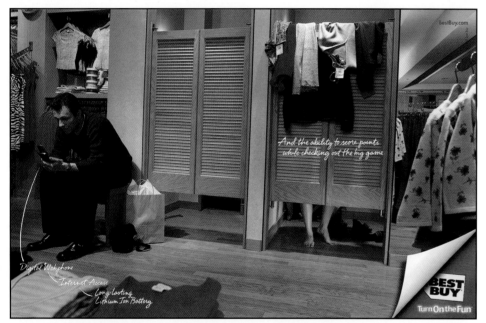

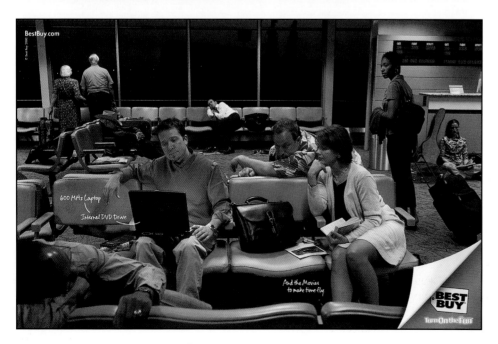

works like MTV, VH1, ESPN, ESPN2, Comedy Central, BET and Turner Sports were an important part of their media plan as well. Best Buy advertised on local, individual stations in their market, thrusting to viewership by their target audience, especially when it comes to sports events and local, syndicated programs like Seinfeld and Frasier.

But it was the launch of the "Turn on the Fun" image campaign that put Best Buy into high gear, further enhancing its name and image to the customer. The program was launched in early 2000 via branded TV advertising, which won top honors at The Retail Advertising Conference in February 2000. According to Engel, the campaign was developed as a way to convey and strengthen Best Buy's "personality factor" to the customer. "We wanted to communicate to the customer how shopping at our stores enhances their lives and lets them have fun," she added.

This is BRAND ASSOCIATION STRATEGY that goes beyond logos and slogans to create a more sustainable meaning of the brand for the customer.

According to Engel, Best Buy pulled out all the stops for its mid-September 2000 New York opening, as the company faced one of its greatest challenges in its 35-year history. "We knew New York would be tough because it's a difficult place to break through as a new retailer and raise awareness among such a mobile audience. We knew we had to tell our story, create a buzz and reach our audience. We knew we had to create a media plan unlike anything we'd ever created and executed," she noted.

So what did Best Buy do? They came to New York with a soft sell, Midwestern campaign. Their strategy was to go big (I5 stores now; 25 stores planned in the market area over the following three years). They created a buzz about their unique brand of fun shopping with media saturation: TV spots, newspaper inserts and themed insert "wraps;" promotions: huge banners wrapped around the New York Stock Exchange, "Fun Zones" introducing Best Buy products and a free Central Park concert starring Sting. They outfitted buses, billboards and commuter railroads with huge Best Buy posters, cards and wraps. They used the Times Square Jumbotron for spots that ran 20 times a day, from September 17 to 30 to pre-sell the opening and keep the Best Buy name in front of the consumer afterward.

For the grand promotional finale, they sent out a live, Best Buy mascot to landmark locations to ask typical New Yorkers what they

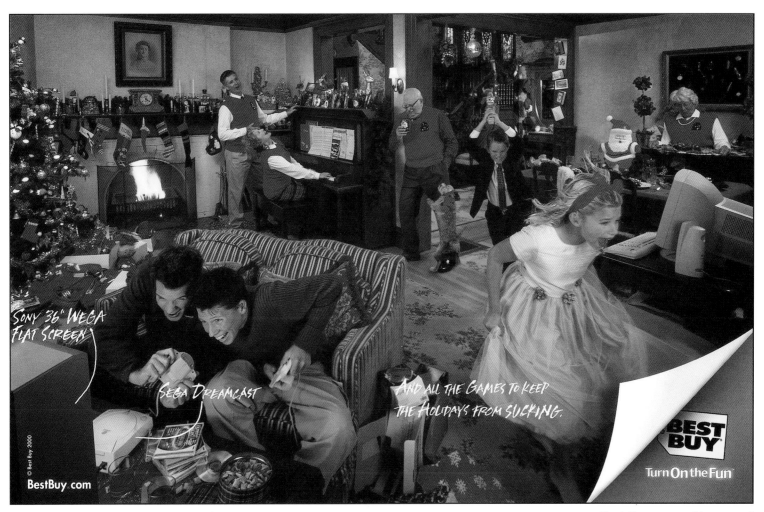

Sony 36" Wega Flat Screen

Sega Dreamcast

And all the games to keep the holidays from sucking.

© Best Buy 2000

BestBuy.com

BEST BUY®

Turn On the Fun™

thought of shopping in electronic stores. The mascot got an earful. He heard complaints about overeager salespeople and high prices. But not one New Yorker batted an eye about his outfit: a big, foam costume with blue tights and yellow high-top shoes. "We wanted the character to act normal despite his outfit. He's like a regular guy. And, that's how New Yorkers treated him," Engel said. When the mascot asked people to name their favorite movies, he and a taxi driver ended up in dueling imitations of Robert De Niro's "You talkin' to me?" from the film, *Taxi Driver.*

Did Best Buy accomplish their goals? You be the judge. Within a month following the grand opening, Best Buy had already broken through in the market and achieved consumer awareness levels comparable to Radio Shack, according to Best Buy Co., Inc. research findings. Grand opening store revenues were 175% vs. plan. Best Buy garnered national and local media coverage from Jay Leno to Fox News to The New York Times, with an estimated $12 million free media value. The Sting concert drew celebrities like Susan Sarandon, Kate Hudson, Kevin Bacon and Conan O'Brien and lots of celebrity coverage, all playing up the Best Buy name and image.

In 2000, Best Buy kicked off its largest ever holiday push with a $100 million, high-tech campaign featuring its distinctive, tag-shaped mascots dressed as Santa, surrounded by swirling, twinkling "magic dust" that brings toys, Christmas stockings and lawn ornaments to life, connecting the mascots to the store and to the website. The multimedia push, which included TV spots, print ads in 16 magazines, including *GQ, Men's Health, Spin* and *Wired,* in-store promos and Sunday circulars, which hit 500 newspapers starting in mid-November, targeted 18-to-49-year olds and emphasized men, who, according to Engel, are typical technology enthusiasts and early adopters.

George Lucas' Industrial Light and Magic produced the one-of-a-kind TV spots with special effects and animation. One 30-second spot, "Magic Laptop," showed magic dust swirling down the chimney and into a family's living room. The Santa mascot sees the stockings hanging by the mantel, eyes a laptop and logs on to BestBuy.com. The site then gives him the option of "Delivery" or "In-store" pickup." The mascot chooses "Delivery," and gifts such as a high-definition TV magically appear. When a child wanders downstairs, the Santa mascot character

Best Buy uses a wide range of magazines such as *Rolling Stone, Newsweek, Wired, Men's Health, Sports Illustrated, ESPN* and *Spin* to get their specialized pictorial/type message across to the target male consumer.

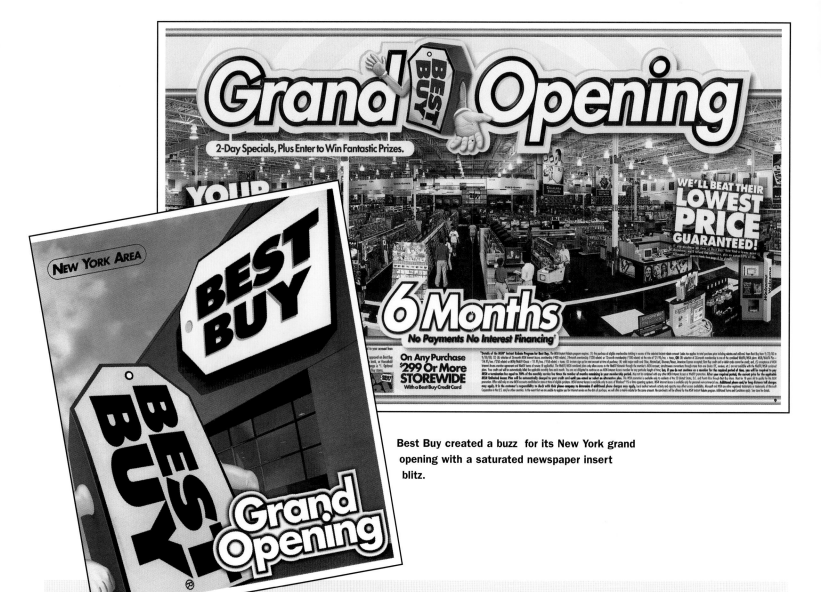

Best Buy created a buzz for its New York grand opening with a saturated newspaper insert blitz.

EYE ON BBA

Some might see BBA, the award-winning, in-house, "business-within-a-business" advertising agency of electronic goliath Best Buy Co., Inc, as the little engine that could. In the first part of the story, there's Julie Engel, who today is BBA's senior vice president/advertising. She started out 20 years ago as the one and only person handling Best Buy's advertising. Moving forward to 2001, Engel now leads a branded, comprehensive in-house agency of more than 300 full-time professionals. The team creates and produces all of Best Buy's national consumer advertising and promotional materials, including image advertising, TV, and magazine/radio spots, along with 48 million weekly or 3.3 billion annually full-color print Sunday inserts, seen in 425 newspapers across the country, as well

as online on BestBuy.com in 130 zip code-specific versions.

The agency currently services Best Buy along with its multiple brand partners such as BestBuy.com, Sam Goody, On Cue, Media Play, Sun Coast, Magnolia Hi-Fi and Red Line Entertainment, with what it calls comprehensive and cost-effective advertising capabilities. BBA will add Best Buy Canada to the roster in 2002.

According to Engel, BBA's goals are simple and direct. The agency's mission statement—"to become the agency of choice, by creating enthusiasm for brands and delighting our clients"—works to support the overall, add-on value package.

Editor & Publisher magazine recently ranked BBA as the #8 retail newspaper advertiser in the country. The Gallup Organization Brand Track Report says BBA produces "higher-rated creative than key competitors." DSN Retailing Today says, "what's astounding about Best Buy is that its in-house agency, BBA, manages to thumb its nose at Madison Avenue and

still beat out the rest of the retail pack."

Under Engel's stewardship, BBA is ranked nationally among the top 50 ad agencies by billings and is the third largest ad agency in Minnesota with annual media billings in excess of $500 million.

For BBA, the process of implementing advertising strategies and tactics that work quickly and efficiently across the national marketplace to attract and capture the consumer's interest and attention embraces Account Services (Account Management, Gift Cards), Media (Research and Planning, Newspaper Print and Broadcast Buying, Alliance Management, Classified Advertising, Paper/Printing Purchasing), Creative (TV/Magazine Image, Insert/ROP Promotional, Corp. Video Productions, In-Store Signage), All Digital Print Production (TV/Radio Broadcast, Product/Lifestyle Photo Studio, Digital Pre-Press) and Printing (Printing/Bindery Print Shop, Retail Signage Fulfillment).

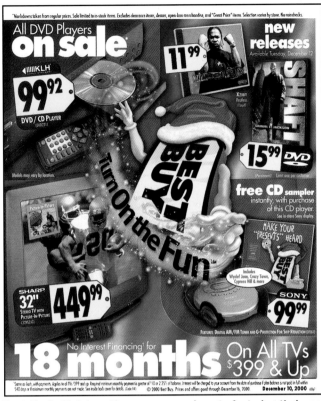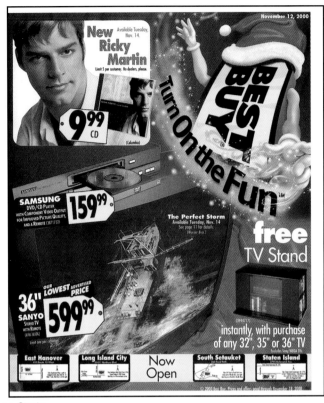

Best Buy's Christmastime newspaper inserts featuring their mascot as Santa.

grabs a cookie left for the real Santa.

"All the elements of the campaign were based on the central theme that by giving gifts from Best Buy, you're really giving the gift of fun," Engel explained. "We feature gifts that people are excited about, especially the latest in digital technology. We sprinkled this campaign with humor, and offbeat and unexpected elements to drive the point home. **We can't own the products, but we can own the in-store shopping experience."**

Best Buy plans expanded their ongoing "Turn on the Fun" advertising program to include national network programming buys, in addition to national cable TV and local spot programming. Additionally, there was added emphasis in print magazines, with holiday-specific advertising geared to the "Best Buy has the ideas to help me have more fun with my time by letting me shop the way I want to shop for the latest technology and entertainment solutions" concept.

Best Buy covered the back-to-school season with its fall "Drive Time" campaign, with a two to three week run. The campaign, which honed in on going back to school after a fun-filled summer, targets students, parents and everyone else involved in the back-to-school experience via newspaper inserts, TV and radio. Best Buy also got the message out to the customer online and in the store, with gift cards, signage and shopping bags.

To bolster its focus on fun and the in-store shopping experience, Best Buy launched a new "Turn on the Fun II" national/local TV campaign. Thirty-second spots rotated through mid-August. One spot, "Automatic Everything," showed a man dancing around a bathroom, playing with faucets and hand-dryers. The sequence was choreographed to an original soundtrack. Voiceover: "Do you like to try things out?" "Well, at Best Buy, you can try a variety of cool, fun electronics." The spot then cut to a Best Buy shopper having lots of fun trying things out in the store. Another spot, "Department Store," showed two bored kids listening to bad music. Then, the music changed to hard-driving rock. The spot then cut to a backroom, where the kids were having fun listening to music when they get busted by a security guard. Voiceover: "We've got tons of music, entertainment products and software in our store and you can listen, try everything out, have fun and be free."

Best Buy, Minneapolis, MN
SENIOR VICE PRESIDENTt: **Julie Engel**
AGENCY: **In-house**
VICE PRESIDENT, BRAND COMMUNICATIONS: **Jennifer Johnston**
VICE PRESIDENT, PRINT ADVERTISING: **Ric West**
CREATIVE DIRECTOR OF PRINT ADVERTISING: **Manny Palomo**
BRAND/CAMPAIGN BROADCAST CREATIVE DIRECTOR: **Bill Nordin**
DIRECTOR, YELLOW TAG PRODUCTIONS: **Steve Prather**
MARKETING COMMUNICATIONS DIRECTOR: **Barry Johnson**

SPIRAL BRANDING
with One-to-One
Multimedia Messages

- Identifying the most profitable customers and investing budget and resources to build **personalized** customer relationships

- Using interactive advertising and direct media in a **"surround** communications" program to encourage customer feedback

- Installing software technology that **selects and communicates** personalized offers and special events to each customer

- Building your brand's message to match the **customer's lifestyle**

- Connecting with your customer **when, where and how they want**

Shopping Centers

Quick and Easy

- Destination Branding
- Attributes Branding
- Spiral Branding
- Brand Awareness

BRANDSTANDS

ANYONE WHO'S ever questioned the vital role research can play in developing a marketing plan should consider the experience of Park Royal Shopping Center.

Park Royal, a regional mall in West Vancouver, British Columbia, was in a good position to focus on growing its business from outside its primary market area. Two of its department stores had recently completed major renovations, and the mall itself had substantially expanded its mix, having added new fashion stores and a home furnishings wing. With 250 stores, Park Royal not only had more stores than its competition, but offered a selection unavailable at competing malls.

"When we began to go after our secondary markets, we started to realize that some of them thought the center wasn't as convenient as some of the other centers," said Cindi Lone, marketing director. "In telephone surveys, people said it was hard to get to." A **DESTINATION BRANDING** strategy was needed.

There was no question that more data was needed to evaluate how this perception impacted on mall business, so in January 1998 the center embarked on a market research project of both its primary and secondary trade areas.

The research found that 96% of Park Royal's primary market shopped at the mall throughout the year, while only 43% of the secondary market did. What's more, the report confirmed that the reason the secondary trade area didn't shop at Park Royal

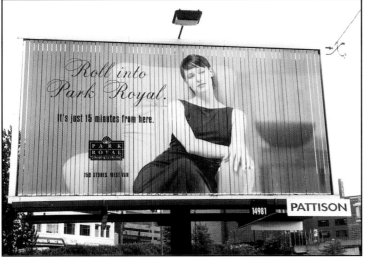

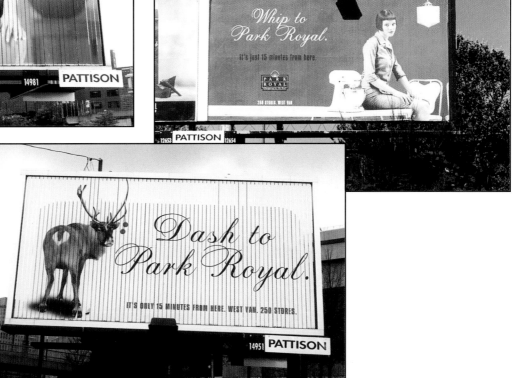

A series of billboards was placed on high-traffic routes in the secondary markets from March to November. The reindeer dashed for five weeks. Visuals and headlines matched the television spots and reiterated the quick and easy message by incorporating the phrase "only 15 minutes from here."

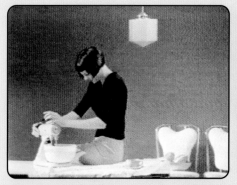

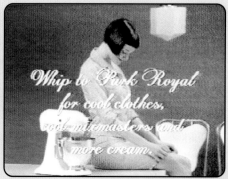

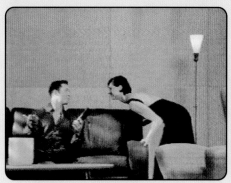

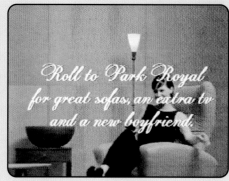

park royal

The TV spots featured various products and retail categories with offbeat scenarios. The commercial above opens on a woman trying to whip cream with an old beater. The cream is splattering everywhere and not whipping. The viewer hears moans and groans of frustration as the woman's clothes are getting splattered. Sound and picture dissolve to a spanking new classic mixmaster and a shot of the now happy woman dressed in a new outfit from Park Royal. Headline and voice come up "Whip to Park Royal for cool clothes, cool mixmasters and more cream. Park Royal. So easy. So quick." Three other scenarios depict similar situations using the headlines: Roll to, Fly to and Zip to Park Royal. The spots were edited to run back-to-back in :30 second time slots in April and September.

By simply changing the tag on the end of the sidewalk sale commercial, Park Royal was able to utilize the same :30 second commercial for both the winter and the summer sales.

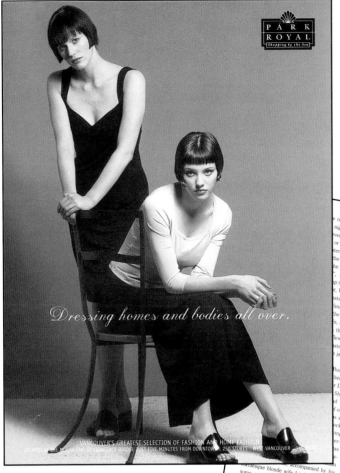

Dressing homes and bodies all over.

VANCOUVER'S GREATEST SELECTION OF FASHION AND HOME FASHION
LOCATED AT THE NORTH END OF LIONS GATE BRIDGE JUST FIVE MINUTES FROM DOWNTOWN . 250 STORES . WEST VANCOUVER . 925 9576

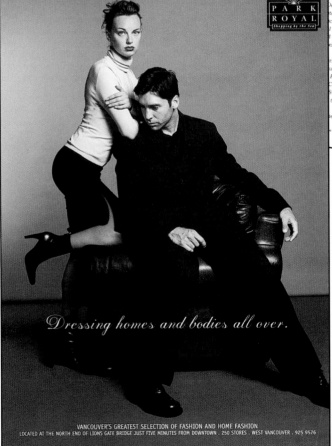

Dressing homes and bodies all over.

VANCOUVER'S GREATEST SELECTION OF FASHION AND HOME FASHION
LOCATED AT THE NORTH END OF LIONS GATE BRIDGE JUST FIVE MINUTES FROM DOWNTOWN . 250 STORES . WEST VANCOUVER . 925 9576

Magazine ads repeatedly emphasized the message that Park Royal offered a superior combination of both fashion and home furnishings. Ads ran in two of Vancouver's most read fashion and home fashion magazines. The tag reinforced the quick and easy message.

more often was that consumers perceived it to be too far from their homes, and that they could access other regional malls in less time. But the reality, according to Lone, was "in actual time it doesn't take any longer." She spoke from experience. Some members of the marketing team had engaged in a little "mother-in-law research," driving various routes themselves. They found that it took an average of 10 to 25 minutes for consumers to drive to the competition and an average of just 10 to 20 minutes to get to Park Royal.

Park Royal clearly needed to change the perception about the time it would take to reach the mall. Furthermore, because the market research also revealed that nearly half of the respondents from the secondary trade area weren't familiar with the selection available at Park Royal, consumers needed to be informed of what they couldn't get at other malls.

When the research reveals that a brand does not have a desired **BRAND ATTRIBUTE** (in this case, time-saving), the marketing objective is clear. The real problem is how to create a strategy and an execution of it that will work.

"We wanted them to know that it's closer than you think, that it's quick and easy to get here and once you're here, we're more than just fashion," said Lone.

Other objectives were to reinforce loyalty within the primary market and to increase sales by increasing the number of shoppers as well as the frequency of secondary trade area visits.

The strategy for achieving these objectives would be a totally integrated advertising campaign that would influence consumer perception and awareness in a way that would make the mall stand out. Integration of media for **SPIRAL BRANDING** can involve one promotional activity, (e.g. advertising), or an integrated schedule of advertising, public relations, sales promotion, special events... The decision should be based on how the message can best be sent to "surround" the receiver.

Park Royal's in-house marketing team, together with an outside professional, created a campaign that depicted situations in which

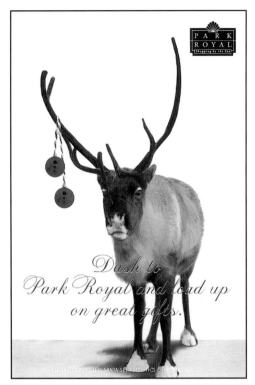

A 20-page Christmas catalog showcased the mall's vast selection.

something was suddenly needed from the mall and—because Park Royal was so quick and easy to get to and had such a great selection—it's the logical place to go.

The plan was to saturate the market using a variety of media, which included television, direct mail, outdoor, magazine, newspaper and in-mall signage. The copy running through all media consistently used verbs such as "whip" to, "race" to, "whiz" to and "peel" to as ways of reminding consumers that getting to Park Royal was quick and easy. Everything had a touch of humor, ranging from amusing to hilarious as is the case of the flying whip cream in one of the TV spots. The tone was sophisticated yet a bit quirky to appeal to a target market of women 25 to 50 and to make the ads memorable.

"We're in an upscale area, so we wanted to have a level of sophistication and still have fun within a budget," Lone said.

The use of television in the media mix was particularly noteworthy. Park Royal was the only shopping center in the market that used originally produced television spots. "TV is difficult because you're up against large national advertisers," Lone said. Even so, the marketing team made the most of it. "People would come up to me and recite the commercial," she said. "It's not easy to get that out of people!"

BRAND AWARENESS can be more than the ablility to recognize a brand. It should also involve the ability to repeat its message, and explain what it means to the consumer.

Placing the three :15 second spots back-to-back in varying orders into :30 second time slots created the illusion of three different :30 second commercials. All the spots were produced at the same time to save money on production, reducing costs from what would have been $88,000 (an average of $22,000 each) to $42,154. Moreover, since the three :15 second spots were non-seasonal, the television station was able to run bonus spots various times during the year when Park Royal wasn't running.

The marketing strategy definitely paid off. "We did research again to see the results" said Lone. "The numbers from our secondary markets went up and, in talking to our tenants, we were told they saw new people. Our customers are extremely loyal, so when there's a flock of new customers, people notice." There were other measures of success—the kind that impact the bottom line. Sales volume increased by 11% for the year ending January '99, and 67% of the secondary trade area now shops at Park Royal, an increase of 24%. The frequency of secondary-market customers shopping one or more times per month also rose substantially to 49%—a 28% increase over the previous year. Park Royal also achieved its objective of maintaining loyalty within its primary market, increasing the frequency of visits from 69% to 85% by customers shopping two or more times per month.

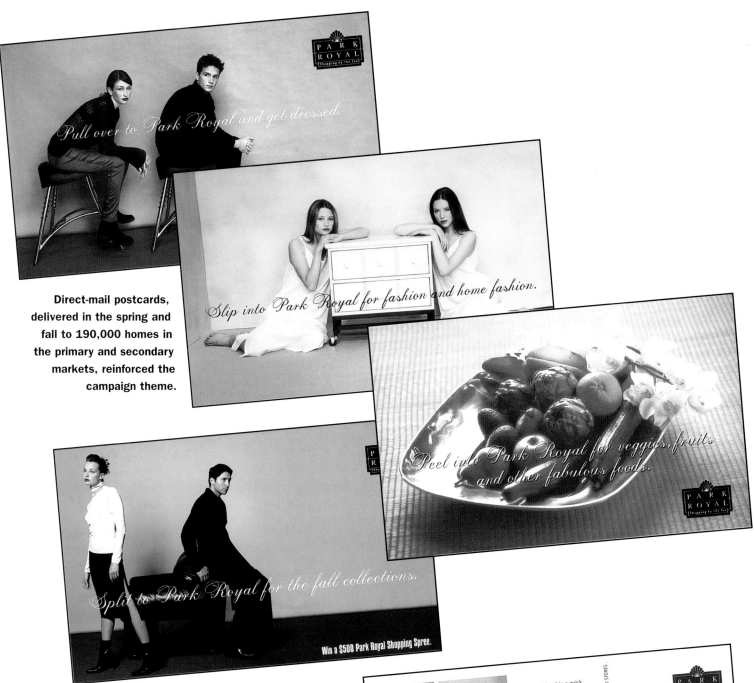

Direct-mail postcards, delivered in the spring and fall to 190,000 homes in the primary and secondary markets, reinforced the campaign theme.

The postcards were carefully targeted to specific areas within both trade areas to feature messages regarding distances to Park Royal. Printing the postcard backs in black and white minimized costs.

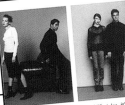
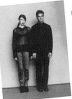

Park Royal Shopping Center,
West Vancouver, BC, Canada
MARKETING DIRECTOR: **Cindy Lone**
ADVERTISING AGENCY: **In-house** and **JFC**, Vancouver
TELEVISION: **Public Pictures**, Vancouver

The Cat's Meow

- Brand Image Positioning
- Brand Attributes
- Brand Associations

BRANDSTANDS

MOST PEOPLE, other than those from the Middle East, would find Dubai hard to place. But in terms of retail activity, the city in the United Arab Emirates has put itself on the map. Despite the fact that Dubai's population is less than a million people, most of whom are low income, the city is a major hub of trade and tourism in the Middle East. In the late 1990's, it had seen a mushrooming of luxury hotels and no fewer than 20 new shopping malls. Moreover, if everything goes according to plan, another 12 malls will be constructed in the area.

This sheer number of shopping malls coupled with the arrival of a department store (a concept new to the region) have given Dubai an astonishing choice of shopping venues. "Dubai has sort of become the Singapore of the Middle East in terms of business," said Claire Calabrise, director of mall marketing for Glimcher Properties, who had been marketing director at BurJuman Centre, Dubai's most upscale mall.

A major reason for the BurJuman's success was its select tenant mix, making it unique in that it was the only mall to carry certain well-known international names. This distinction was eroding, however, as some of these stores were looking to expand their presence into newer—and in some cases bigger—malls.

When the center opened in 1992, it was under the ownership and management of a family that also owned another mall in the city that had been operating for a number of years. Although the malls had different tenant and customer profiles, both were managed by the same team.

With the number of new centers growing at a rate faster than the population, and the prospect of additional competition, it became clear that BurJuman and its sister mall needed to develop individual identities in order to compete. As a result a new team was appointed to manage and market BurJuman exclusively, and a new advertising agency, TEAM/Young & Rubicam, was brought on board.

A **BRAND IMAGE POSITIONING** strategy was needed to differentiate their mall-as-a-brand. **Their objective was to create a unique identity for the center** so that it would be perceived to be different from all the other shopping choices. This would not only help build a long-term loyal customer base not easily diverted by new fads, but also give the mall

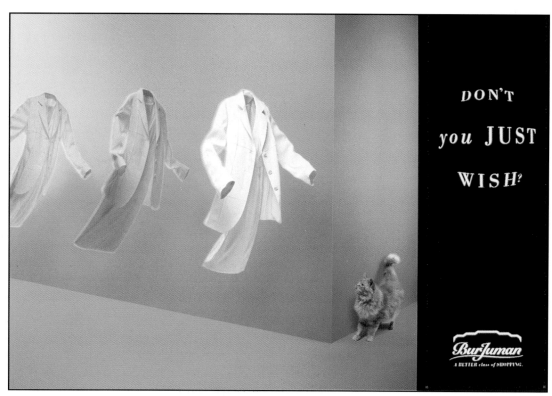

DON'T you JUST WISH?

BurJuman
A BETTER class of SHOPPING.

The BurJuman Centre carefully assessed their market situation reviewing their competitive position and the target markets they could best serve.

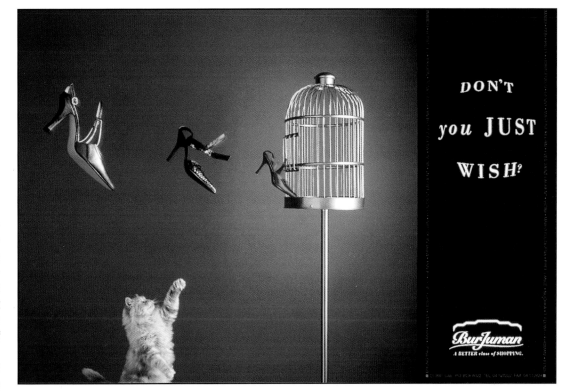

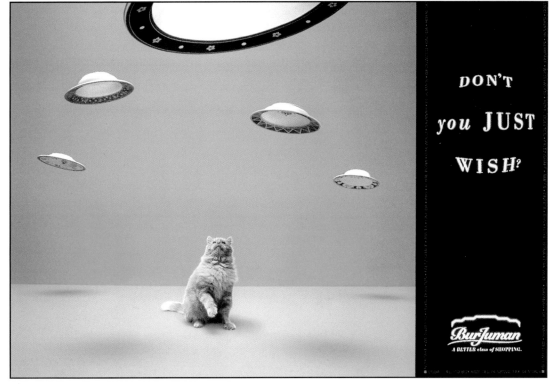

recognition beyond the limited confines of Dubai. "So often in a competitive environment you have people with similar messages," said Calabrise. "So throughout the whole strategic planning process we kept focusing on what the BurJuman Centre had as **its compelling point of difference."**

That difference was the Centre's **BRAND ATTRIBUTE:** a world-class group of tenants. While other centers had some prestigious international brand-name stores too, **there wasn't another center that could talk about the number of brands.** "That really our calling card," she said. But customers who shop primarily in these high-end stores weren't their only market. "There's only a certain amount that's high end and that same high-end customer has the means to shop outside the market. Then there are the masses," she added. "We have to go after that market as well."

The local target was middle to upper income groups, because as Calabrise pointed out, "Even if the individual does not have a high disposable income, that person will actually save up in order to make a purchase of value at BurJuman." The international target customer, on the other hand, consisted of upper-middle to upper income groups who traveled to Dubai for business or pleasure.

The solution was **to position BurJuman as the most exclusive shopping address in the Middle East**—a positioning that would send a message that BurJuman Centre was all **about the most desirable, the best**—"A Better Class of Shopping." **Designed to build the mall's equity as a brand,** rather than to encourage short-term traffic, the creative strategy was to skew to the target consumer with a positioning that would be difficult for competitors to infringe upon.

In order to play up BurJuman's strengths (women's and men's fashion, jewelry, watches, cosmetics, eyewear and tableware), the advertising that was developed was anything but conventional. Each category was promoted in a manner whereby the items become animate objects, each with a personality of its own. **As for the unusual choice of a cat, the idea was for it to function as a metaphor for the aspirational shopper who looks at the various items longingly to demonstrate their desirability.**

Julian, the London cat that outclassed all the others, was no stranger to the business. "The cat was wonderful!" exclaimed Calabrise. "Experienced in the industry and very friendly."

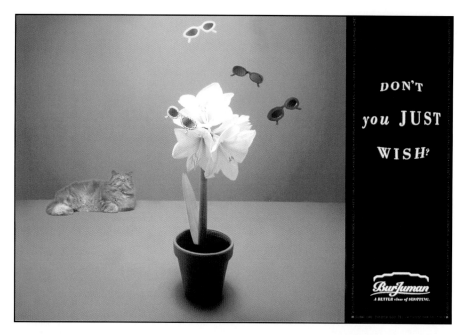

This campaign creates **BRAND ASSOCIATIONS** with a desired life of pampering and indulgence. The brands available in the BurJuman Centre offer a unique merchandise/store assortment for the shopper who is interested in the emotional benefits of economic aspirations and societal positioning.

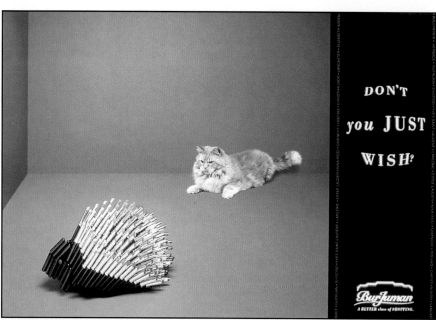

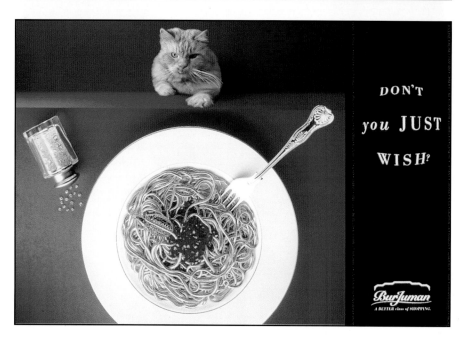

"In a way it had a two-pronged effect," said Calabrise. "I think the customer in Dubai is still much more status brand and label conscious than we see in the U.S. And if you talk about the aspirational customer, it could be someone like me who would love to give a gift in a Tiffany box."

What inspired the creative team to use a cat? "In Dubai, they love pets and cats in particular, so there was a little of bit of that," explained Calabrise. "But it was also what a cat evokes, whether you have a cat or not, in terms of the **pampering and being an indulgent creature.**"

Imagine the casting call for this model!

"The shoot took place in the photographer's studio in London," said Calabrise. "We went in for a week. A woman came in with 17 cats, mostly long hair because of their luxury. We talked to the cat trainer in terms of what she could actually get a cat to do, since there was a certain number of movements we had to get."

The media used was a combination of publications that would reach potential shoppers in the United Arab Emirates as well as shoppers in neighboring countries and visitors to Dubai from farther away.

The campaign was developed for the long-term over at least a couple of years. "I remember when we launched this positioning knowing that it was going to take a year or two to know what kind of results we'd have," Calabrise recalled. "We thought pushing the creative edge was okay since this is something different and unique. But it took some courage on the shopping center's part, since it's not a literal thing.

"When we first broke the campaign we got calls from consumers and ad people who thought we were nuts, I remember getting a call from someone saying he wanted to buy the cat!"

The campaign ran in both English and Arabic versions depending on media, largely in double-page spreads. In each execution, brand names relevant to the ads create a subtle border around the headline and logo.

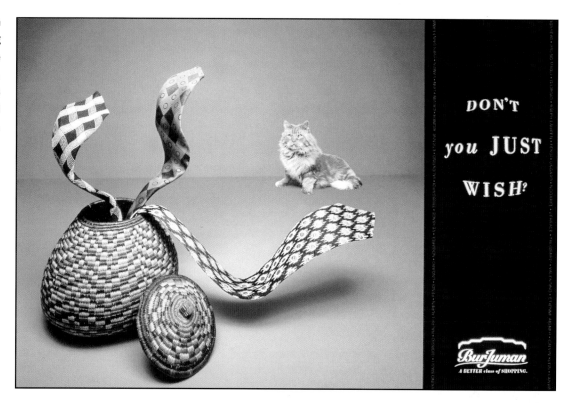

The creative execution is mindful of the target audiences' interests, brand preferences, shopping experience and joy of buying.

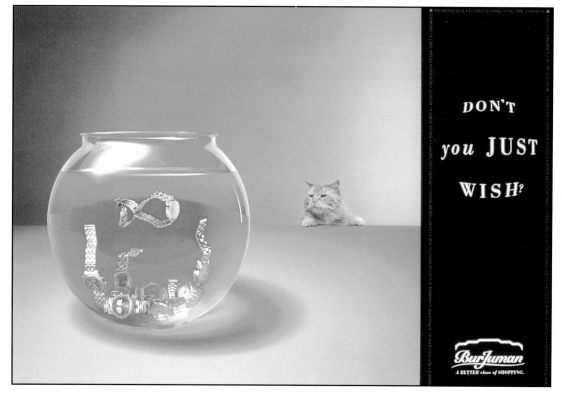

BurJuman Centre, Dubai, United Arab Emirates
MARKETING MANAGER: **Pamela Gravitte**
MARKETING MANAGER: (during campaign development) **Claire Calabrise**
ADVERTISING AGENCY: **TEAM/Young & Rubicam**, United Arab Emirates
CREATIVE DIRECTOR: **Sam Ahmed**
COPYWRITER: **Shair Ahmed**
ART DIRECTOR: **Sam Ahmed**
ACCOUNT DIRECTOR: **Michael Jackson**
PHOTOGRAPHER: **David Stuart**

Rebranding a Mall

SHOULDN'T _____ EVERYTHING _____ BE AN EXPERIENCE?

PACIFIC VIEW

VENTURA

PACIFIC VIEW would like to thank
all of our Ventura County Star readers
for voting us their number one mall.

PACIFIC VIEW.
Incredible shopping, cafes and grand terraces all await you.
And just think... there's so much more to come.

A Macerich Company Property
www.macerich.com

MILLS ROAD & MAIN STREET • VENTURA • 805-642-0605 / WWW.SHOPPACIFICVIEW.COM
MACY'S • JCPENNEY • SEARS • ROBINSONS-MAY • EXCITING NEW SHOPS & CAFES

Magazine ad thanking the readers of *Ventura County Star* for voting Pacific View the number one mall.

- Brand Image Positioning
- Brand Associations
- Experiential Branding

BRANDSTANDS

THIRTYSOMETHING is a great age if you're talking about people. But for a mall, it has a different connotation. Like many shopping centers built in the 1960s Buenaventura Mall in Ventura, CA, was feeling its age. Its tenant mix and merchandise left a lot to be desired compared with that of jazzy new centers in the area. "It felt tired," said Susan Valentine, Sr. VP Marketing for Macerich, the company that purchased the mall with the intention to completely renovate it.

When Macerich broke ground October '98, its objective wasn't to merely freshen up the mall. It intended to wipe out any association with it whatsoever. The plan was to completely overhaul it, top to bottom, north to south, in order to reflect the area's laid-back, comfortable-in-its-skin lifestyle. "We needed a whole new **BRAND POSITIONING IMAGE** that would say 'this is not the Buenaventura Mall that you knew,'" said Valentine. "We made a conscious decision to change the name because the mall's draw was so small," said Valentine. It would be known as Pacific View Ventura to reflect its location and the lifestyle its represented.

David Kelker, creative director of Infinitee Communications, the Atlanta agency that relaunched the center, added, "They took a mall that was really just a mall and changed the name and the whole perception. The whole California feeling of Ventura is world's apart from the way people are in L.A. It's a whole different market."

The challenge was to develop an advertising campaign that repositioned the **BRAND IMAGE.** The center would be perceived as an entirely new brand. The new brand strategy would be to launch the Pacific View Ventura name, align it with **BRAND ASSOCIATIONS** that reminded customers of their lifestyle

Construction barricade posters.

association with the beach. It would erase the memory of the old center.

In the process of physically transforming the mall, a second level was added. The mall was kept open throughout the construction, Valentine explained that all the stores in the south end of the mall had to be put on the north side while construction was being done. Then everything got moved back while the other end was done. "Throughout the construction people had to go through a tunnel," she explained. "We called it the runway to give it a fashion theme."

Meanwhile, Macerich was in the middle of leasing all through the mall with everything from The Gap to Ann Taylor coming in. Huge barricades, 25 feet or longer, were all over the place. Instead of what Valentine referred to as "junking up the mall," the barricades became an opportunity to pique the curiosity of customers and build excitement for the opening. Instead of one image, every store wanted to do a different one. The result was 35 different images at various phases of store openings.

With the mall in transition, still in the process of building and leasing, it was too early to break the whole campaign. But it was felt that a kickoff ad for the holidays was need-

Tourism ad.

167

Valentine's Day ad

Holiday ad.

:30 Radio Spot
Name Change

SFX: OPEN SPOT WITH SOUNDS OF WAVES AND WATER.

V/O: Remember the first time you experienced the sun setting on the ocean?

It will help to prepare you.

Or the last time you experienced something truly new?

You will...

Nothing can prepare you for something so memorable that it stays in your mind forever.

It's time... to experience the new Pacific View Ventura. Buenaventura Mall has been transformed into a new shopping experience. Sun-splashed interiors, verandas and ocean views and there's more to come. Experience all that you dreamed at Pacific View.

:30 Radio Spot
Parade

WOMAN: Okay Jason, let's go...

BOY: But Mom...

WOMAN: Come on, we'll be back.

BOY: I know, but just 10 more minutes?

WOMAN: So... you had a good time?

BOY: I saw a Santa that surfs, and he has his own beach house and reindeer riding waves...

ANNCR: Surf's up and Santa's riding the wave straight to Pacific View... just in time for our annual Pacific View Community Holiday Parade on November 20 at 10 a.m. Then, visit surfin' Santa at his beach house—complete with Pacific View's own surfin' Woody and wave-ridin' reindeer.

Experience all that you dreamed at Pacific View.

directory of stores

Cover of the mall directory.

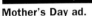
Mother's Day ad.

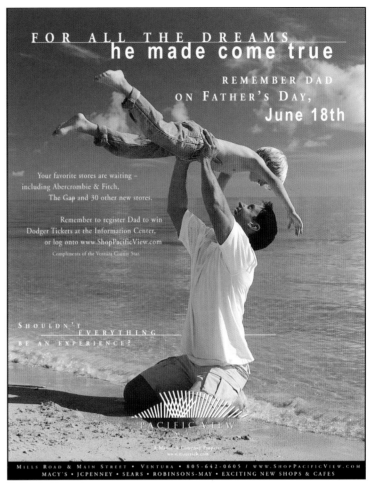
Father's Day ad.

ed. The ad used **EXPERIENTIAL BRANDING STRATEGIES** to say, "Experience all that you dreamed." It was the first to introduce the mall as Pacific View Ventura. The mood shot of sand and the new logo (added digitally) circumvented having to show the mall under construction; more importantly, it launched the new campaign's signature imagery.

Infinitee had shot the campaign for the whole year in just two days in Florida. In addition to 4C and duotone newspaper ads, radio spots were running on four stations, includ-

The big advertising push started in November. Said Valentine, "This is the best, the most targeted campaign for a shopping center I've seen, without going over the edge and being arrested for false advertising. It really fits."

Apparently, Ventura-area shoppers thought so. Response to the new center was phenomenal. Said Valentine, "Sales were so strong during the holiday season, it enabled us to bring in more new merchants.

And the new name had totally caught on.

Pacific View Vent] Ventura, CA
OWNER: **Macerich Company,** Santa Monica, CA
SR VP MARKETING: **Susan Valentine**
REGIONAL MARKETING DIRECTOR: **Phil Vise**
AGENCY: **Infinitee Communications,** Atlanta, GA
VP CREATIVE: **David Kelker**
DESIGNER: **Brian Shively**
ACCOUNT EXECUTIVE: **Debbie Ham**
PHOTOGRAPHER: **Alban Christ,** New York
WEBSITE: **www.shoppacificview.com**

ing a Spanish language station. According to Valentine, a big part of the market are agricultural workers. Many lemon and orange groves employ a large Spanish-speaking population.

Inaugurating L.L.Bean

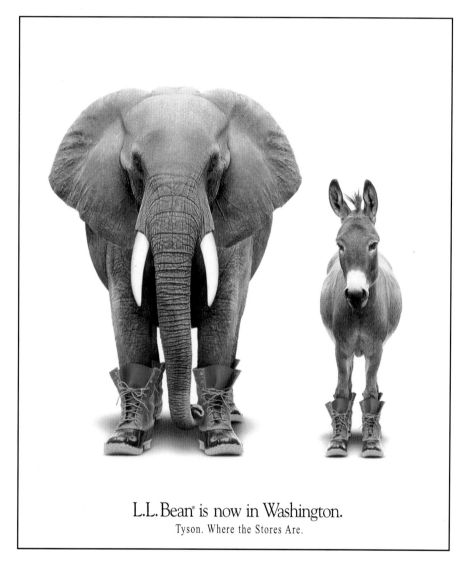

L.L.Bean® is now in Washington.
Tyson. Where the Stores Are.

- Brand Image Positioning
- Viral Branding
- Destination Branding

BRANDSTANDS

IT'S BEEN 83 YEARS since L.L.Bean opened on Main Street in Freeport, Maine. Since that time the company has grown beyond simply a clothing store or outfitter into something approaching an American institution. From the beginning, the store did mailings, followed shortly by the catalog, which eventually grew so large, the post office had to assign L.L.Bean its own ZIP code.

L.L.Bean has been spreading its presence through its website and e-commerce around the world. But despite all this commotion, until the end of 1999, there was still only one bona fide L.L.Bean bricks-and-mortar store in the U.S.

Then the venerable retailer announced it was taking off for other parts.

An L.L.Bean store outside Maine? Clearly, this was a pivotal moment in the company's history. For its first out-of-state location, Bean selected the place where history is made every day—the Washington, D.C. area.

Tysons Corner Center, located in the suburban Washington, D.C. area, is one of the highest-grossing malls in the country. For the center, the imminent arrival of L.L.Bean was an opportunity to promote the mall as a whole by associating it with such an important tenant. Despite the obvious, that malls are known by the stores they keep, specific tenant-focused advertising has rarely been done. It appears to be picking up, however, as an increasing number of malls around the country are finding that promoting its tenants is an effective way to promote the mall.

The branding strategy for **POSITIONING THE IMAGE** of a mall uses a special tenant as a **BRAND ATTRIBUTE.** The marketing objective in this case was to position this mall as a preferred **DESTINATION** with the most appealing mix of stores. In addition to helping L.L. Bean inaugurate its first "out-of-the-Maine stream" store, Tysons Corner Center is sharing the spotlight.

Promoting tenants doesn't mean a laundry list, or names dropped into an ad. *It makes the store the star.* In fact, L.L.Bean was depicted as so important, it was right up there with the country's most beloved national landmarks.

According to Paul Horenkamp, account executive at Adworks, Tysons Corner's advertising agency, the mall asked the agency to do some concept work heralding the opening of the first retail store outside

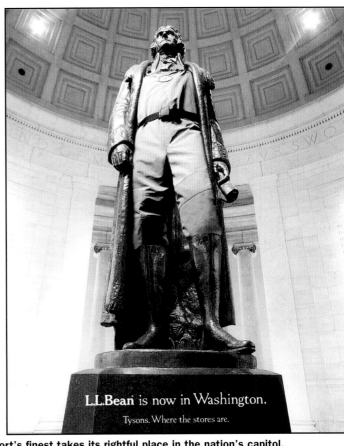

By spoofing DC landmarks, including the new Roosevelt memorial, Freeport's finest takes its rightful place in the nation's capitol. While hardly known for her shopping ventures, Eleanor Roosevelt was an activist for other women's rights.

Maine to be at Tysons Corner Center. "We had been working with Tysons for 10 years to help build their business," he explained. "In recent years we've been working strategically to upgrade the tenant mix and the center overall."

This was definitely big news, but as Horenkamp described it, in more ways than one. "The new L.L.Bean store is so big it's considered Tysons' fifth anchor store, so we knew we were going to do something big."

The objective was to use the **brand awareness** of Bean's to create a history-making arrival at Tysons Corner Center; The creative strategy gently spoofed D.C. landmarks in a way that would immediately communicate the essence of what Bean is.

The "spoofing of D.C. landmarks" is **VIRAL BRANDING**—where one consumer asks another, "did you see what Tysons Corner is doing?"

When Tysons later showed the creative work to the people at Bean, the folks in Maine called Adworks to ask if they could use their materials instead of those that had been developed by their own agency. A clear case of "co-branding."

The folks up in Freeport had to be mighty pleased with the results. The store's first weekend revenue projection was exceeded on the Friday before the first weekend technically even began!

The clearly successful campaign consisted of a series of print ads in the *Washington Post* that had started running the week of July 10th, two weeks before the July 28th opening. There was also a metro diorama, and a TV spot that aired locally the week

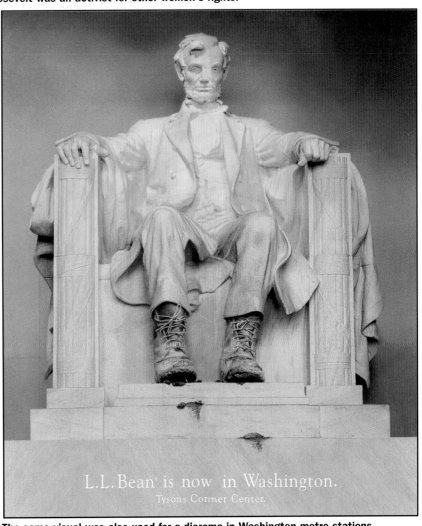

The same visual was also used for a diorama in Washington metro stations.

171

Gone Fishin' :30

SFX: Country sounds, birds and water.

SFX: Country sounds continued.

SFX: City sounds begin.

VO: L.L. Bean is now in Washington.

SFX: City sounds, horns and crashes.

before the opening.

Of the campaign itself, which produced such attention-getting images, Horenkamp had this to say. "It's such a simple concept. The beauty is in the retouching. It's amazing what some of these retouching issues can be: Should Abe's pants be inside or outside the boots? What about the mud on the steps?"

And how about creating the image in the ad with the elephant? Well, actually three elephants. As Horenkamp explained it, the elephant with the beautiful body didn't have such great ears. The elephant with the nice ears didn't have such white tusks. "There's natural discoloration." (And you thought *you* had problems!)

As for producing the TV spot, that too was fraught with rough spots. "Nothing was working in our favor that day," said Horenkamp. "They had arranged for a helicopter to do the special shoot. They literally had the camera for one day to do it, and the day dawned gray and rainy."

When the skies started to brighten so the shoot could be done, there was big trouble. At the last minute traffic control stopped everything, because there was a jumper on the bridge. "Fortunately, the jumper didn't jump and the heavens cooperated too. All of a sudden for an hour and a half, it was a perfectly beautiful day. "Ultimately we got our shot."

What a great country! And so, L.L.Bean, encouraged by the reception in our nation's capital, proceeded to open a second store at the Mall in Columbia, Maryland.

The **BRANDSTAND PARADIGM** shows the interaction and reinforcement of branding strategies designed to build brand equity. In this case, the strategies were created to use the brand associations of original L.L.Bean products "worn" by American icons in Washington D.C.

Tysons Corner Center, McClean, VA
AGENCY: **Adworks Inc.,** Washington, DC
CREATIVE DIRECTOR: **Mark Greenspun**
ART DIRECTOR: **Bill Cutter**
ACCOUNT SUPERVISOR: **Paul Horenkamp**
PRODUCER: **Cheryl Breeden**
RETOUCHER: **Slingshot Studios**
PHOTOGRAPHER: **Burwell & Burwell**

L.L.Bean® is now in Washington.

Tysons. Where the Stores Are.

A BRANDSTAND GLOSSARY

The following definitions are derived from the strategic concepts of *retail brand building* that are explored in the BrandStand case studies. They may be defined in different terms to describe other marketing concepts.

Added Value — Intangible attributes of a brand that are more than functional.

Appeal — A reason to buy given by the brand designed to motivate the consum...

Attr... a product or a service as per-

... red by the consumer ... service.

Bra... to make a product, comp... competition.

Brand A... of a product, service or id... at already exist in the min... th Model in the Introduction.

Brand Awaren... cognize a brand by its attr... al or verbal identification. ... Introduction.)

Brand Concept Mana... and advancing everything t...

Brand Equity — The long... importance to the consume...

Brand Extension — The use o... product in a new category (see

Brand Image Positioning — Bran... uses intangible appeals to consume... ...ciations and values. (See the Brandwidth Mode... ...e introduction.)

Brand Meaning — The brand's personality, price/quality/value and experiential connection to each customer. (See the Brandwidth Model in the Introduction.)

Brand Media Mix — In the strategic plan, media selected based on the media preferences of the target audience. (See the Brandwidth Model in the Introduction.)

Brandstand — The author's term for an innovative retailer's strategy that adds value to its store-as-a-brand, its products and its services.

Brandstand Checklist — A guide for *Brandstand* case study that considers the retail marketing plan's situation analysis, brand objective, creative strategy, target audience, and brand building results evaluation.

Brand Strategy — A plan that describes how a brand will attain a marketing objective.

Brand Tactics — The communication tools and media activities used to implement strategies.

Brandwidth — The authors' term for synergizing communications to create a *Brandstand*. (See the Brandwidth Model in the introduction.)

Brandwidth Model — A graphic that positions the relationships and interactions of the objectives, strategies and appeals involved in retail brand building. (See the Brandwidth Model in the Introduction.)

Channel — A distribution structure that enables goods and services to be delivered. The traditional or non-traditional medium through which communications can be sent.

Commitment — A brand's promise to deliver the best performance to consumers, their cultures and their communities.

Consumer — a potential customer. The ultimate user of a product or service.

Customer — An individual who is now buying and using a brand. A regular or frequent buyer.

Database Marketing — A system that gathers and interprets behavioral data on customers and prospects.

Destination Branding — Creating a U.S.P. that establishes that *this* is the place to buy, e.g., building the store-as-a-brand.

Differentiation — Perception of superiority or uniqueness for a company, product or service.

Direct Marketing — A distribution system from a producer or designer to sell products, services or ideas directly to the consumer.

Direct Marketing Media — Direct mail, telemarketing, cable TV, print and broadcast used for direct marketing.

Direct Response Advertising — Advertising designed to elicit a consumer response or to make a sale.

Emotional Appeal — A reason to buy given by the brand based on the consumer's aspirations and desires.

Events Branding — Sponsorships, tie-ins, expos, co-branding events that contribute to the brand meaning. (See the Brandwidth Model in the Introduction.)

Experiential Branding — Using the consumer's lifestyle and experiences with the brand as the brand's key benefits. (See the Brandwidth Model in the Introduction.)

Global Brand — A brand that has similar appeals and values to consumers in countries throughout the world.

[handwritten annotations: in-store media / marketing / public relations / multi-channel retailing / position / promotion / repositioning / USP / viral branding]

A BRANDSTAND GLOSSARY

In-Store Media — Advertising and promotion media inside of a store: point-of-purchase display, signage, murals, video walls, kiosks.

Integrated Marketing Communications (IMC) — Marketing management that employs a full mix of communication tactics to build Brandwidth.

Line Extension — The strategy of assigning an existing brand name to a different product in the same category (see Brand Extension).

LTCV, LifeTime Customer Value — The process of evaluating what the long-term loyalty of an individual customer is worth to the brand.

Market Segmentation — The process of identifying target audiences with similar motivations and predictable responses to appeals.

Marketing Plan — A statement of strategies, creative execution, and evaluation of a campaign, to attain a marketing objective.

Marketing Public Relations (MPR) — Planned activities, events and sponsorships designed to make a Brand "stand" out.

Media Plan — A statement of how media will be implemented to attain marketing objectives. Includes how the media budget will be spent.

Multi-Channel Retailing — Retailers using web, catalog and the physical store to provide "seamless service" to their customers.

Position — The comparative perception of a brand's appeals to a consumer segment.

Positioning — The process of creating perceptions of a brand in the mind of consumers that challenge its competition.

Product — A reference to a brand that describes its function, service and benefits.

Promotion — The mix of communication activities used to get response from a target audience. Also an abbreviation for Sales Promotion (special offers to increase sales).

Promotional Mix — Advertising, direct marketing, sales promotion, publicity/public relations, special events, visual merchandising, and personal selling

Rational Appeal — A reason to buy given by the brand based on information for the functional and utilitarian needs of the consumer.

RePositioning — Creating new perceptions of a brand for new or changing target audiences.

Sales Promotion — Activities that provide extra incentives to encourage the consumer to buy.

Spiral Branding — The development of a program to surround the consumer with a synergy of communications, especially in new and unexpected places. (See the Brandwidth Model in the Introduction.)

Strategy — How an objective will be attained.

Tactic — A specific action that is directed by an objective and its strategy.

Target Audience — A common segment that has the right profiles for the brand. The profiled group for whom the *brand is right*.

U.S.P., Unique Selling Proposition — An *attribute, benefit or commitment* of a brand that is uniquely different and more appealing than its competition. Also: Unique Styling Persona, Unique Service Personality, Unique Strategic Positioning.

Viral Branding — A program designed to encourage customers to communicate (spread) the brand's value to others. Before it was "programmed", it was known as "word-of-mouth advertising." Internet chat rooms and planned special events are often employed. (See the Brandwidth Model in the Introduction.)